HOW TO CREATE
FANTASY ART

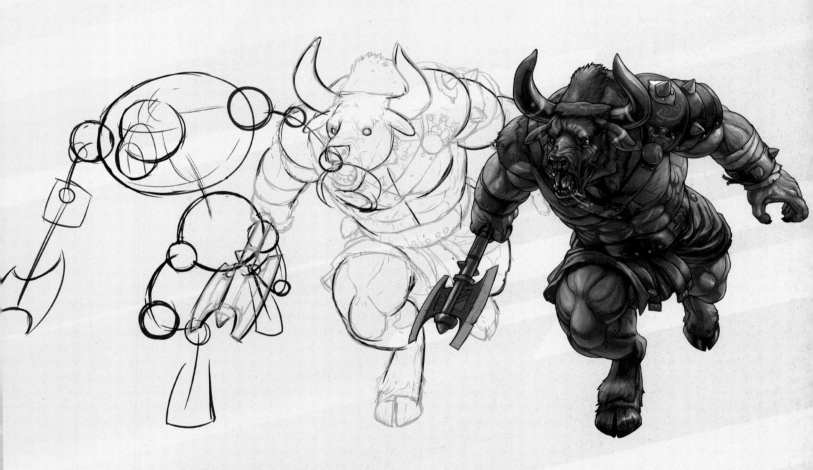

Juan Calle and William Potter

ARCTURUS

ARCTURUS

This edition published in 2018 by Arcturus Publishing Limited
26/27 Bickels Yard, 151–153 Bermondsey Street,
London SE1 3HA

Illustrations by Liberum Donum (Juan Calle, colours by Juan Calle,
Luis Suarez, Ivar Osorio, and Santiago Calle)
Written by William Potter
Designed by our-kid-design.com
Edited by Sebastian Rydberg

Additional images: Shutterstock

ISBN: 978-1-78828-792-0
CH006241NT
Supplier 26, Date 1018, Print run 7086

Printed in China

CONTENTS

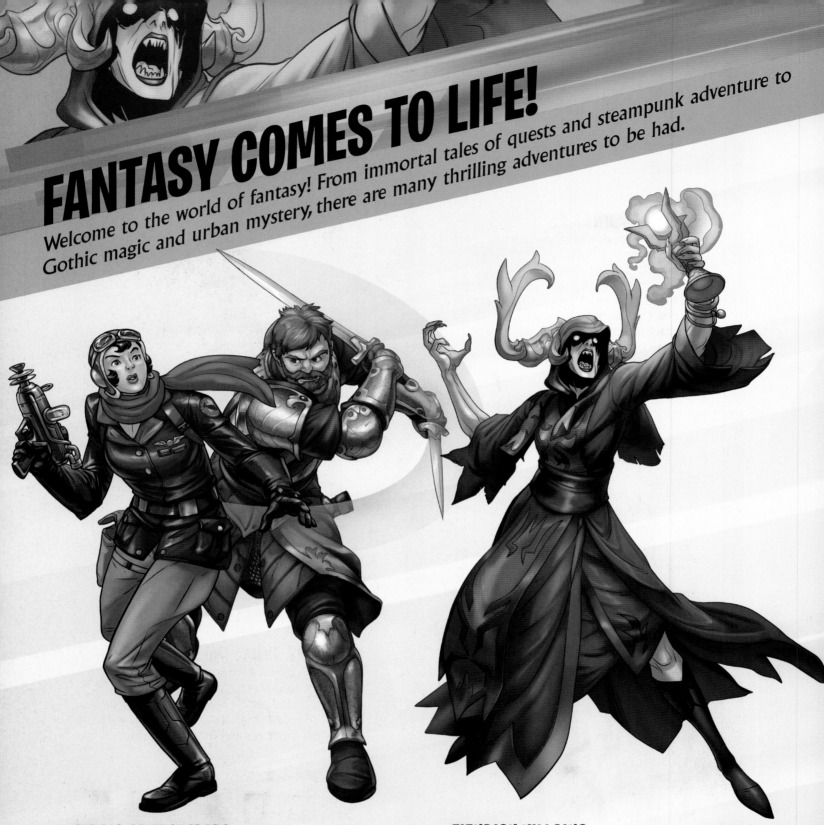

FANTASY COMES TO LIFE!

Welcome to the world of fantasy! From immortal tales of quests and steampunk adventure to Gothic magic and urban mystery, there are many thrilling adventures to be had.

HEROIC ADVENTURERS

In this book, you'll learn how to draw classic and modern characters, and find plenty of inspiration for creating your own heroes. From first steps to detailed pencils to finished paints, you'll bring to life amazing Amazons, sword-slinging adventurers, steampunk pilots, pirates, and fairie queens, devious dwarves, noble samurai, and street wizards.

FIENDISH VILLAINS

Your fantasy heroes will have many challenges to overcome, as you discover how to draw all kinds of villains: from dark wizards and vampire lords, to sinister scientists and evil enchantresses. Pick up tips on posing characters, plus costume details and settings, with expert advice on drawing fabric, fur, furniture, and flames.

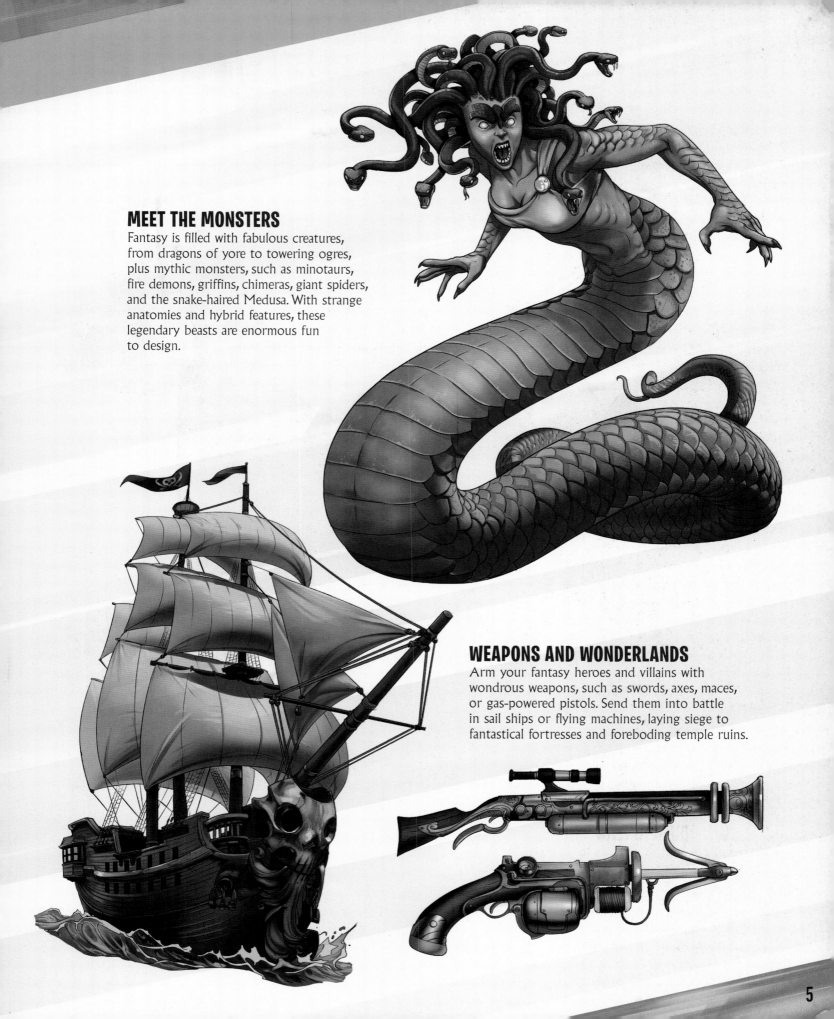

MEET THE MONSTERS

Fantasy is filled with fabulous creatures, from dragons of yore to towering ogres, plus mythic monsters, such as minotaurs, fire demons, griffins, chimeras, giant spiders, and the snake-haired Medusa. With strange anatomies and hybrid features, these legendary beasts are enormous fun to design.

WEAPONS AND WONDERLANDS

Arm your fantasy heroes and villains with wondrous weapons, such as swords, axes, maces, or gas-powered pistols. Send them into battle in sail ships or flying machines, laying siege to fantastical fortresses and foreboding temple ruins.

5

TOOLS OF THE TRADE

All you need to get started is a pencil and paper, but here are a few more tools you can use to add some extra magic.

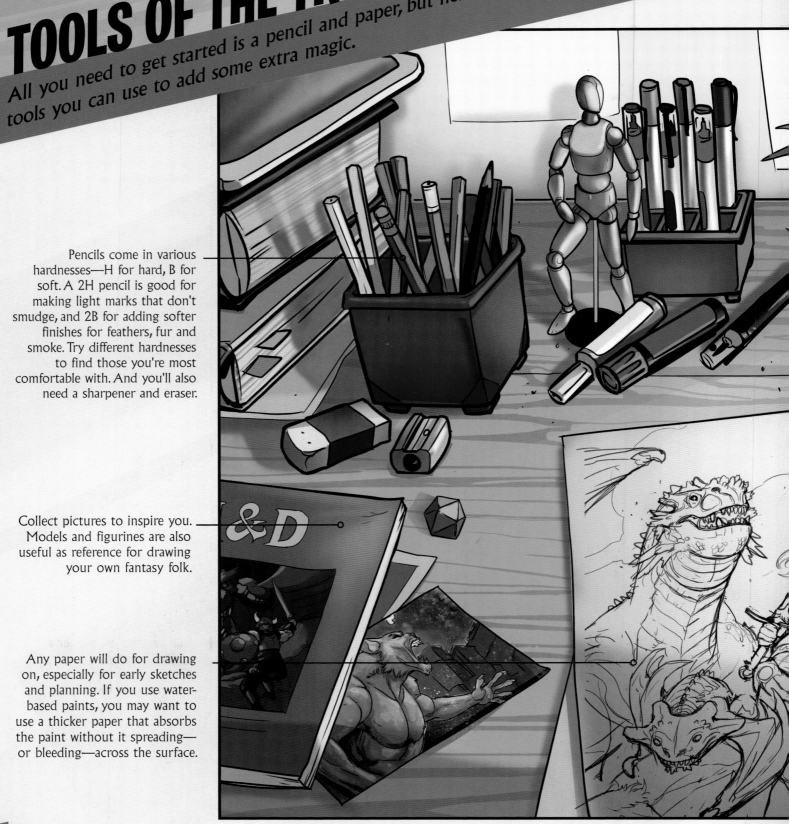

Pencils come in various hardnesses—H for hard, B for soft. A 2H pencil is good for making light marks that don't smudge, and 2B for adding softer finishes for feathers, fur and smoke. Try different hardnesses to find those you're most comfortable with. And you'll also need a sharpener and eraser.

Collect pictures to inspire you. Models and figurines are also useful as reference for drawing your own fantasy folk.

Any paper will do for drawing on, especially for early sketches and planning. If you use water-based paints, you may want to use a thicker paper that absorbs the paint without it spreading—or bleeding—across the surface.

You can use a waterproof ink pen to go over your pencil lines before painting. Alternatively use a nib pen or a fine brush dipped in ink. Using brush and ink requires some patience and a steady hand but can produce impressive results.

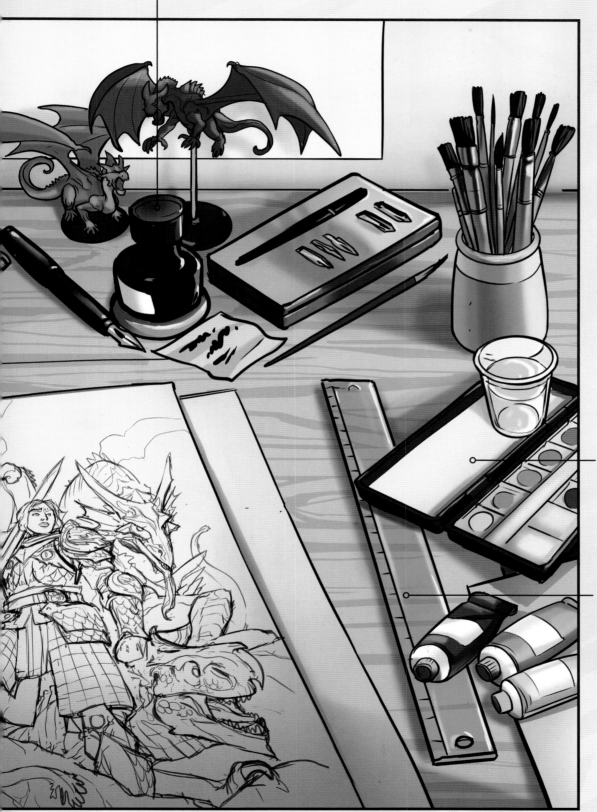

For the finished picture use a range of brushes with water-based or acrylic paints, plus a tray or plate to mix different shades.

While many fantasy lands are full of forests, craggy mountains, and crumbling ruins, you may still need to use a ruler as a guide, for straight weapons, buildings, mechanical devices, and planning the perspective of an action scene.

PERSPECTIVE AND PALETTES

A little knowledge of 3D shapes and perspective goes a long way in helping the most incredible scene look real.

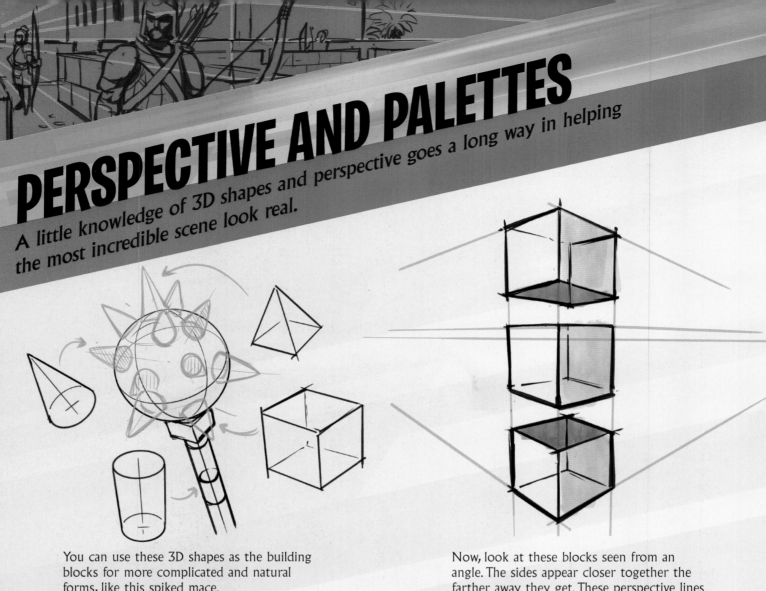

You can use these 3D shapes as the building blocks for more complicated and natural forms, like this spiked mace.

Now, look at these blocks seen from an angle. The sides appear closer together the farther away they get. These perspective lines continue until they join at a vanishing point.

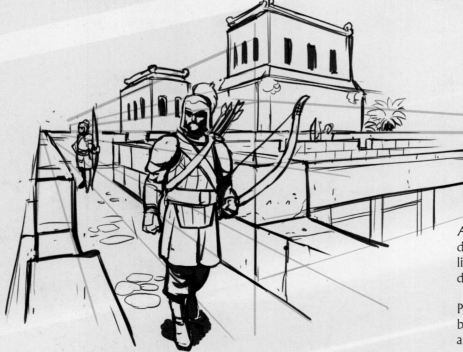

And here's a wall, getting smaller in the distance, following its own perspective lines. The guards also appear smaller in the distance, following the same rules.

Perspective lines are useful when you're building a scene that includes buildings and depth.

Reds suggest blood, fire, and passion. Use these to raise the temperature of your fantasy scenes, when dragons use their flaming breath or demons arise from dark domains.

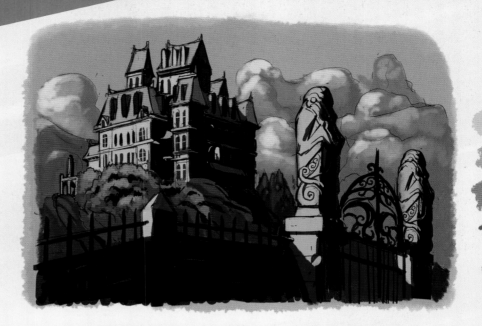

Browns and greens are calming, reminding you of nature. Many adventures involve quests across romantic countrysides. Create drama by beginning a journey in a relaxing green environment, and transitioning to a more threatening domain of red and black …

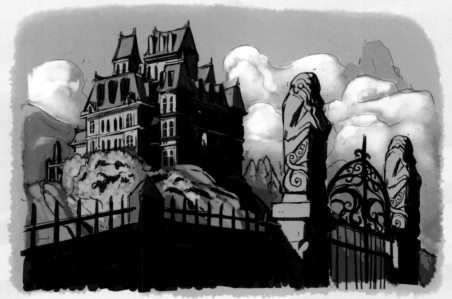

Blues are cooler, and suggest frosty, unfeeling, ghostly moods. Use these for moonlit scenes and the chilly castles of vampires.

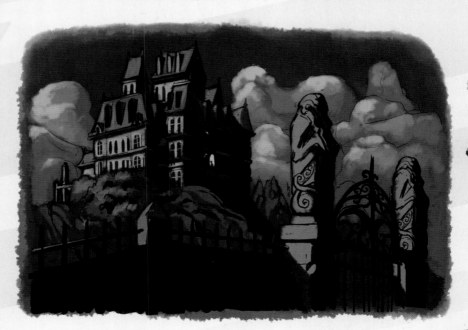

THE HUMAN FIGURE

Before adding features or clothing to your fantasy people, you should get to grips with basic human anatomy. Here's an average male and female body with correct proportions.

The body is about eight heads high, with the waist is about three heads down the body, and hands reaching midway down the thigh.

A woman's body goes in at the waist, then curves out to wider hips, like the number 8.

The body is symmetrical, with bones and muscles on the left matching those on the right.

The man's shoulders are broader than the woman's.

The man's body goes in from the chest to the hips.

When standing up straight, a line can be drawn from the top of the head, through the waist to the knees and middle of the feet. The shoulders push back as far as the bottom, while the chest pushes out level with the toes.

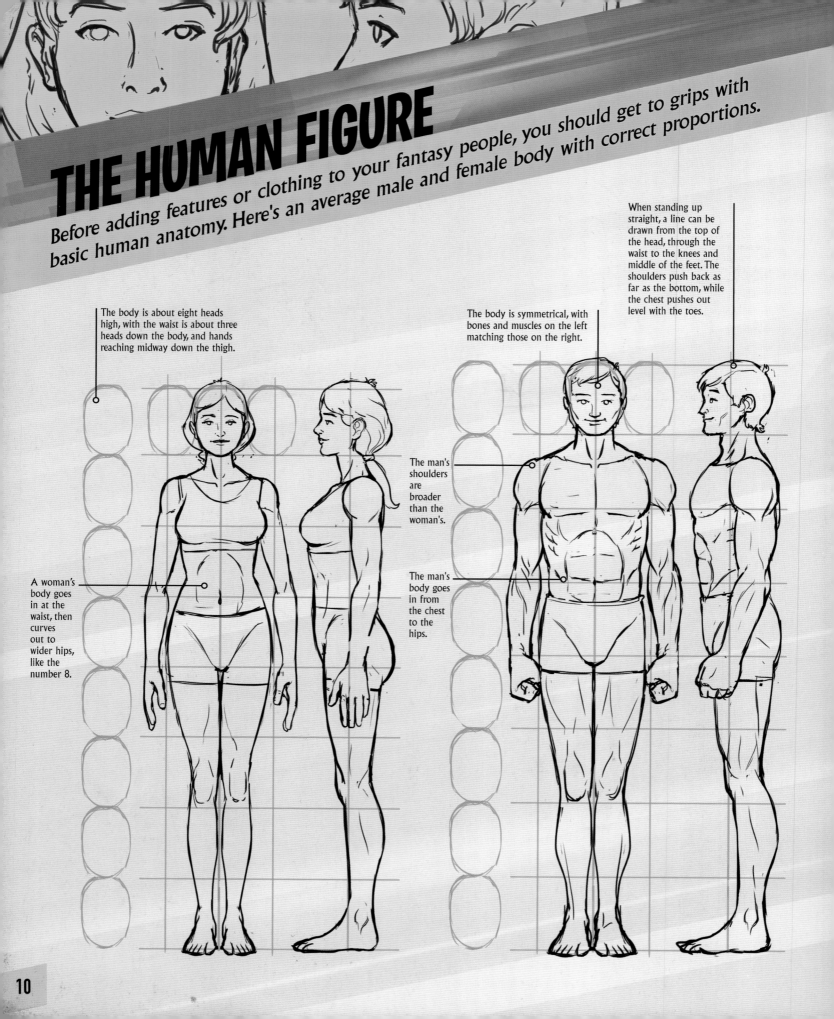

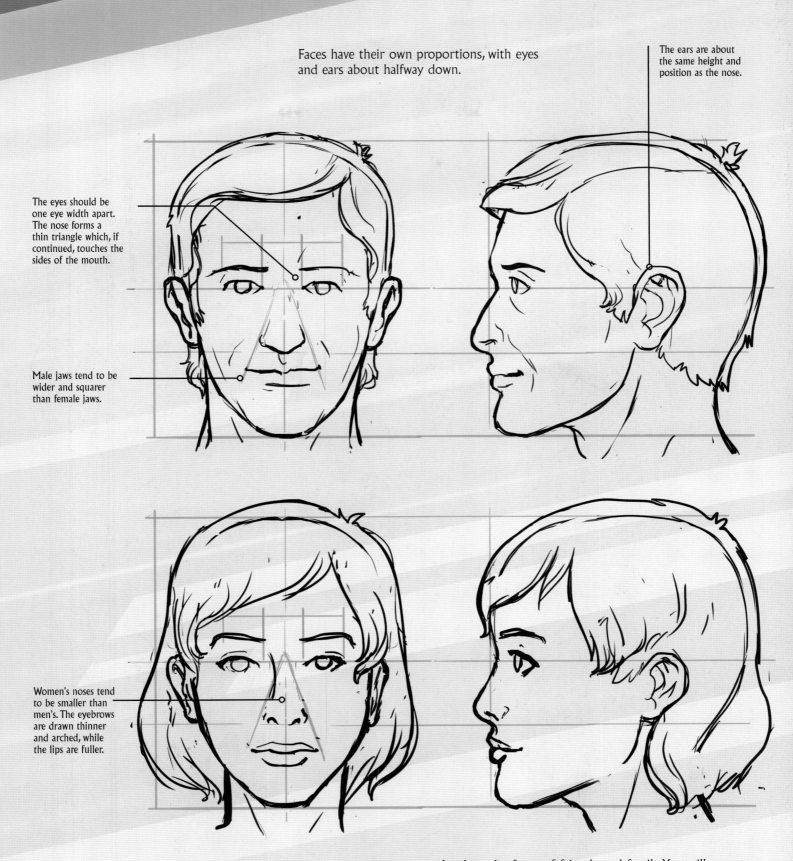

Faces have their own proportions, with eyes and ears about halfway down.

The ears are about the same height and position as the nose.

The eyes should be one eye width apart. The nose forms a thin triangle which, if continued, touches the sides of the mouth.

Male jaws tend to be wider and squarer than female jaws.

Women's noses tend to be smaller than men's. The eyebrows are drawn thinner and arched, while the lips are fuller.

Look at the faces of friends and family. You will see many variations. Sketch details you see and study hairstyles which you can use to make each of your comic characters unique.

STEP BY STEP

In this book, simple steps will guide you through the process of creating detailed fantasy figures and scenes.

1. Get things started by sketching a basic stick figure in pencil, showing the character's pose. The head, torso, pelvis, and limbs are indicated here.

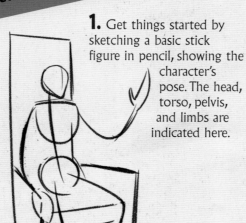

2. Still working in pencil, begin fleshing out the figure. We have shown the new lines in blue, so that you can easily pick them out.

3. Then continue to add details: the basic human form is given more character, with some facial detail and a choice of suitable clothing.

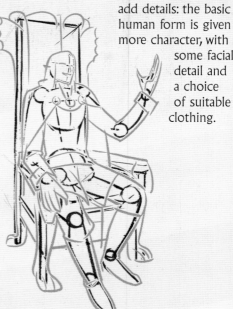

4. You can erase your working lines as you go. In these final pencils, more detail has been added to the figure and chair.

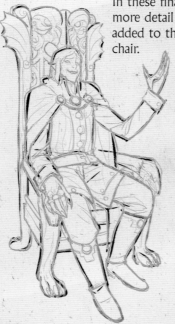

5. At this stage, it may help you to create a rough "thumbnail" to work out the exact palette of your final image.

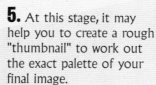

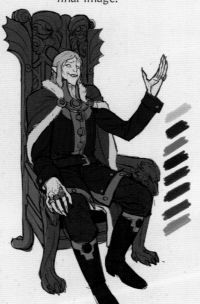

6. To create your final artwork, trace over the pencil lines with waterproof ink. Once the ink has dried, go over the whole image carefully with an eraser, before starting to work in markers or paint.

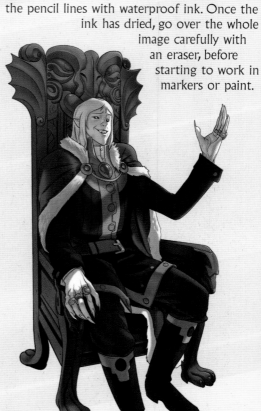

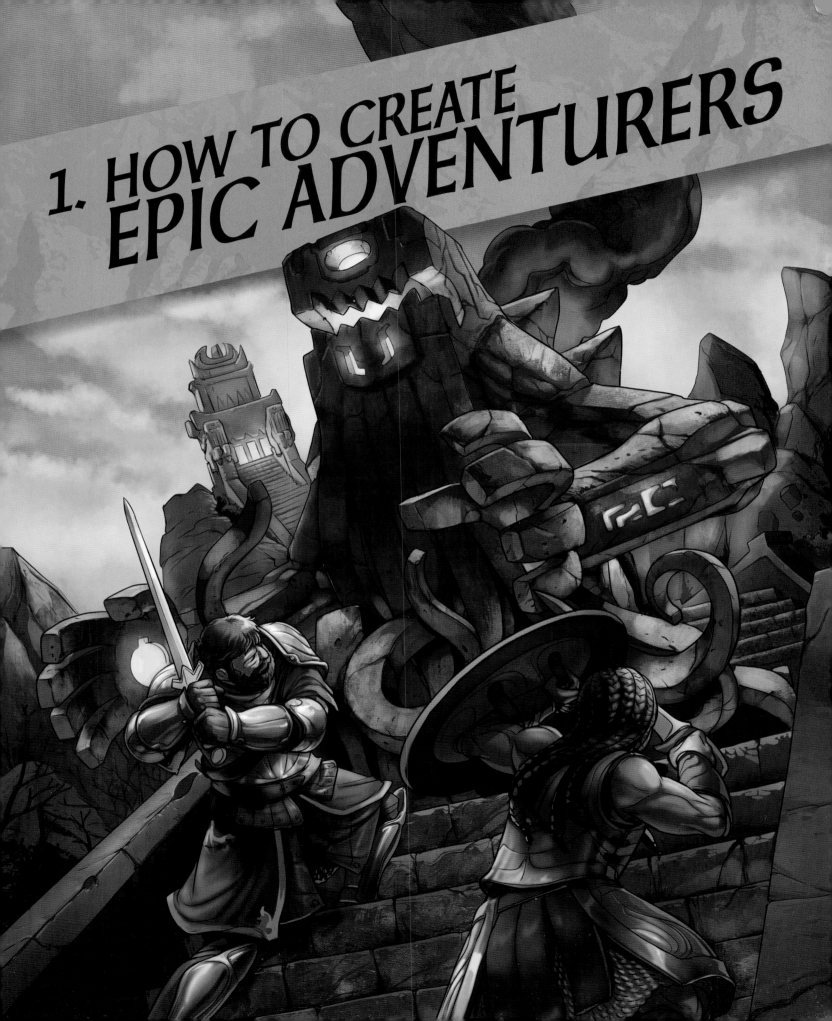

1. HOW TO CREATE EPIC ADVENTURERS

THE ADVENTURE BEGINS

In an ancient time of warring tribes, kingdoms, wizards, and wanderers, heroes fought evil and injustice. Here are some ideas for characters to inspire your own epic fantasy tales.

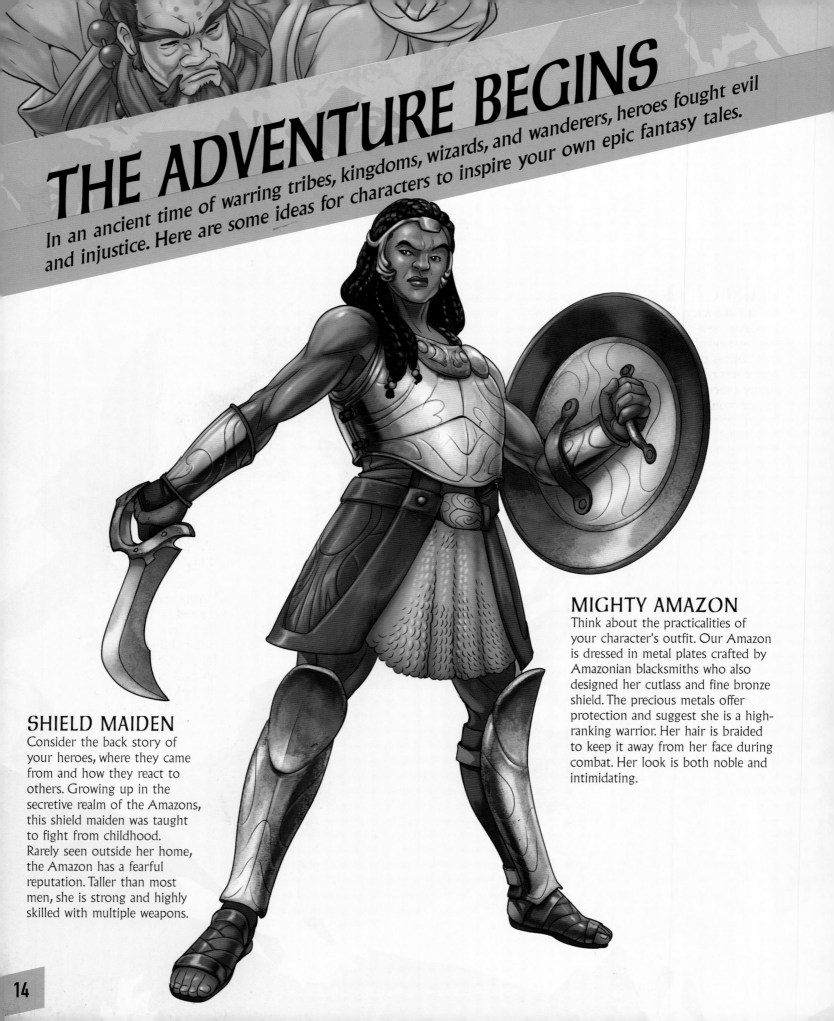

SHIELD MAIDEN

Consider the back story of your heroes, where they came from and how they react to others. Growing up in the secretive realm of the Amazons, this shield maiden was taught to fight from childhood. Rarely seen outside her home, the Amazon has a fearful reputation. Taller than most men, she is strong and highly skilled with multiple weapons.

MIGHTY AMAZON

Think about the practicalities of your character's outfit. Our Amazon is dressed in metal plates crafted by Amazonian blacksmiths who also designed her cutlass and fine bronze shield. The precious metals offer protection and suggest she is a high-ranking warrior. Her hair is braided to keep it away from her face during combat. Her look is both noble and intimidating.

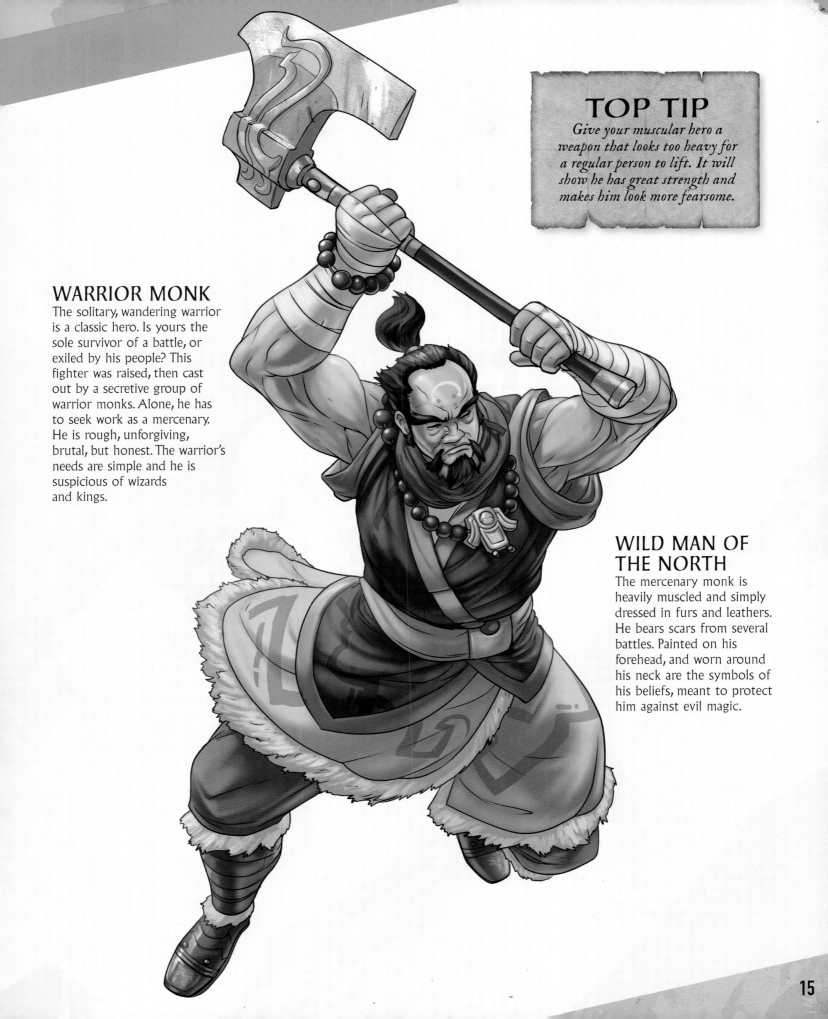

WARRIOR MONK

The solitary, wandering warrior is a classic hero. Is yours the sole survivor of a battle, or exiled by his people? This fighter was raised, then cast out by a secretive group of warrior monks. Alone, he has to seek work as a mercenary. He is rough, unforgiving, brutal, but honest. The warrior's needs are simple and he is suspicious of wizards and kings.

WILD MAN OF THE NORTH

The mercenary monk is heavily muscled and simply dressed in furs and leathers. He bears scars from several battles. Painted on his forehead, and worn around his neck are the symbols of his beliefs, meant to protect him against evil magic.

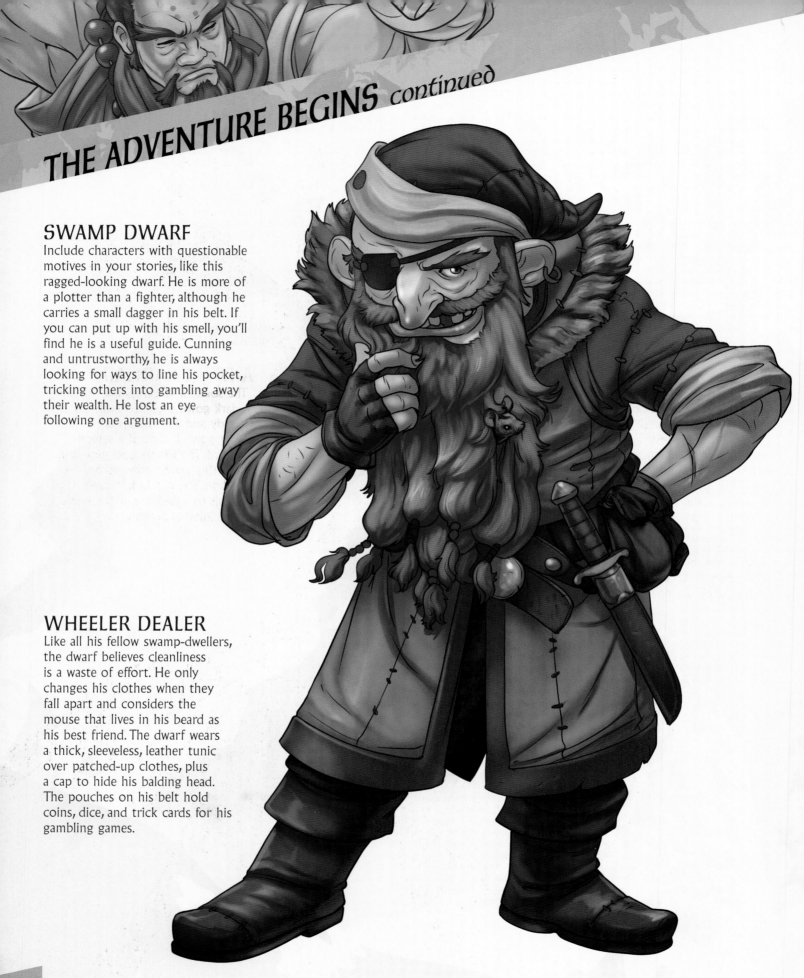

SWAMP DWARF

Include characters with questionable motives in your stories, like this ragged-looking dwarf. He is more of a plotter than a fighter, although he carries a small dagger in his belt. If you can put up with his smell, you'll find he is a useful guide. Cunning and untrustworthy, he is always looking for ways to line his pocket, tricking others into gambling away their wealth. He lost an eye following one argument.

WHEELER DEALER

Like all his fellow swamp-dwellers, the dwarf believes cleanliness is a waste of effort. He only changes his clothes when they fall apart and considers the mouse that lives in his beard as his best friend. The dwarf wears a thick, sleeveless, leather tunic over patched-up clothes, plus a cap to hide his balding head. The pouches on his belt hold coins, dice, and trick cards for his gambling games.

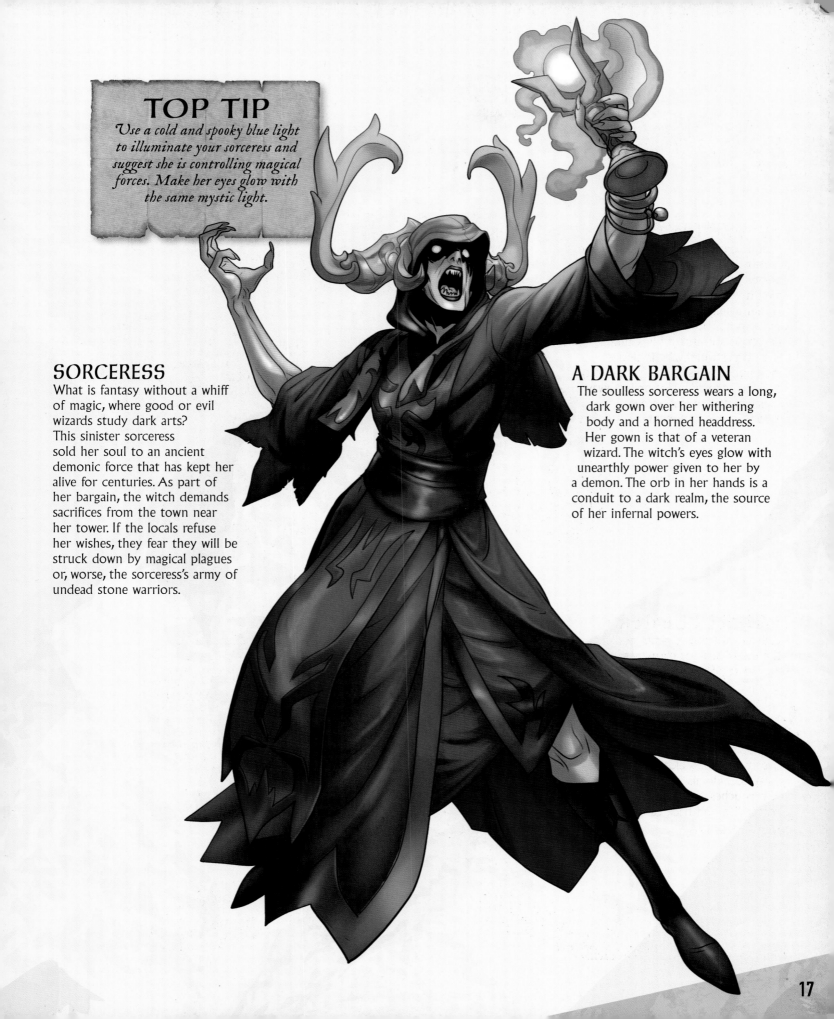

TOP TIP

Use a cold and spooky blue light to illuminate your sorceress and suggest she is controlling magical forces. Make her eyes glow with the same mystic light.

SORCERESS

What is fantasy without a whiff of magic, where good or evil wizards study dark arts? This sinister sorceress sold her soul to an ancient demonic force that has kept her alive for centuries. As part of her bargain, the witch demands sacrifices from the town near her tower. If the locals refuse her wishes, they fear they will be struck down by magical plagues or, worse, the sorceress's army of undead stone warriors.

A DARK BARGAIN

The soulless sorceress wears a long, dark gown over her withering body and a horned headdress. Her gown is that of a veteran wizard. The witch's eyes glow with unearthly power given to her by a demon. The orb in her hands is a conduit to a dark realm, the source of her infernal powers.

SOLO SWORDSMAN

Grab your pencils to draw a dashing hero swinging his sword across the page.

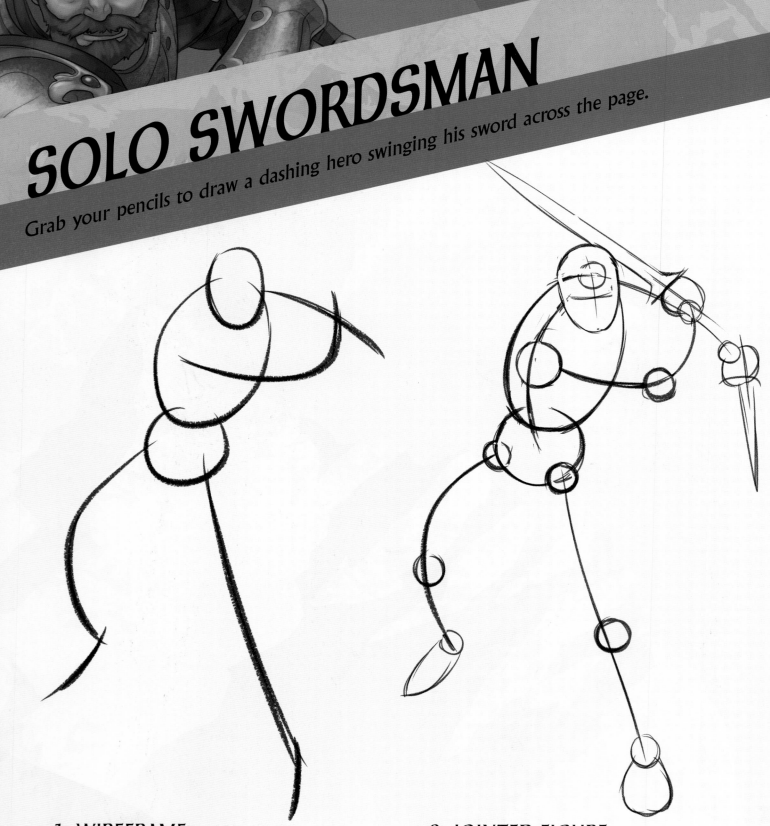

1. WIREFRAME

Using light pencil marks, draw a simple stick figure showing your swordsman's pose. The shoulders are at right angles to his hips as the top half of his body turns, ready to swing his sword.

2. JOINTED FIGURE

Use circles to mark the position of joints. The swordsman's left arm seems shorter than the right as it stretches behind the body. Draw a rough sword in the right hand and a dagger in the left. Indicate the position of the eyes on the face.

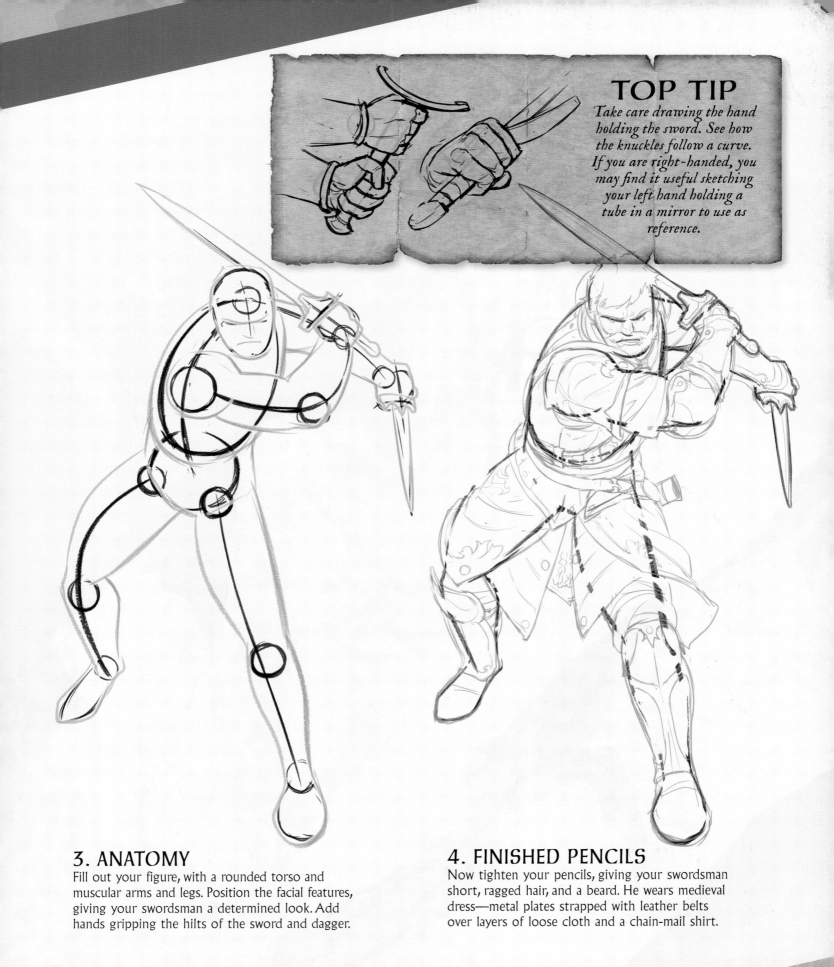

TOP TIP

Take care drawing the hand holding the sword. See how the knuckles follow a curve. If you are right-handed, you may find it useful sketching your left hand holding a tube in a mirror to use as reference.

3. ANATOMY

Fill out your figure, with a rounded torso and muscular arms and legs. Position the facial features, giving your swordsman a determined look. Add hands gripping the hilts of the sword and dagger.

4. FINISHED PENCILS

Now tighten your pencils, giving your swordsman short, ragged hair, and a beard. He wears medieval dress—metal plates strapped with leather belts over layers of loose cloth and a chain-mail shirt.

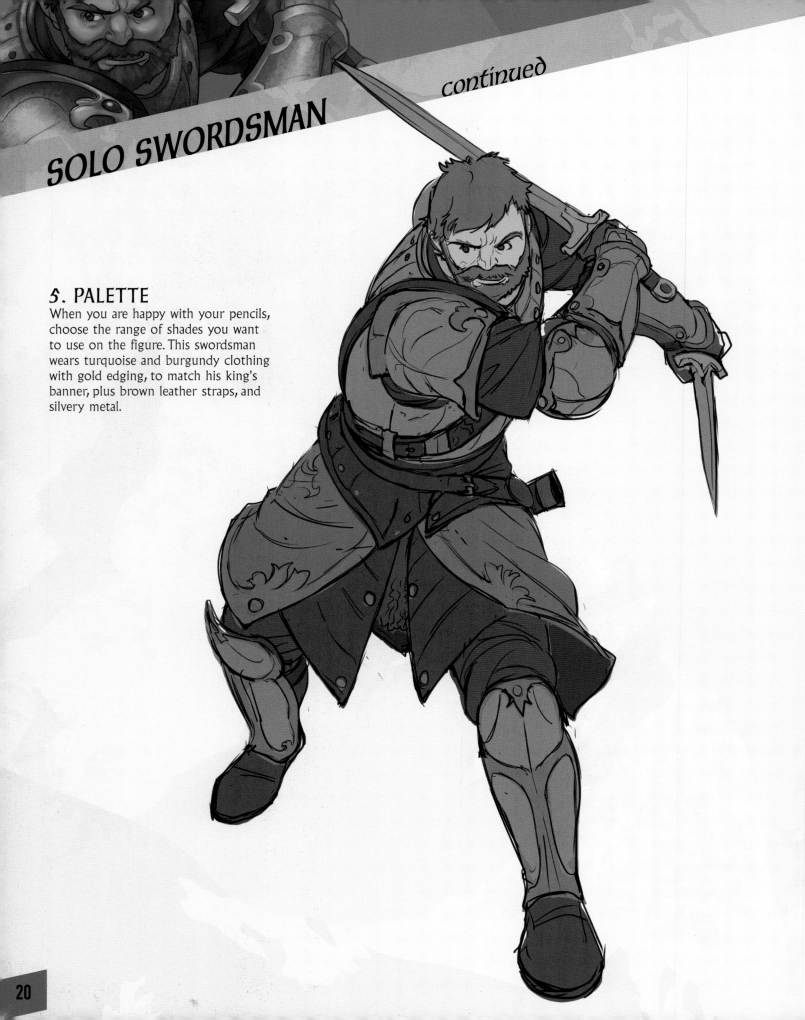

5. PALETTE

When you are happy with your pencils, choose the range of shades you want to use on the figure. This swordsman wears turquoise and burgundy clothing with gold edging, to match his king's banner, plus brown leather straps, and silvery metal.

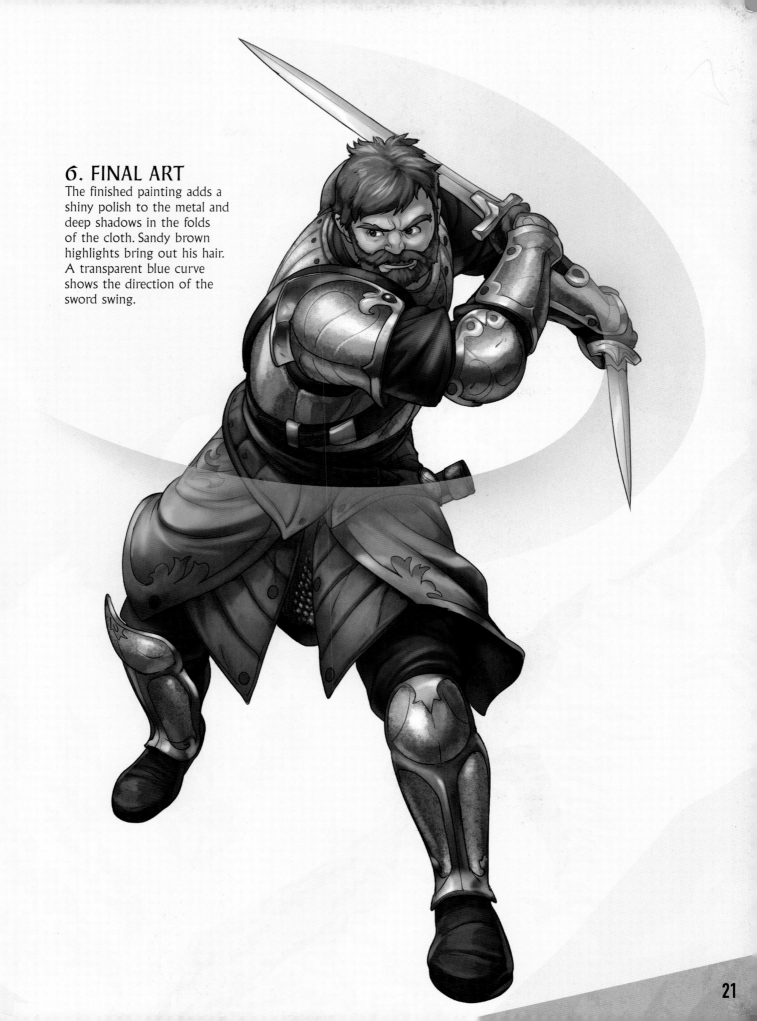

6. FINAL ART

The finished painting adds a shiny polish to the metal and deep shadows in the folds of the cloth. Sandy brown highlights bring out his hair. A transparent blue curve shows the direction of the sword swing.

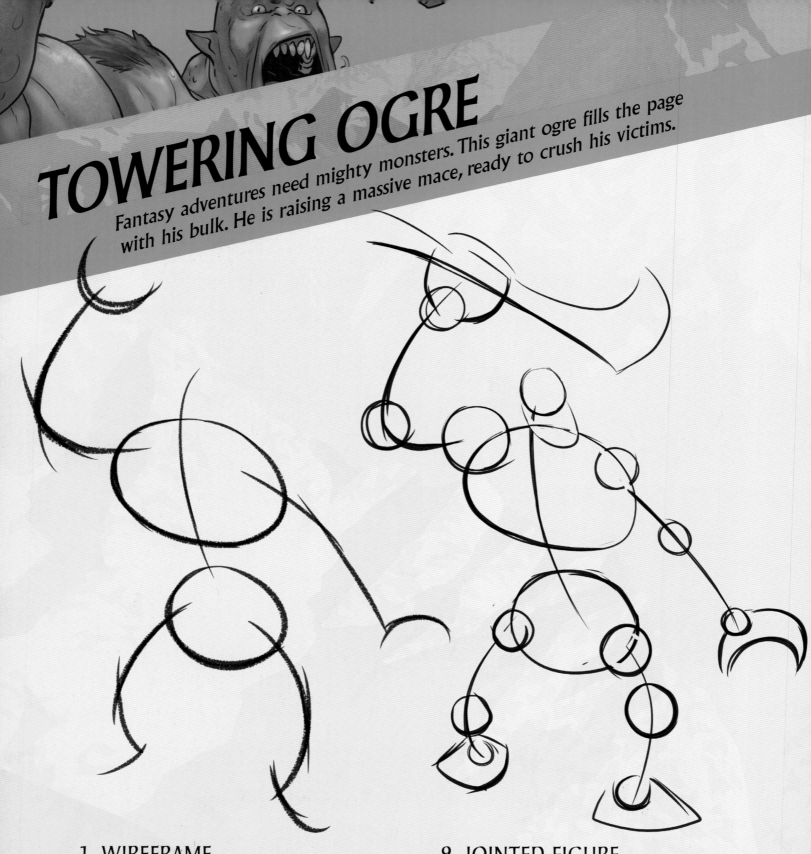

TOWERING OGRE

Fantasy adventures need mighty monsters. This giant ogre fills the page with his bulk. He is raising a massive mace, ready to crush his victims.

1. WIREFRAME

Using light pencil marks, draw a simple stick figure for your ogre's pose. Add a large oval for the chest and circle for the pelvis. The body curves back toward the head, with one arm raised, ready to swing the mace downward.

2. JOINTED FIGURE

Mark the position of the ogre's joints with circles. His hands are huge, his arms are long, while his legs are short and stumpy. His neck is hidden by his wide head. Draw a rough outline for his heavy mace.

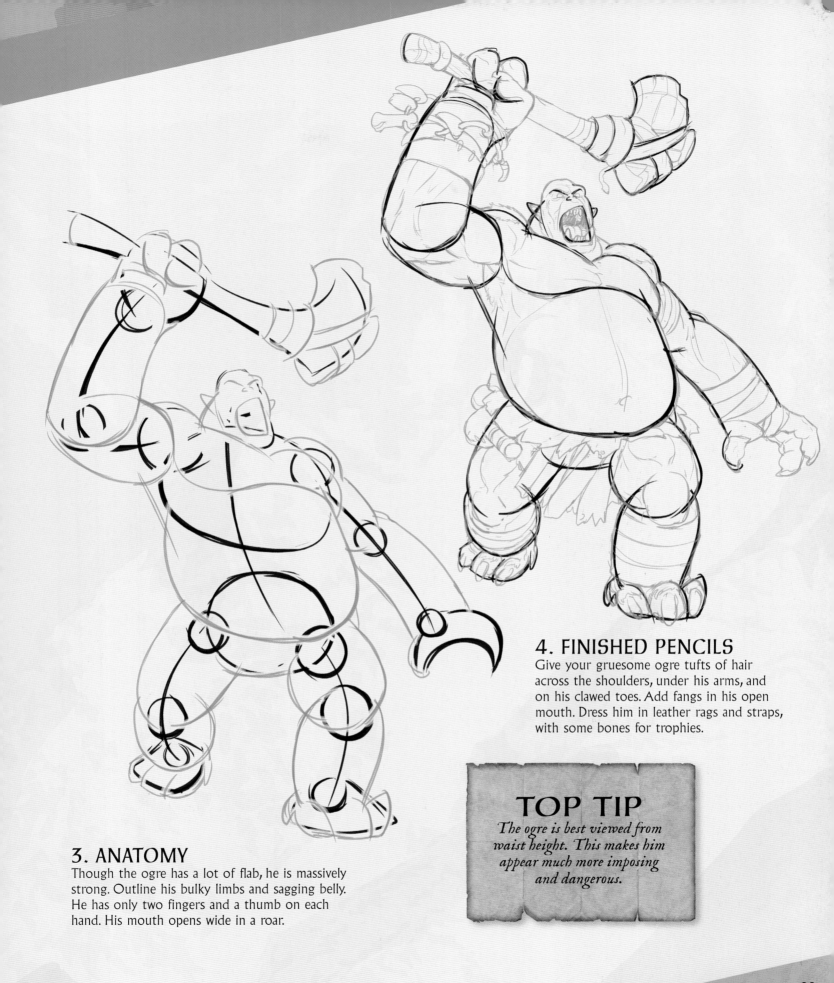

4. FINISHED PENCILS
Give your gruesome ogre tufts of hair across the shoulders, under his arms, and on his clawed toes. Add fangs in his open mouth. Dress him in leather rags and straps, with some bones for trophies.

3. ANATOMY
Though the ogre has a lot of flab, he is massively strong. Outline his bulky limbs and sagging belly. He has only two fingers and a thumb on each hand. His mouth opens wide in a roar.

TOP TIP
The ogre is best viewed from waist height. This makes him appear much more imposing and dangerous.

23

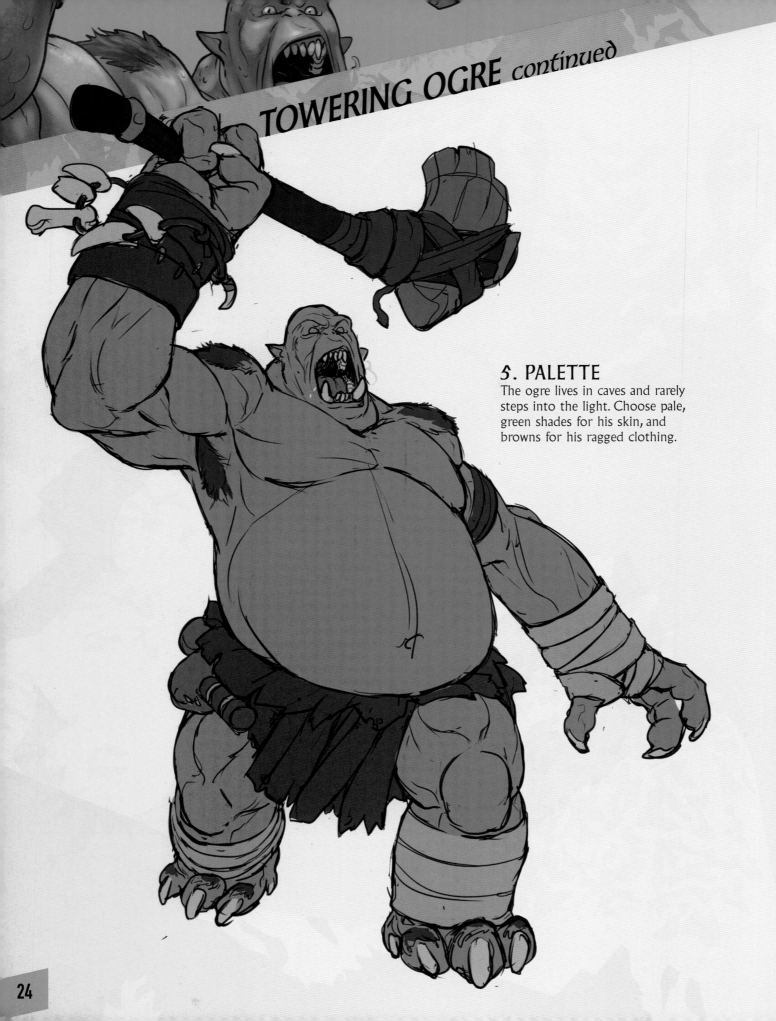

5. PALETTE

The ogre lives in caves and rarely steps into the light. Choose pale, green shades for his skin, and browns for his ragged clothing.

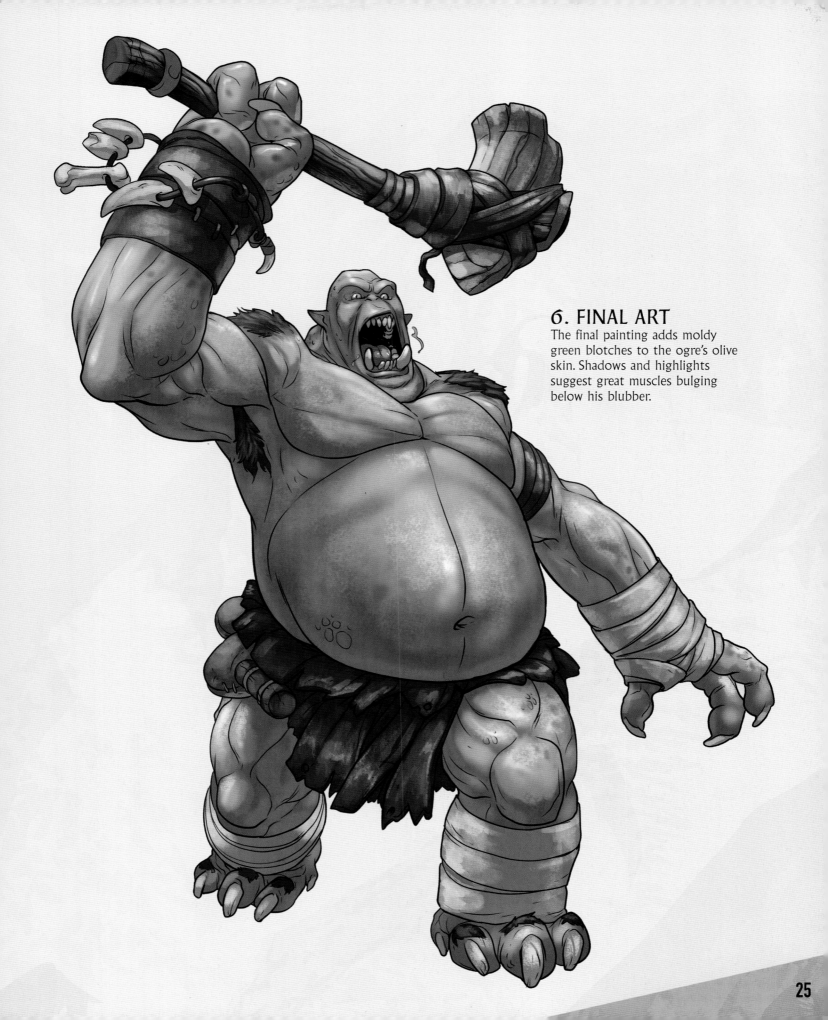

6. FINAL ART

The final painting adds moldy green blotches to the ogre's olive skin. Shadows and highlights suggest great muscles bulging below his blubber.

WEAPONS OF WAR

When epic characters come to blows, it's metal against metal. Choose the weapons and defences for your fighting fantasy characters.

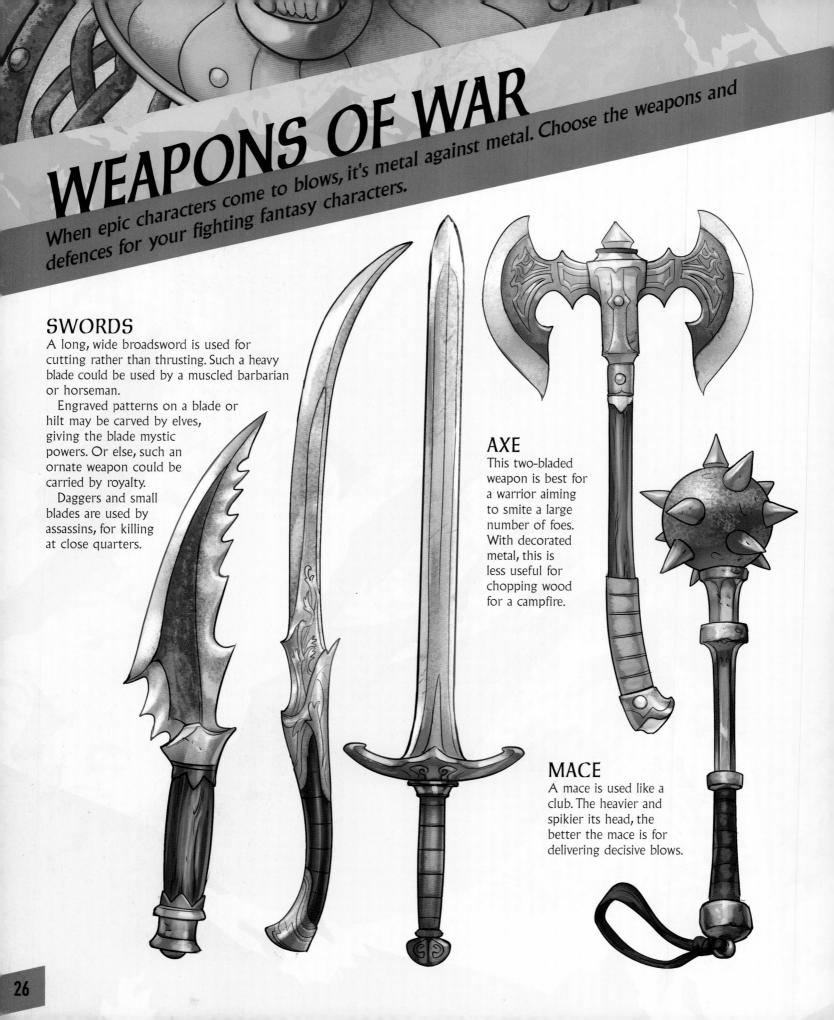

SWORDS

A long, wide broadsword is used for cutting rather than thrusting. Such a heavy blade could be used by a muscled barbarian or horseman.

Engraved patterns on a blade or hilt may be carved by elves, giving the blade mystic powers. Or else, such an ornate weapon could be carried by royalty.

Daggers and small blades are used by assassins, for killing at close quarters.

AXE

This two-bladed weapon is best for a warrior aiming to smite a large number of foes. With decorated metal, this is less useful for chopping wood for a campfire.

MACE

A mace is used like a club. The heavier and spikier its head, the better the mace is for delivering decisive blows.

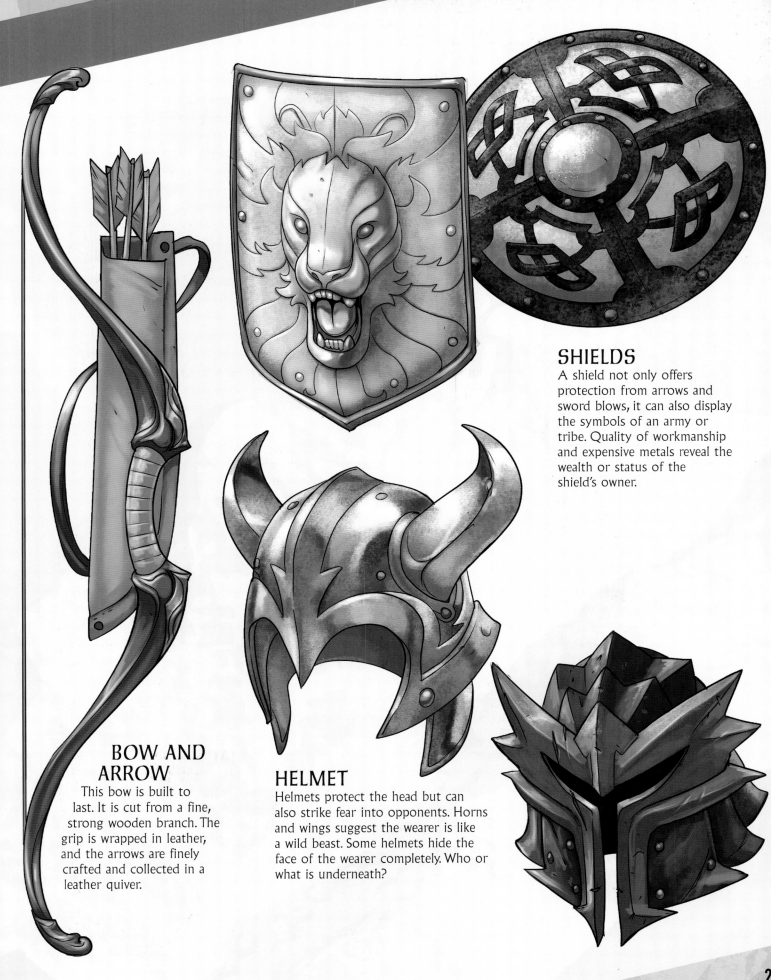

SHIELDS

A shield not only offers protection from arrows and sword blows, it can also display the symbols of an army or tribe. Quality of workmanship and expensive metals reveal the wealth or status of the shield's owner.

BOW AND ARROW

This bow is built to last. It is cut from a fine, strong wooden branch. The grip is wrapped in leather, and the arrows are finely crafted and collected in a leather quiver.

HELMET

Helmets protect the head but can also strike fear into opponents. Horns and wings suggest the wearer is like a wild beast. Some helmets hide the face of the wearer completely. Who or what is underneath?

FANTASY FASHION

What your character wears says a lot about them. Here's how to draw different materials.

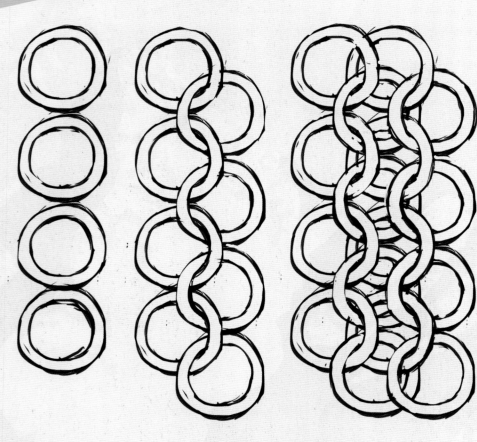

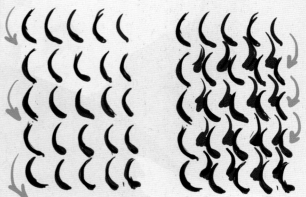

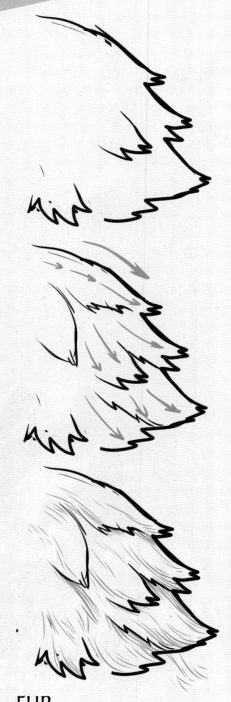

CHAIN MAIL
Close up, chain mail is made up of a series of interlocking rings. Draw it by alternating rows of curves.

FUR
For a furry finish, draw soft zigzag outlines, then add thin, feathery strokes for tufts of soft hair.

GEM

This oval gem has a dark, rounded shadow inside. A bright spot is added where a light source hits it.

BRONZE

Painting metal is all about reflections. Use patches of dark and light to suggest light bouncing off the metal. Add a hint of yellow and green for a bronze finish.

FORMAL WEAR

The Amazon is dressed for a regal ceremony rather than warfare, with glittering gems, polished metals, thick furs, and robes on display.

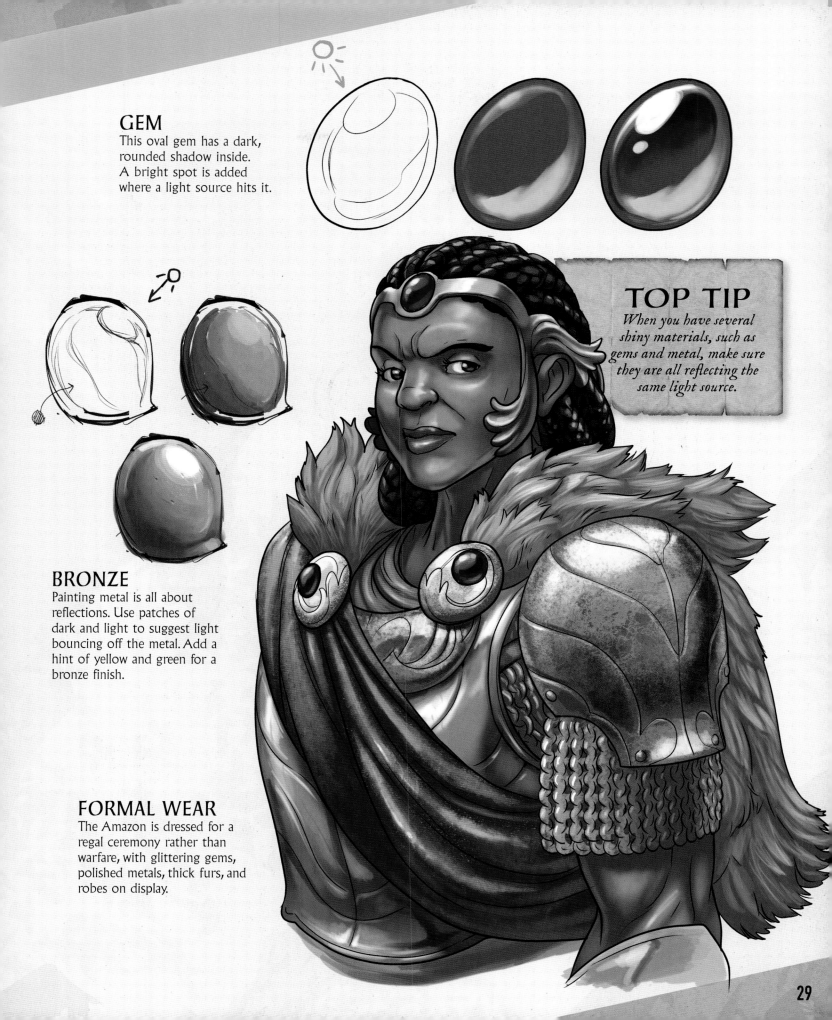

TOP TIP

When you have several shiny materials, such as gems and metal, make sure they are all reflecting the same light source.

LOST TEMPLE

Here's how to build a background for a fantasy showdown. The temple may look abandoned, but it comes alive through the power of dark magic.

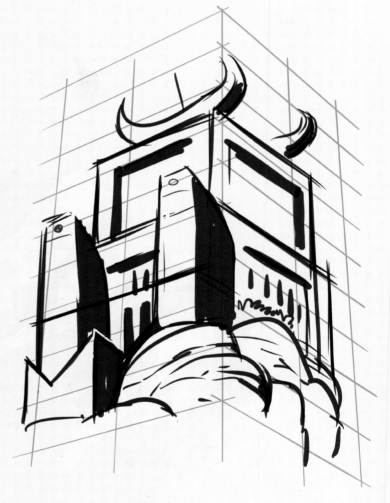

1. The setting is an ancient temple, with a pair of scary statues guarding the entrance. Use a ruler to draw pale perspective lines showing the angle of the building. Build up the scene with 3-D shapes.

2. This rough sketch shows how light and shade will appear on the building. The temple is lit from the top-left. Apply these shading rules to your detailed drawing.

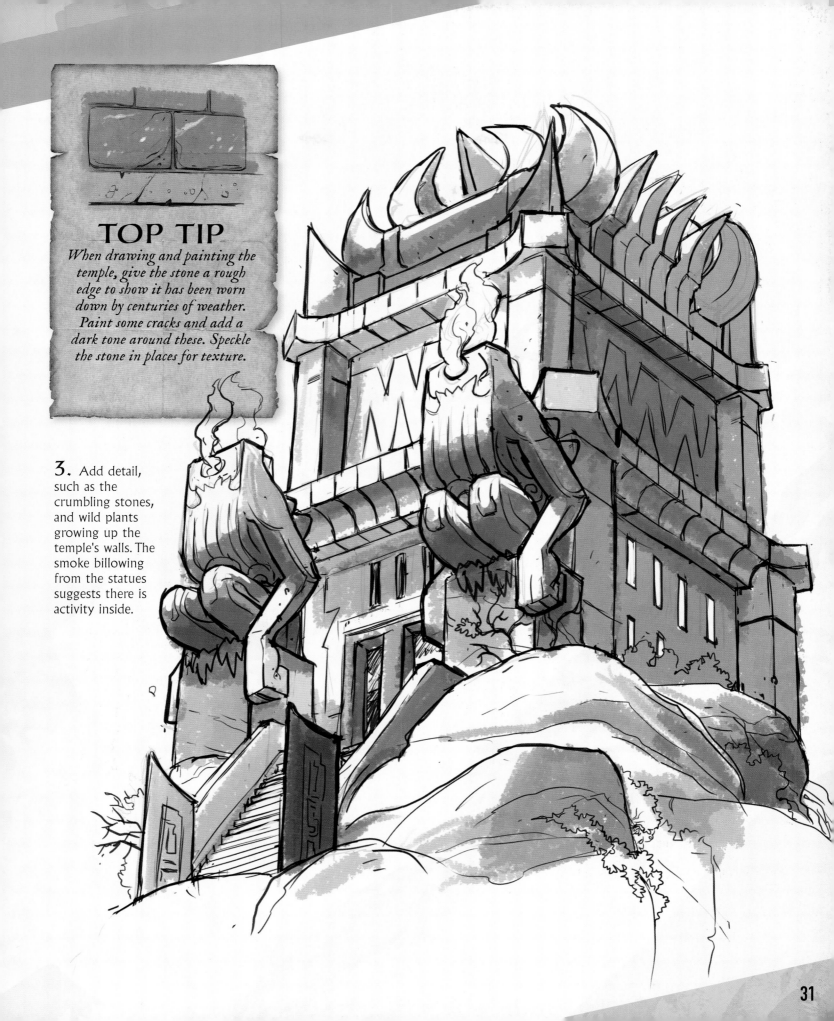

TOP TIP

When drawing and painting the temple, give the stone a rough edge to show it has been worn down by centuries of weather. Paint some cracks and add a dark tone around these. Speckle the stone in places for texture.

3. Add detail, such as the crumbling stones, and wild plants growing up the temple's walls. The smoke billowing from the statues suggests there is activity inside.

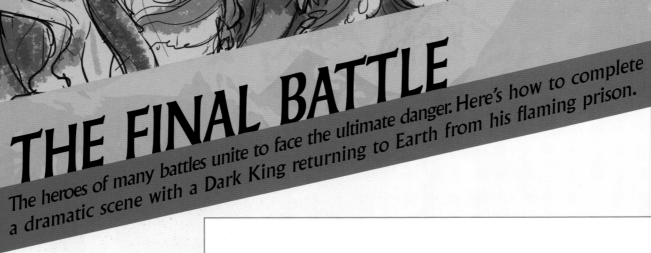

THE FINAL BATTLE

The heroes of many battles unite to face the ultimate danger. Here's how to complete a dramatic scene with a Dark King returning to Earth from his flaming prison.

1. In this picture, the warrior monk, shield maiden, and swordsman are ready to battle a Dark King who has used magic to return aboard a winged monster. The setting is the ancient temple. Do small sketches to work out where to position your characters in the scene.

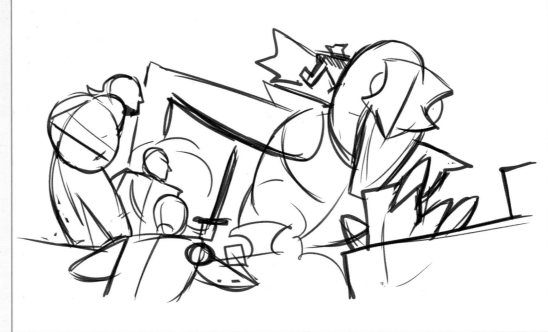

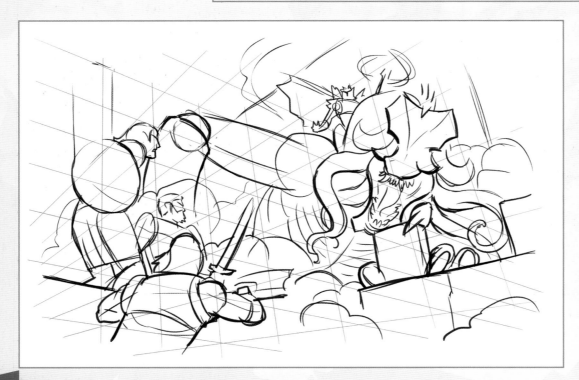

2. Once you are happy with everyone's position, map out the angles of the background on a large piece of paper, and build up your characters using 3-D shapes.

3. Tighten up your pencils and begin to add shading to the scene. The fire behind the Dark King is the source of most of the light, so the warrior, shield maiden, and swordsman are lit from the front, while the Dark King is lit from behind.

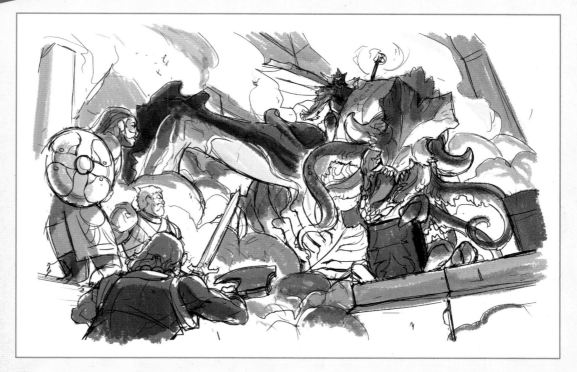

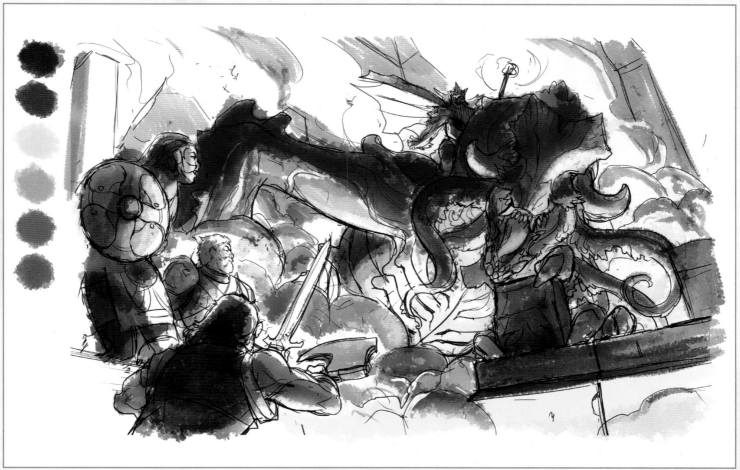

4. The Dark King arrives in a burst of flames, so a range of fiery shades from yellow to orange, red, and dark brown will be used in the finished picture. The Dark King is mostly in shade, adding more mystery to him.

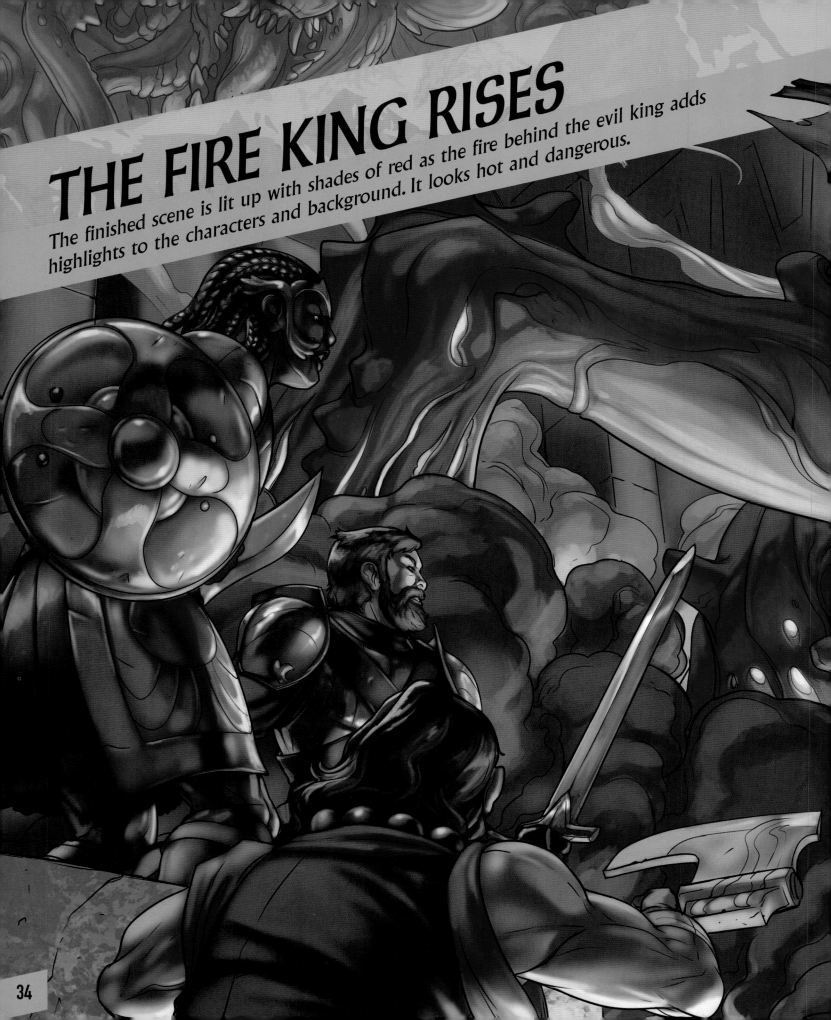

THE FIRE KING RISES

The finished scene is lit up with shades of red as the fire behind the evil king adds highlights to the characters and background. It looks hot and dangerous.

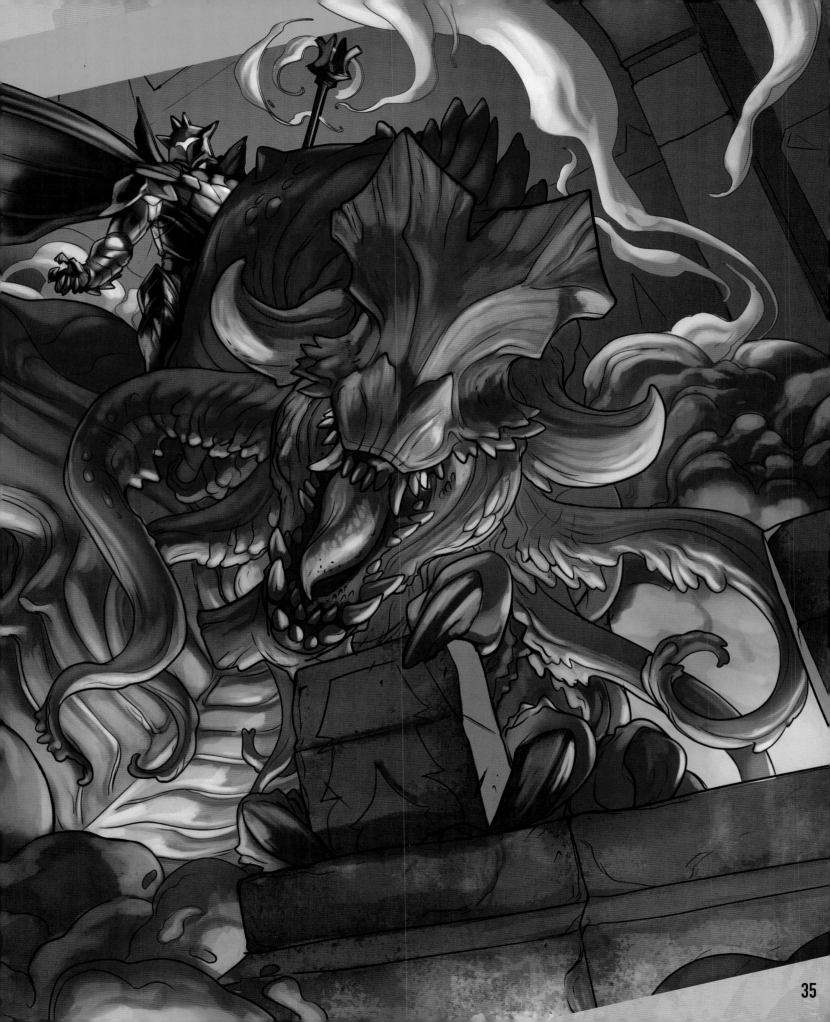

GATEWAYS

Gateways play a huge part in fantasy adventures. They may hide secret pathways, dark domains, treasure, or prisoners. Often a spell or secret knowledge will be needed to unlock the doors. Here are some examples to inspire your tales.

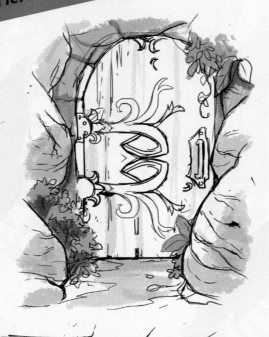

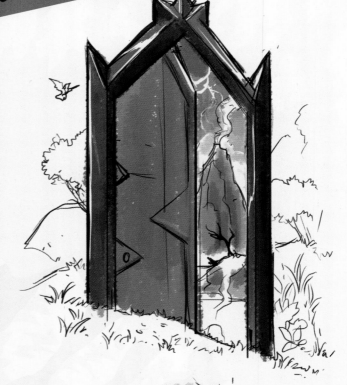

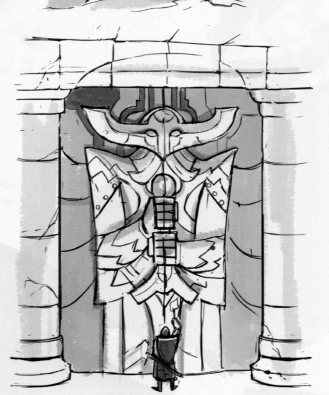

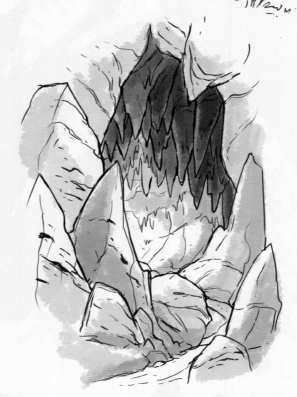

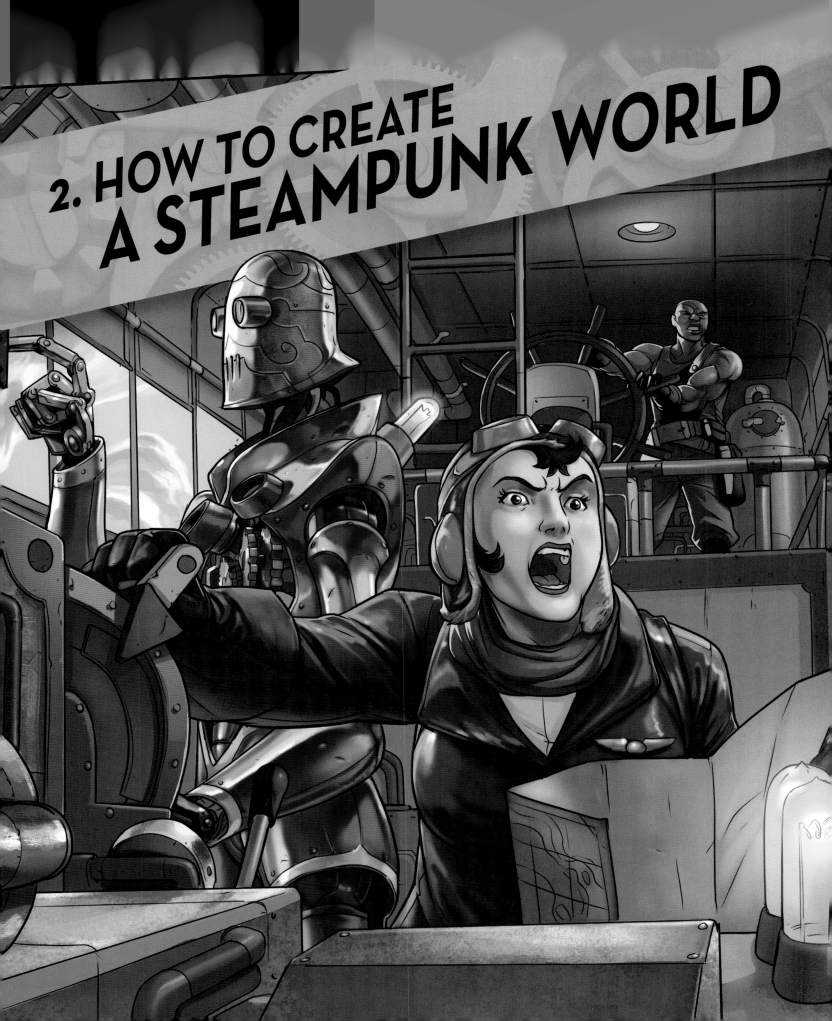

2. HOW TO CREATE A STEAMPUNK WORLD

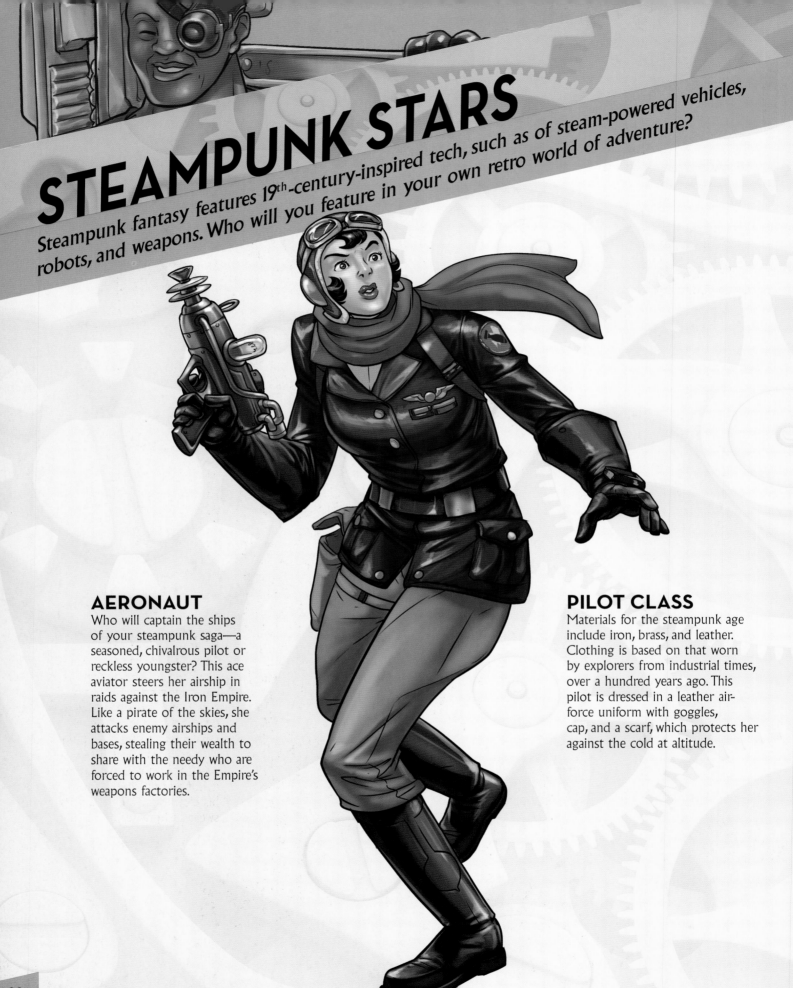

STEAMPUNK STARS

Steampunk fantasy features 19th-century-inspired tech, such as of steam-powered vehicles, robots, and weapons. Who will you feature in your own retro world of adventure?

AERONAUT

Who will captain the ships of your steampunk saga—a seasoned, chivalrous pilot or reckless youngster? This ace aviator steers her airship in raids against the Iron Empire. Like a pirate of the skies, she attacks enemy airships and bases, stealing their wealth to share with the needy who are forced to work in the Empire's weapons factories.

PILOT CLASS

Materials for the steampunk age include iron, brass, and leather. Clothing is based on that worn by explorers from industrial times, over a hundred years ago. This pilot is dressed in a leather air-force uniform with goggles, cap, and a scarf, which protects her against the cold at altitude.

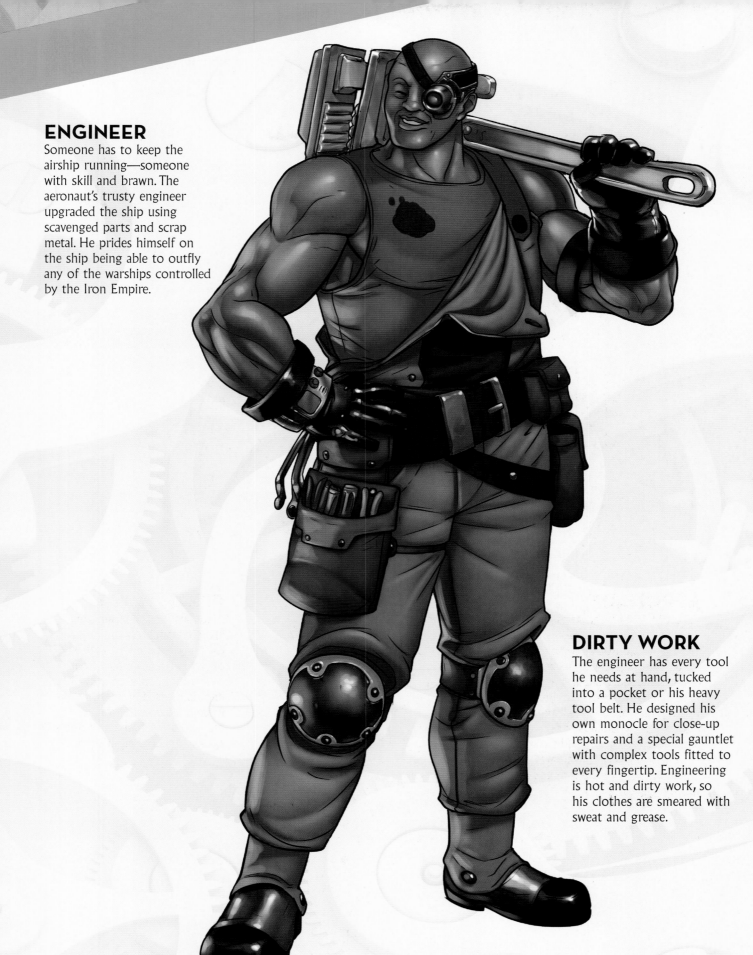

ENGINEER

Someone has to keep the airship running—someone with skill and brawn. The aeronaut's trusty engineer upgraded the ship using scavenged parts and scrap metal. He prides himself on the ship being able to outfly any of the warships controlled by the Iron Empire.

DIRTY WORK

The engineer has every tool he needs at hand, tucked into a pocket or his heavy tool belt. He designed his own monocle for close-up repairs and a special gauntlet with complex tools fitted to every fingertip. Engineering is hot and dirty work, so his clothes are smeared with sweat and grease.

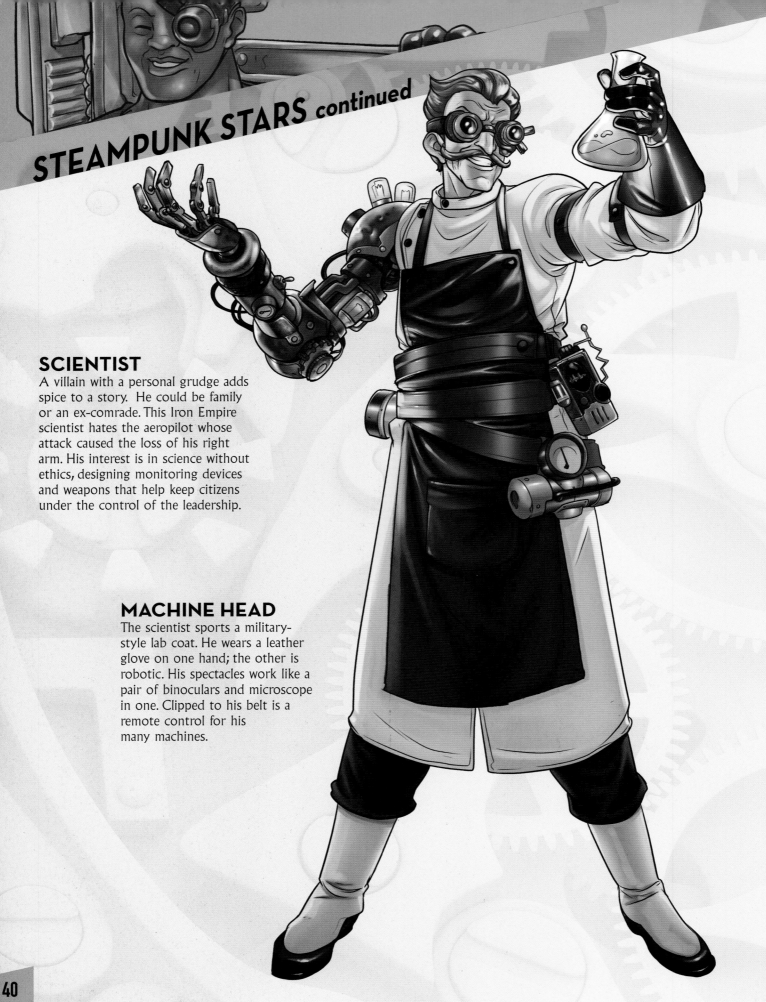

SCIENTIST

A villain with a personal grudge adds spice to a story. He could be family or an ex-comrade. This Iron Empire scientist hates the aeropilot whose attack caused the loss of his right arm. His interest is in science without ethics, designing monitoring devices and weapons that help keep citizens under the control of the leadership.

MACHINE HEAD

The scientist sports a military-style lab coat. He wears a leather glove on one hand; the other is robotic. His spectacles work like a pair of binoculars and microscope in one. Clipped to his belt is a remote control for his many machines.

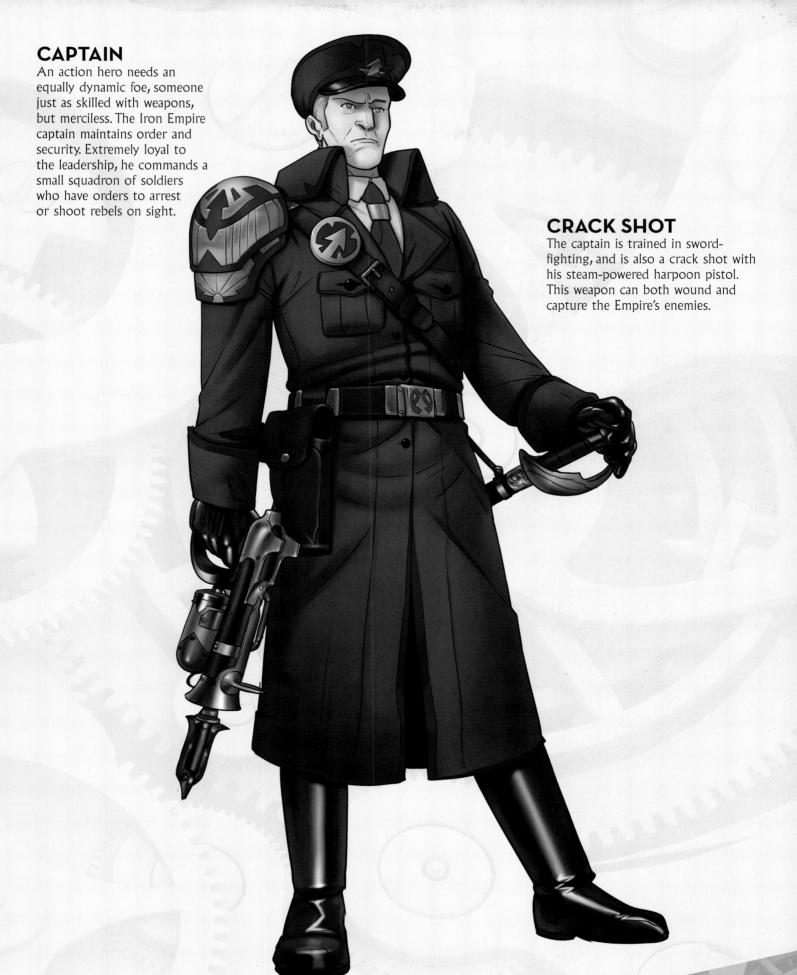

CAPTAIN

An action hero needs an equally dynamic foe, someone just as skilled with weapons, but merciless. The Iron Empire captain maintains order and security. Extremely loyal to the leadership, he commands a small squadron of soldiers who have orders to arrest or shoot rebels on sight.

CRACK SHOT

The captain is trained in sword-fighting, and is also a crack shot with his steam-powered harpoon pistol. This weapon can both wound and capture the Empire's enemies.

EXPLORING THE UNKNOWN

There are still unmapped areas of the world to be discovered in the steampunk era.
Follow the steps to design an intrepid explorer and treasure hunter.

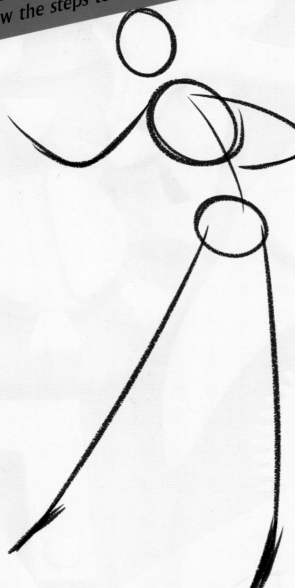

1. WIREFRAME

Using light pencil marks, draw a simple stick figure
showing your explorer's pose. The body is curved
as she leans to the left to adjust her camera.

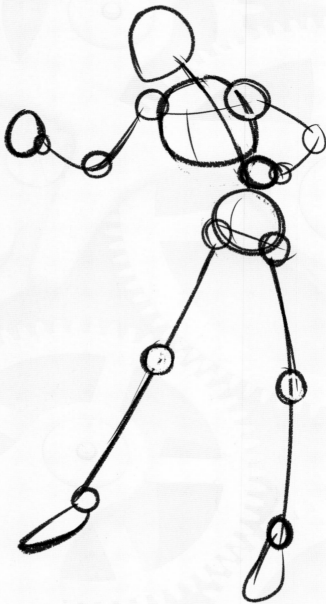

2. JOINTED FIGURE

Add circles to the frame to mark the joints, hands,
and feet. Position the legs, even though they will
later be covered by a loose skirt.

TOP TIP

It's worth looking through history books for inspiration for your steampunk world. Look at Victorian clothing and steam-powered machines invented during the industrial revolution. Then, imagine how the same parts could be used on more modern inventions.

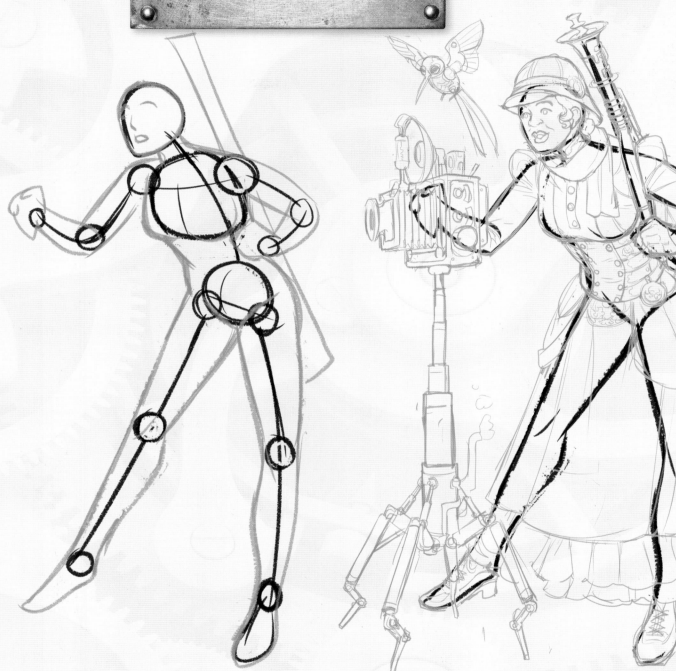

3. ANATOMY

Over these building blocks add more accurate anatomy, outlining the body. A long, steam-powered rifle is carried over one shoulder.

4. FINISHED PENCILS

Now tighten your pencils, including costume details. She wears a pith helmet, a scarf, a leather corset over her jacket, plus a long, flowing skirt, and outdoor boots. Her camera stands on an extended tripod. A robotic pet bird flutters above it.

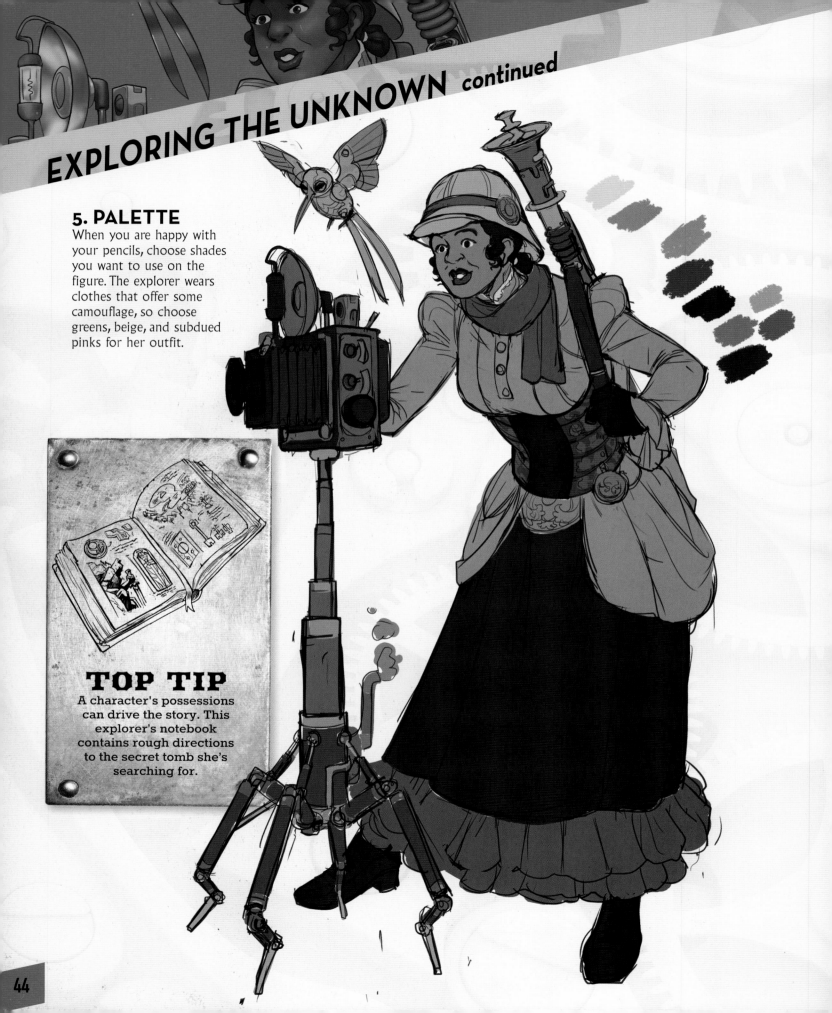

5. PALETTE

When you are happy with your pencils, choose shades you want to use on the figure. The explorer wears clothes that offer some camouflage, so choose greens, beige, and subdued pinks for her outfit.

TOP TIP

A character's possessions can drive the story. This explorer's notebook contains rough directions to the secret tomb she's searching for.

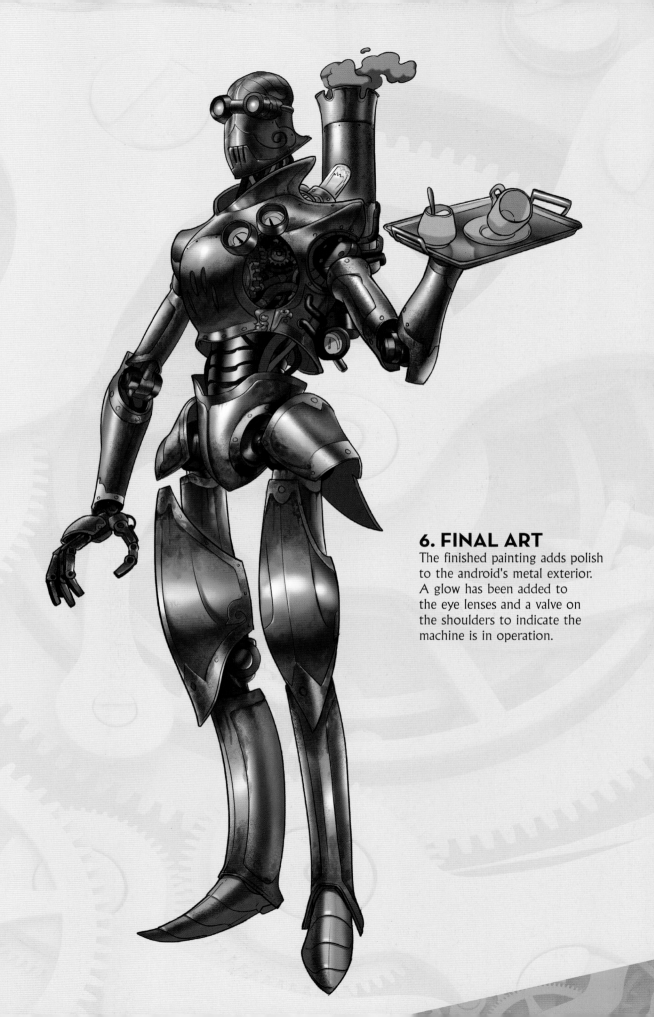

6. FINAL ART
The finished painting adds polish to the android's metal exterior. A glow has been added to the eye lenses and a valve on the shoulders to indicate the machine is in operation.

TAKE TO THE AIR

An aeronaut needs a flying machine. Follow the steps to build your own high-flying, steam-driven airship.

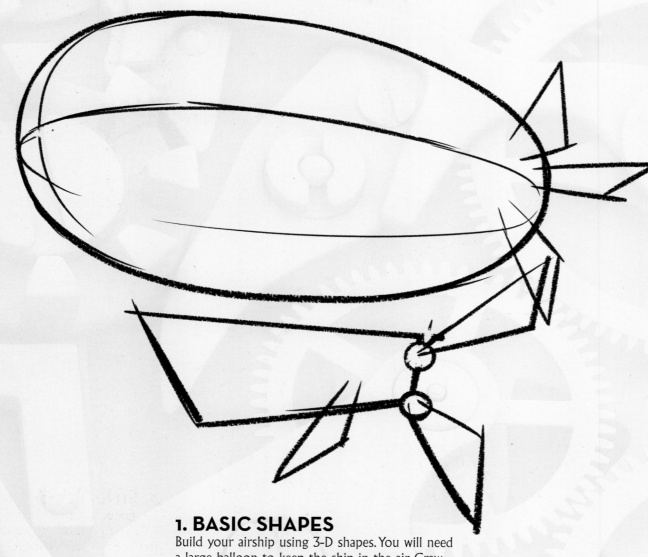

1. BASIC SHAPES

Build your airship using 3-D shapes. You will need a large balloon to keep the ship in the air. Crew members guide the ship from quarters suspended below this balloon. Sails, wings, and a rudder help to lift and turn the ship.

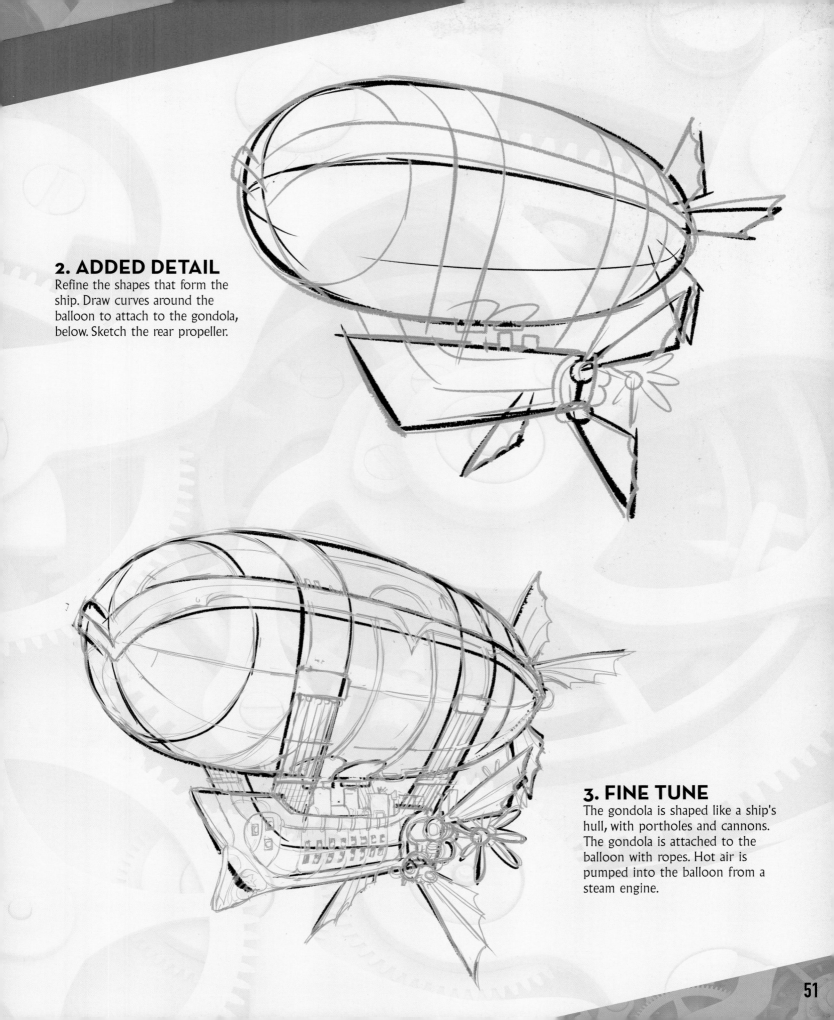

2. ADDED DETAIL

Refine the shapes that form the ship. Draw curves around the balloon to attach to the gondola, below. Sketch the rear propeller.

3. FINE TUNE

The gondola is shaped like a ship's hull, with portholes and cannons. The gondola is attached to the balloon with ropes. Hot air is pumped into the balloon from a steam engine.

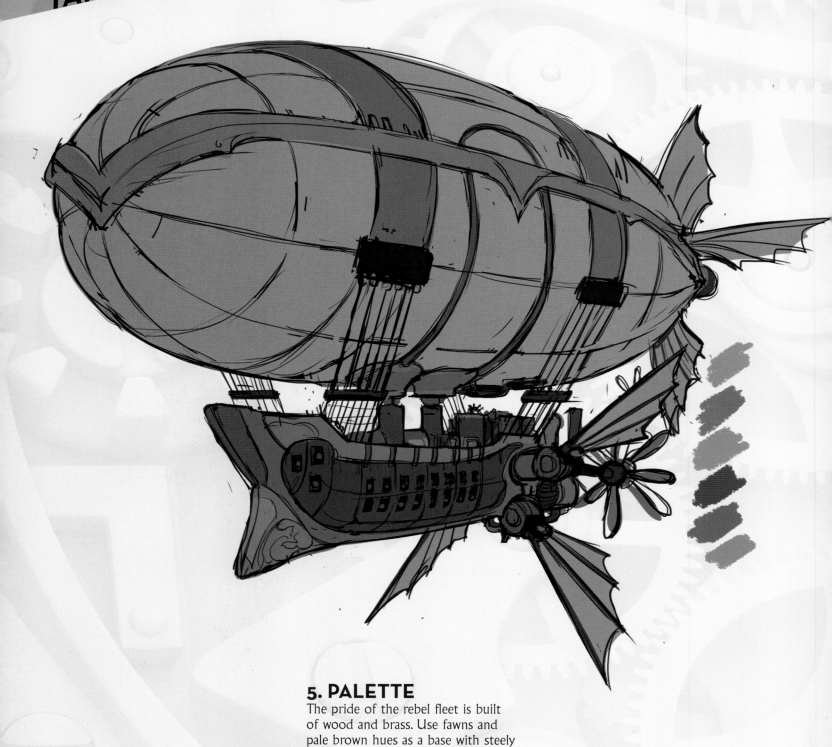

5. PALETTE
The pride of the rebel fleet is built of wood and brass. Use fawns and pale brown hues as a base with steely blues for metalwork.

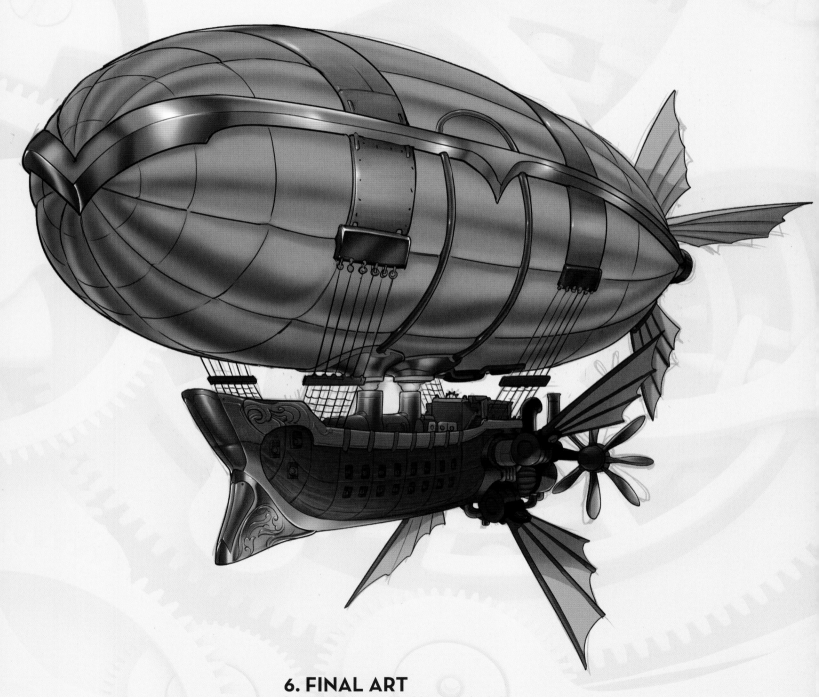

6. FINAL ART
Painted shadows add ribbing to the balloon.
The wooden gondola is in the balloon's
shadow but lit up by the fires in the engine.

STEAM POWER

Steampunk machines need power! Here's how to build an engine to keep your airships and factories running.

1. FRAMEWORK
Start your engines! Sketch a series of circles, blocks, and cylinders as the basis for your steam engine.

2. WORKING PARTS
Add detail to the shapes, turning circles into wheels, gauges, and cogs. Join these together with pipes. Add some levers and a steam vent.

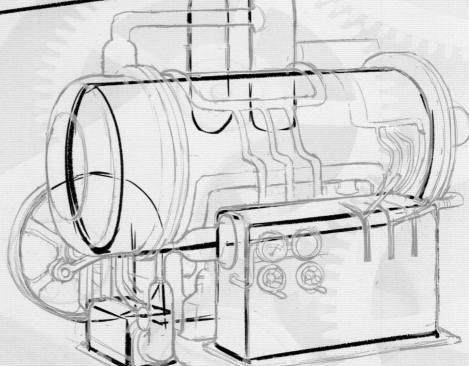

3. FINISHED PENCILS

Join sections of the engine together with rings and rivets. Add even more controls, and the engineer working on the machine for scale.

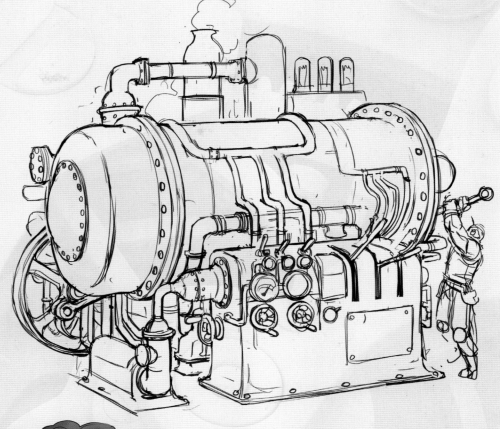

4. ALL IN ORDER

The finished engine is now in working order, painted with green, red, and yellow shades. Highlights have been added, along with a puff of smoke from the chimney.

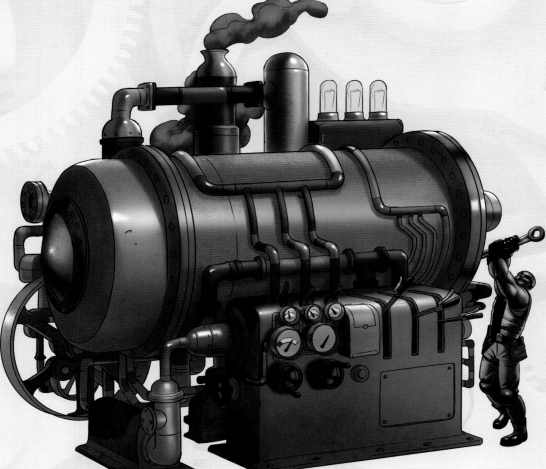

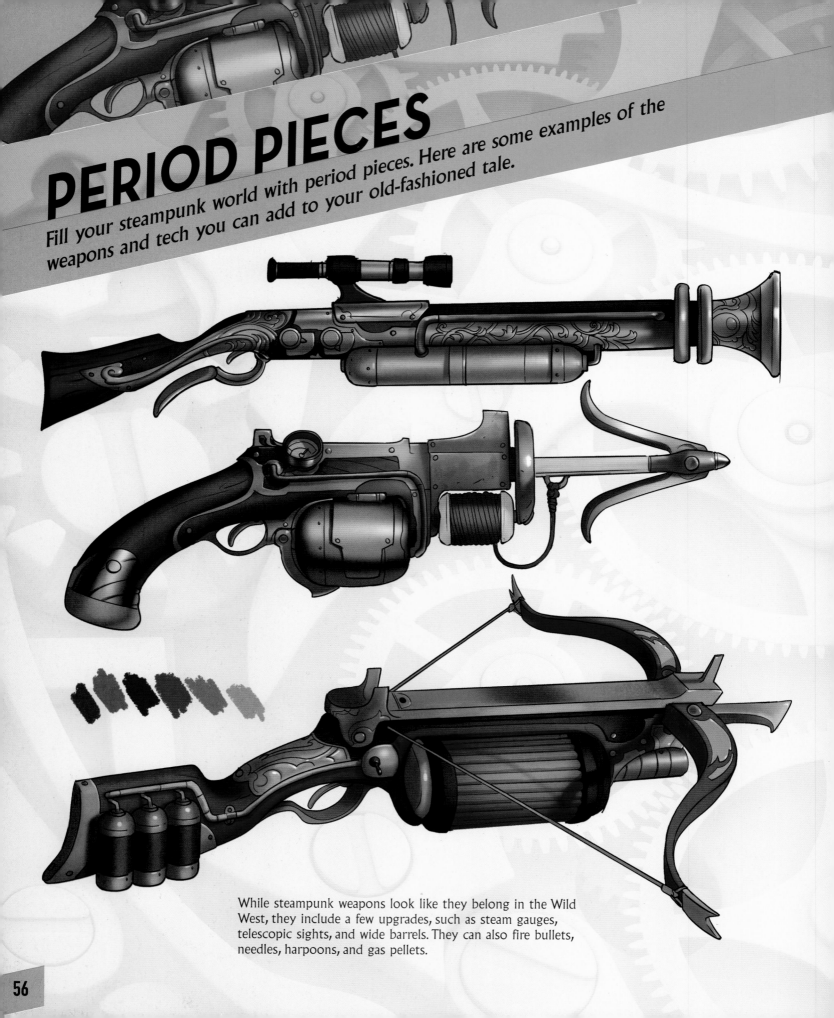

PERIOD PIECES

Fill your steampunk world with period pieces. Here are some examples of the weapons and tech you can add to your old-fashioned tale.

While steampunk weapons look like they belong in the Wild West, they include a few upgrades, such as steam gauges, telescopic sights, and wide barrels. They can also fire bullets, needles, harpoons, and gas pellets.

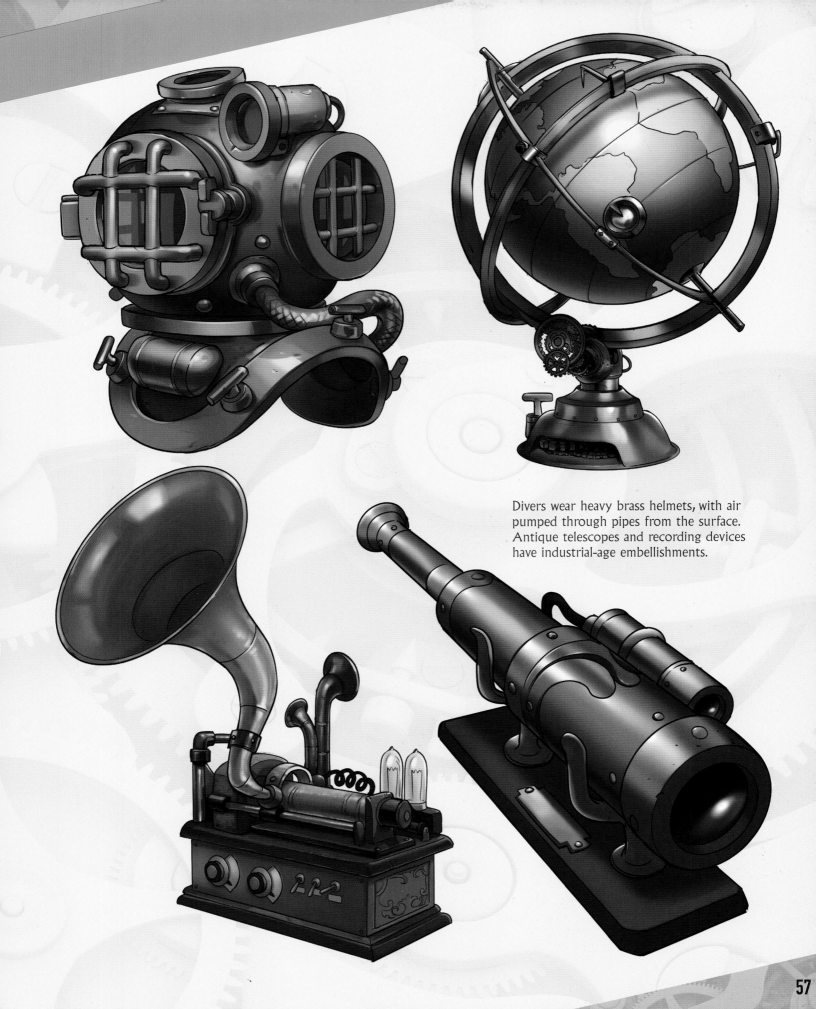

Divers wear heavy brass helmets, with air pumped through pipes from the surface. Antique telescopes and recording devices have industrial-age embellishments.

AIRSHIP ATTACK

The rebels are mounting an air raid on the Iron Empire's fleet. Follow the steps to bring this audacious attack blazing to life.

1. The view of the air raid is from an Iron Empire gondola. The Empire's lead scientist cowers in fear, leaving the captain to deal with the rebel threat. He aims a harpoon pistol at the rebel pilot but she has a cannon pointed directly at his airship.

2. The view of the action is tilted to add drama. Use perspective lines to show the angle of the rebel's ship compared to the Empire's vessel.

3. Add more detail and shading to the scene. Balloons shade the gondolas and crew, and dark clouds of smoke rise from burning airships.

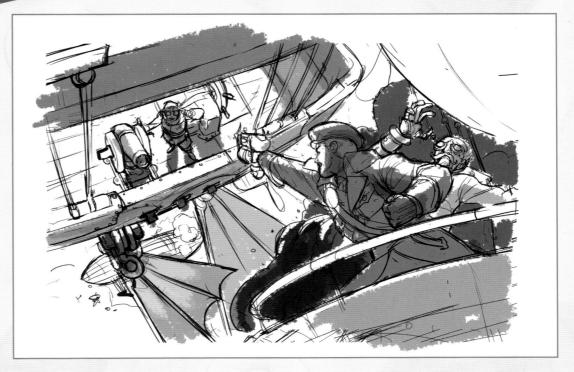

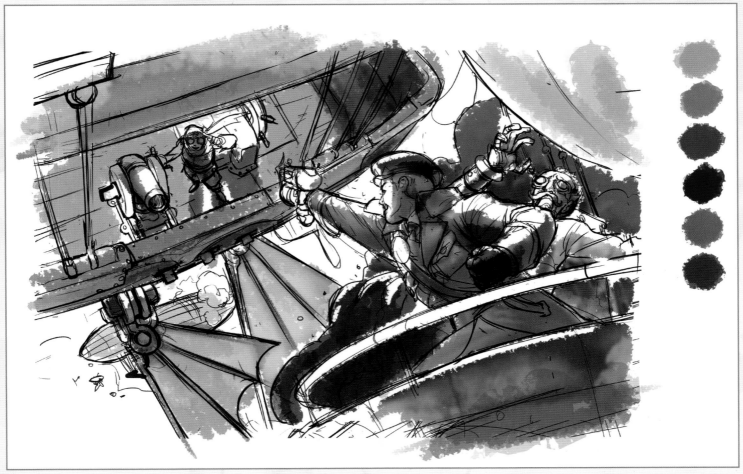

4. The airships are painted with autumnal shades while the captain's military uniform matches the inkiness of the smoke.

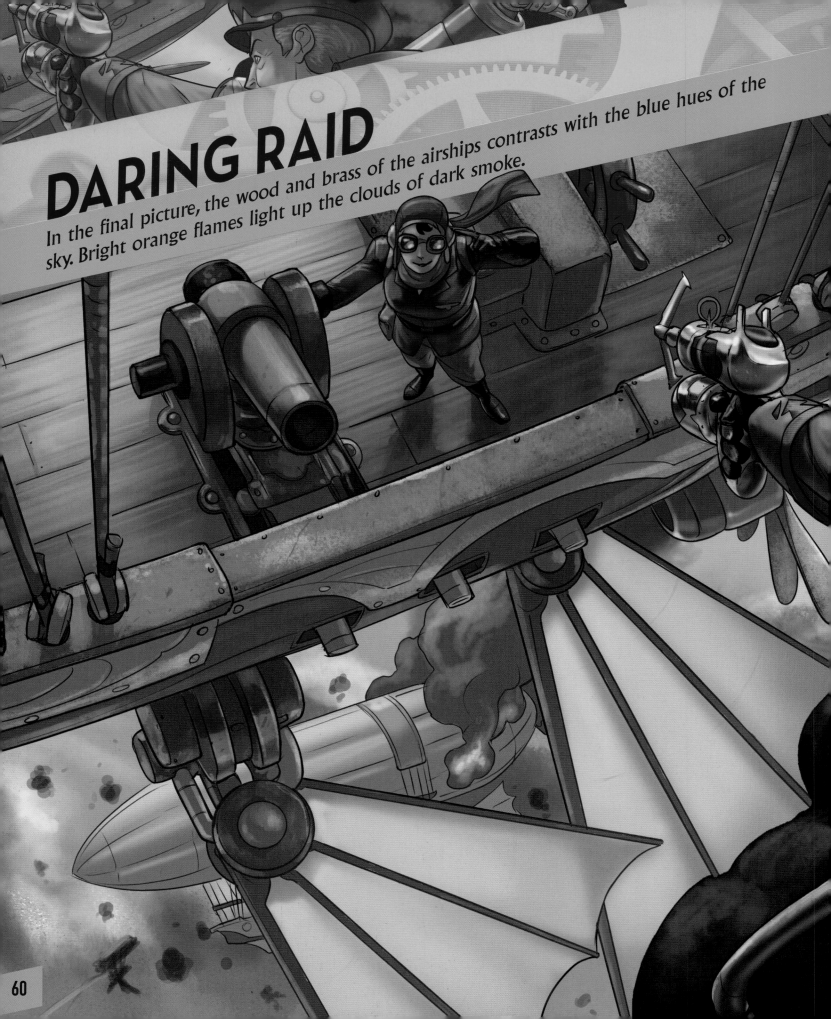

DARING RAID

In the final picture, the wood and brass of the airships contrasts with the blue hues of the sky. Bright orange flames light up the clouds of dark smoke.

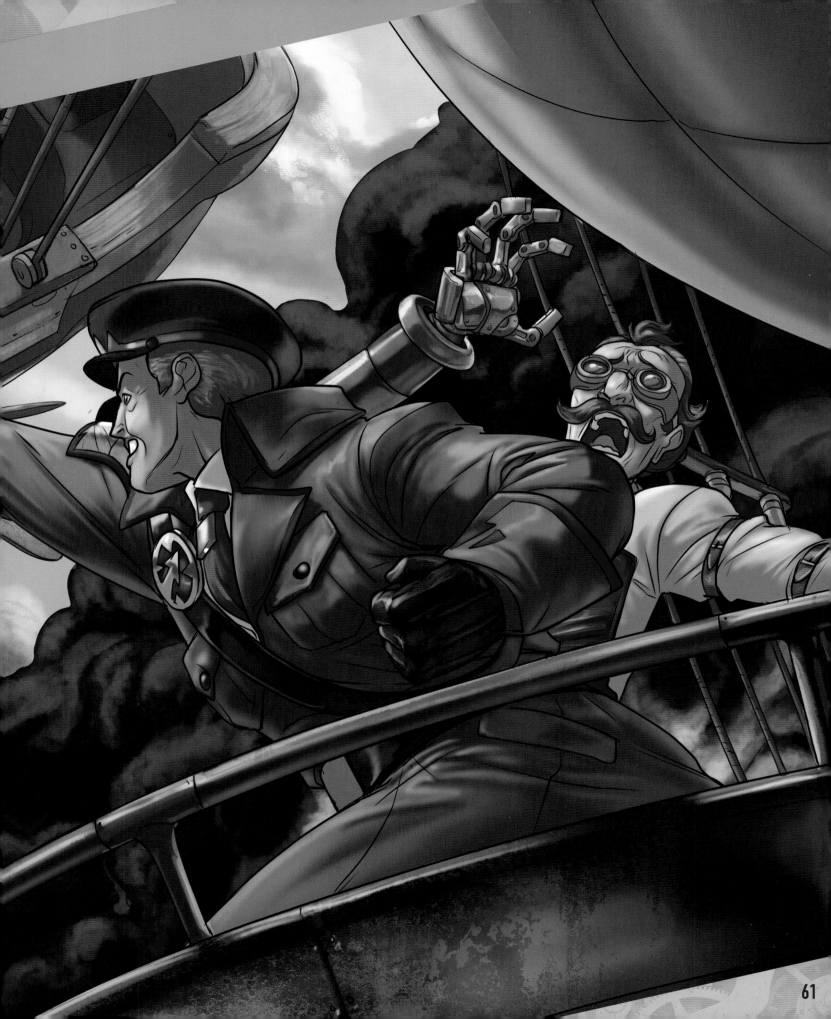

MAPPING YOUR WORLD

Find your way around the steampunk world by drawing your own antique map.

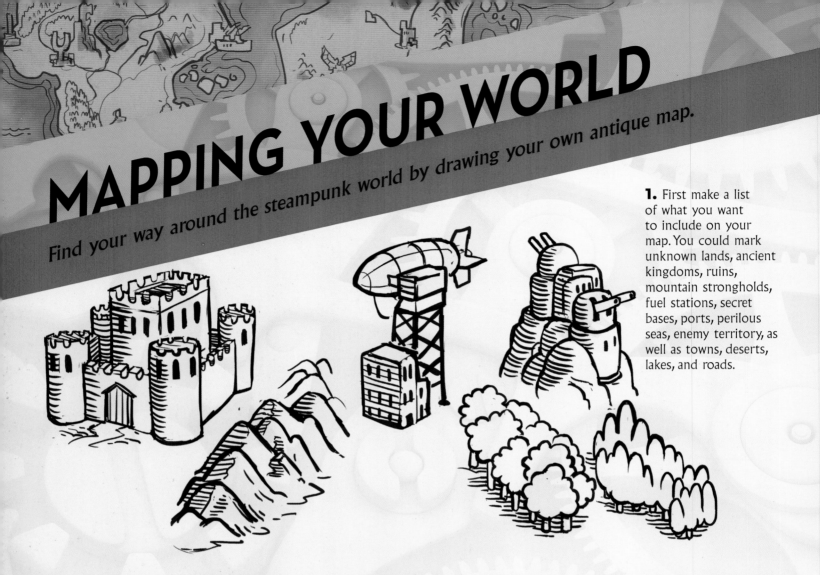

1. First make a list of what you want to include on your map. You could mark unknown lands, ancient kingdoms, ruins, mountain strongholds, fuel stations, secret bases, ports, perilous seas, enemy territory, as well as towns, deserts, lakes, and roads.

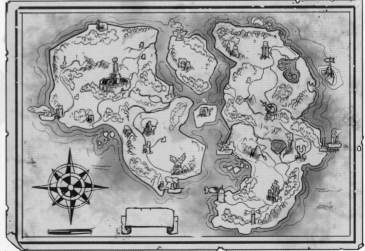

2. Draw rough outlines of your land, islands, and boundaries. Add a few rough tree-like shapes to indicate forests, and walls on the edge of towns. You can use symbols to mark castles and ruins.

3. Now, give your map an antique look with faded washes of brown. Add a compass in the corner of the map. You could also dip a sponge into cold weak coffee and dab it on to the map to give it an aged look. You can then add names of places in careful handwriting.

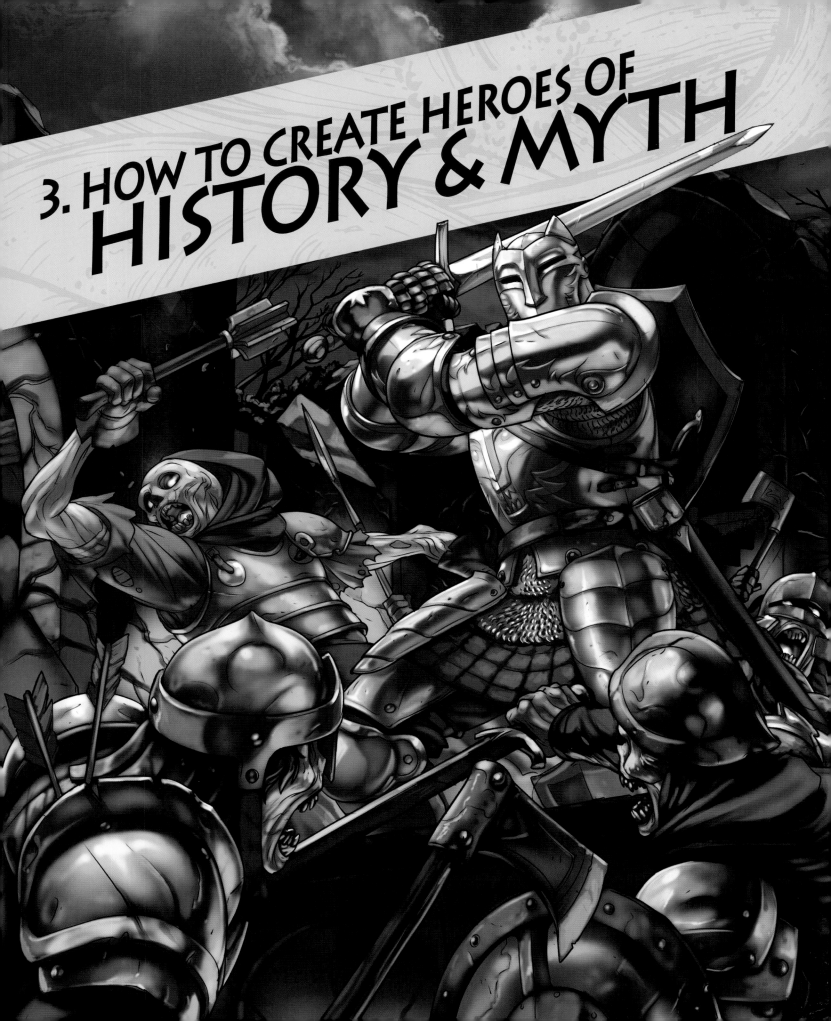

3. HOW TO CREATE HEROES OF HISTORY & MYTH

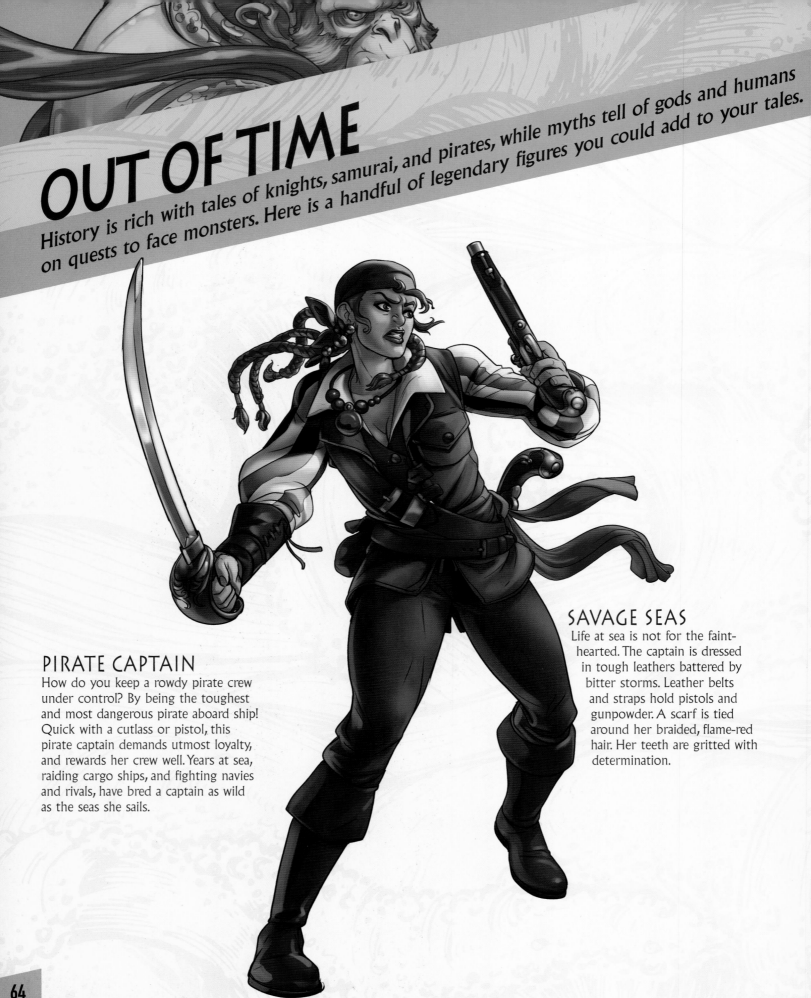

OUT OF TIME

History is rich with tales of knights, samurai, and pirates, while myths tell of gods and humans on quests to face monsters. Here is a handful of legendary figures you could add to your tales.

PIRATE CAPTAIN

How do you keep a rowdy pirate crew under control? By being the toughest and most dangerous pirate aboard ship! Quick with a cutlass or pistol, this pirate captain demands utmost loyalty, and rewards her crew well. Years at sea, raiding cargo ships, and fighting navies and rivals, have bred a captain as wild as the seas she sails.

SAVAGE SEAS

Life at sea is not for the faint-hearted. The captain is dressed in tough leathers battered by bitter storms. Leather belts and straps hold pistols and gunpowder. A scarf is tied around her braided, flame-red hair. Her teeth are gritted with determination.

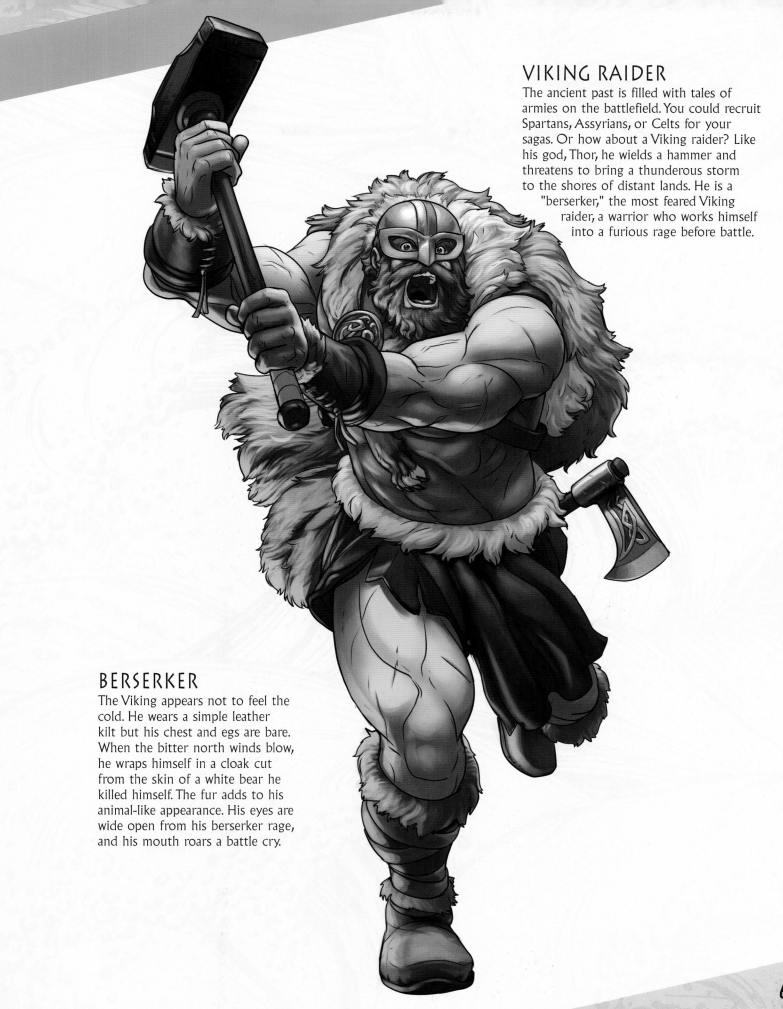

VIKING RAIDER

The ancient past is filled with tales of armies on the battlefield. You could recruit Spartans, Assyrians, or Celts for your sagas. Or how about a Viking raider? Like his god, Thor, he wields a hammer and threatens to bring a thunderous storm to the shores of distant lands. He is a "berserker," the most feared Viking raider, a warrior who works himself into a furious rage before battle.

BERSERKER

The Viking appears not to feel the cold. He wears a simple leather kilt but his chest and egs are bare. When the bitter north winds blow, he wraps himself in a cloak cut from the skin of a white bear he killed himself. The fur adds to his animal-like appearance. His eyes are wide open from his berserker rage, and his mouth roars a battle cry.

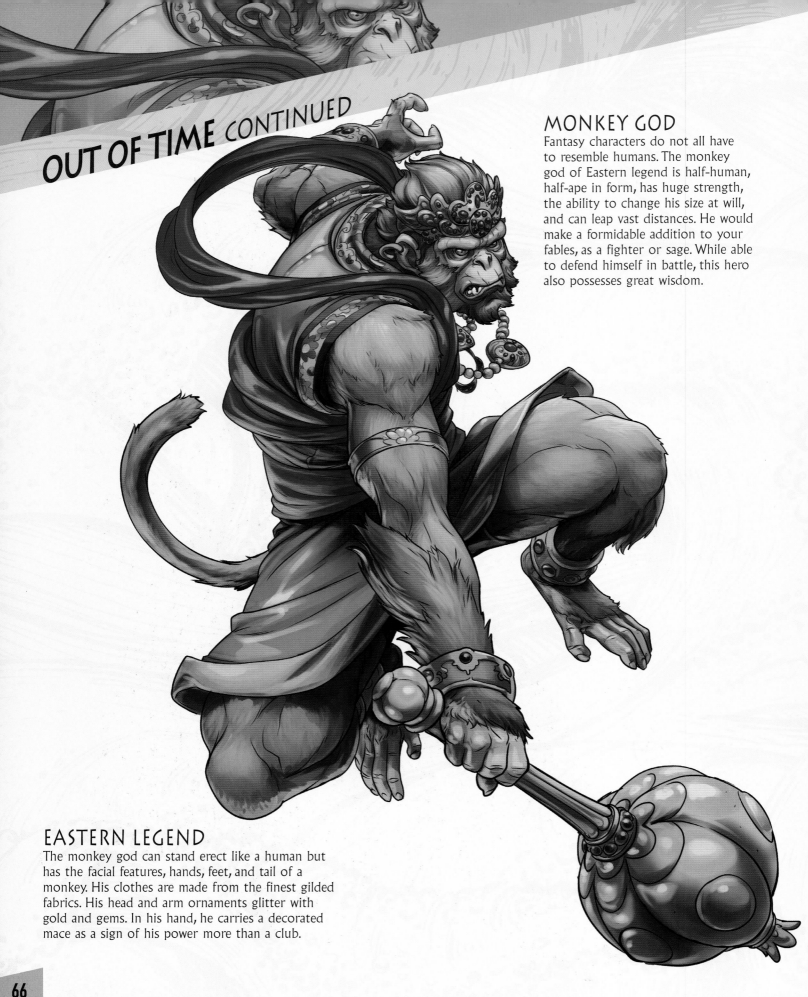

MONKEY GOD

Fantasy characters do not all have to resemble humans. The monkey god of Eastern legend is half-human, half-ape in form, has huge strength, the ability to change his size at will, and can leap vast distances. He would make a formidable addition to your fables, as a fighter or sage. While able to defend himself in battle, this hero also possesses great wisdom.

EASTERN LEGEND

The monkey god can stand erect like a human but has the facial features, hands, feet, and tail of a monkey. His clothes are made from the finest gilded fabrics. His head and arm ornaments glitter with gold and gems. In his hand, he carries a decorated mace as a sign of his power more than a club.

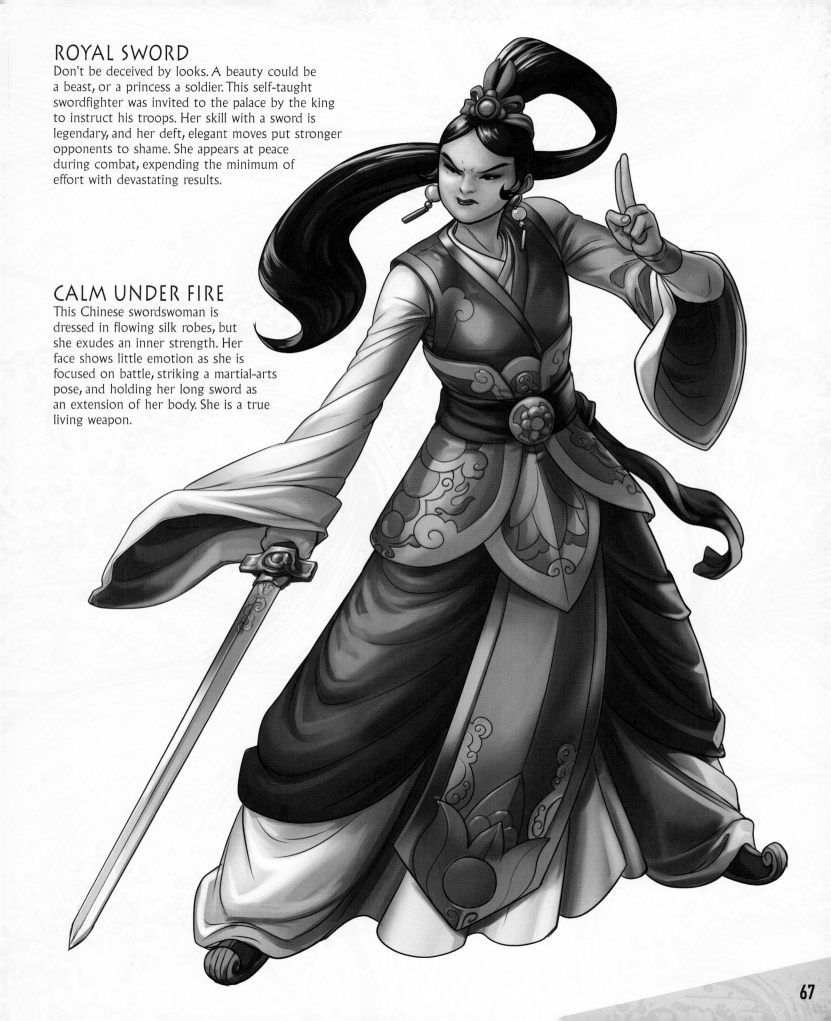

ROYAL SWORD

Don't be deceived by looks. A beauty could be a beast, or a princess a soldier. This self-taught swordfighter was invited to the palace by the king to instruct his troops. Her skill with a sword is legendary, and her deft, elegant moves put stronger opponents to shame. She appears at peace during combat, expending the minimum of effort with devastating results.

CALM UNDER FIRE

This Chinese swordswoman is dressed in flowing silk robes, but she exudes an inner strength. Her face shows little emotion as she is focused on battle, striking a martial-arts pose, and holding her long sword as an extension of her body. She is a true living weapon.

NOBLE SAMURAI

The samurai, or bushi, were a warrior class that ruled Japan for centuries. While adept with bows, spears, and guns, they were most known for their sword skills.

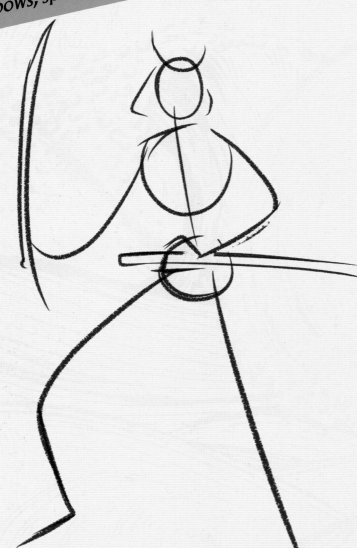

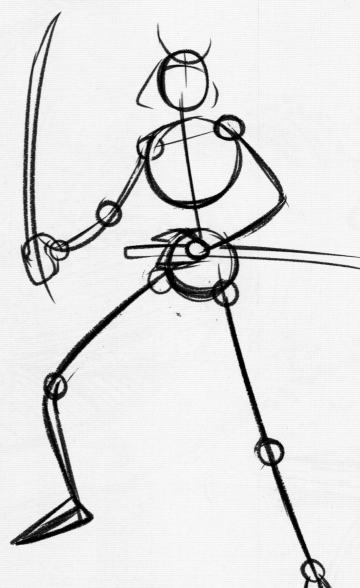

1. WIREFRAME

Using light pencil marks, draw a simple stick figure showing your samurai's pose, with lines for his sword and sheath. He has just taken out his sword, and raises it to show he is ready for battle.

2. JOINTED FIGURE

Now, use circles to indicate the position of the samurai's joints. The left leg is held straight, while the right leg is bent at the knee.

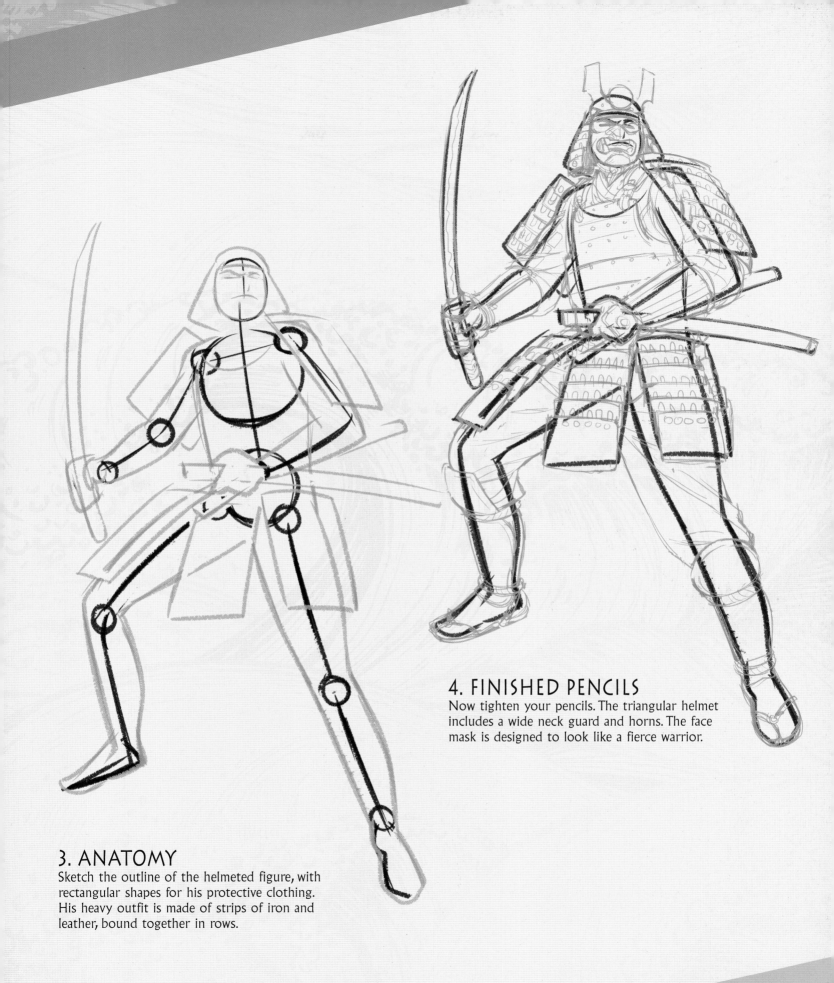

4. FINISHED PENCILS
Now tighten your pencils. The triangular helmet includes a wide neck guard and horns. The face mask is designed to look like a fierce warrior.

3. ANATOMY
Sketch the outline of the helmeted figure, with rectangular shapes for his protective clothing. His heavy outfit is made of strips of iron and leather, bound together in rows.

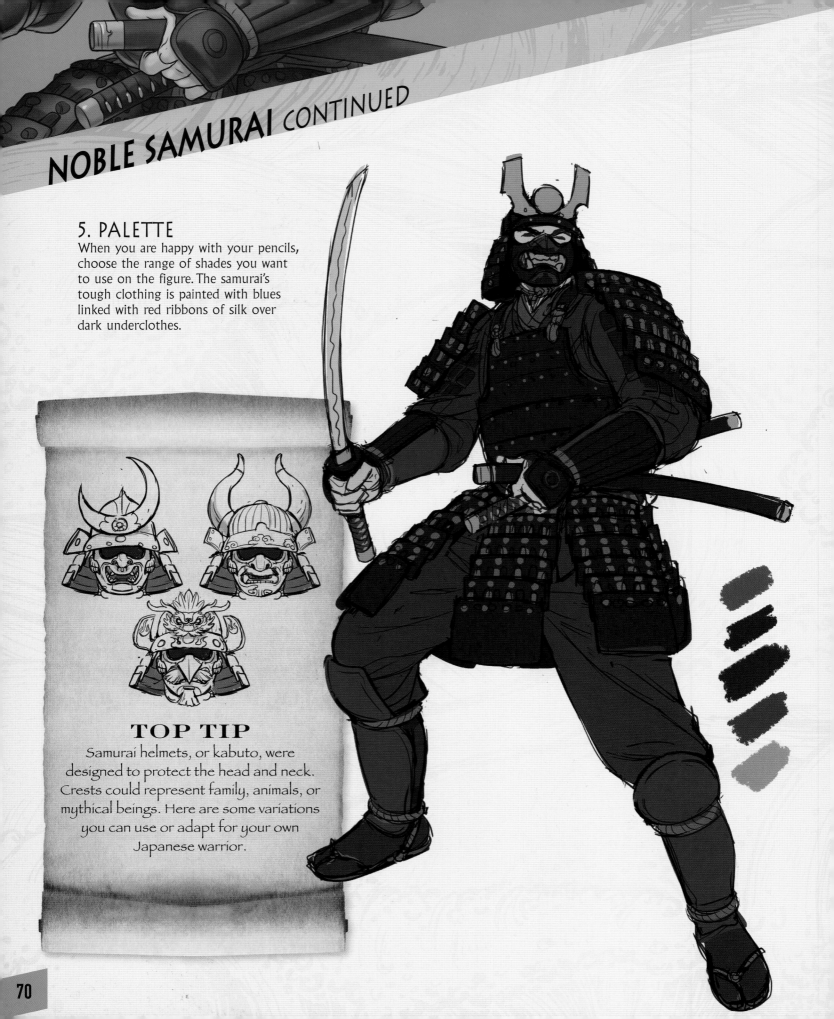

5. PALETTE

When you are happy with your pencils, choose the range of shades you want to use on the figure. The samurai's tough clothing is painted with blues linked with red ribbons of silk over dark underclothes.

TOP TIP

Samurai helmets, or kabuto, were designed to protect the head and neck. Crests could represent family, animals, or mythical beings. Here are some variations you can use or adapt for your own Japanese warrior.

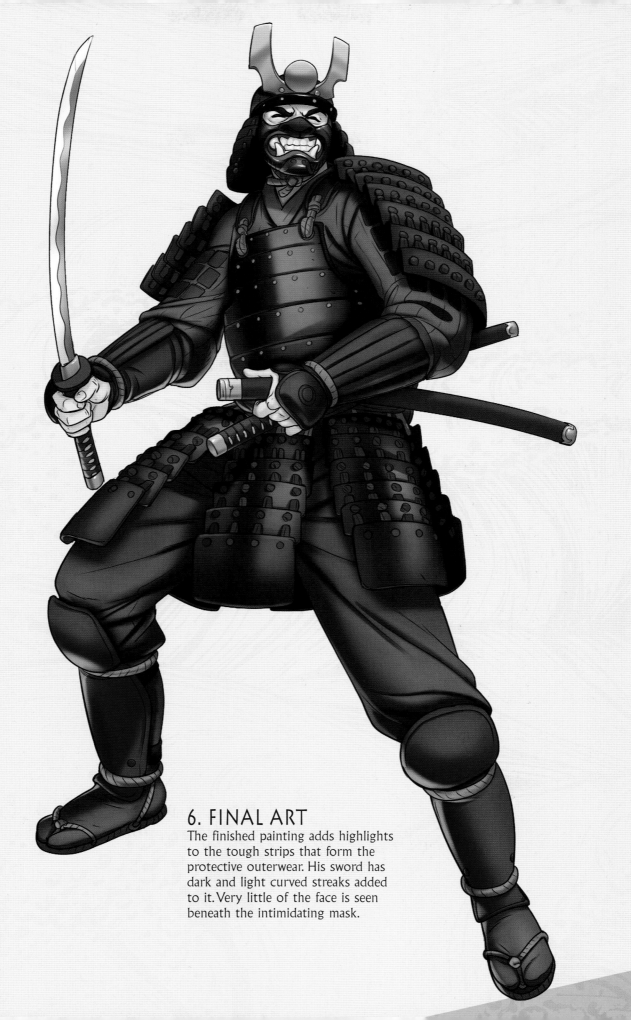

6. FINAL ART
The finished painting adds highlights to the tough strips that form the protective outerwear. His sword has dark and light curved streaks added to it. Very little of the face is seen beneath the intimidating mask.

FAERIE QUEEN

The faerie queen is a woodland spirit who protects the animals that live in her realm. She wears many disguises but appears to the fortunate few as a winged maiden.

1. WIREFRAME

Using light pencil marks, draw a simple stick figure showing your faerie queen's crouching pose and the outline of her wings and sword.

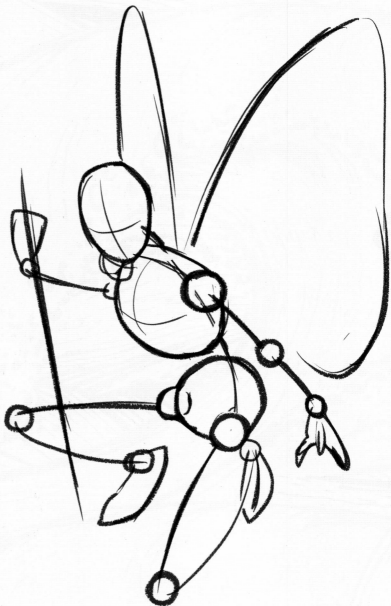

2. JOINTED FIGURE

Use a cross to indicate the front of her face and eyeline. Use circles to mark the position of her arms and leg joints.

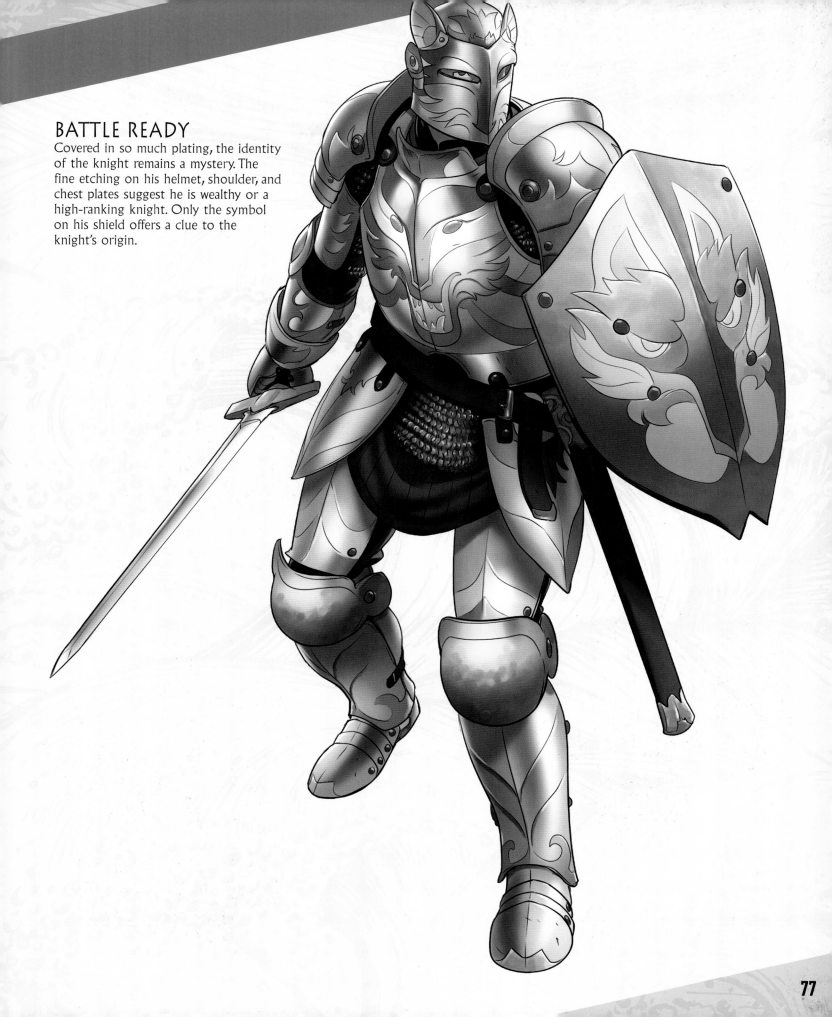

BATTLE READY

Covered in so much plating, the identity of the knight remains a mystery. The fine etching on his helmet, shoulder, and chest plates suggest he is wealthy or a high-ranking knight. Only the symbol on his shield offers a clue to the knight's origin.

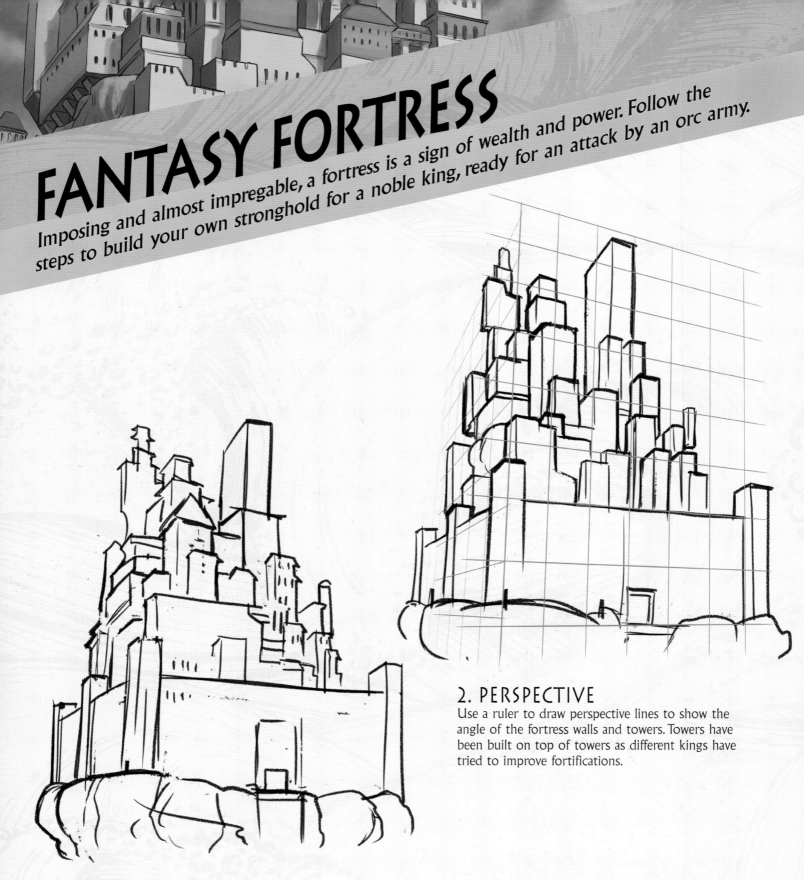

FANTASY FORTRESS

Imposing and almost impregable, a fortress is a sign of wealth and power. Follow the steps to build your own stronghold for a noble king, ready for an attack by an orc army.

2. PERSPECTIVE

Use a ruler to draw perspective lines to show the angle of the fortress walls and towers. Towers have been built on top of towers as different kings have tried to improve fortifications.

1. BUILDING PLAN

This rough sketch shows the fortress as seen from below. The castle is built on a high cliff, and from this angle, it looks impossible to break into.

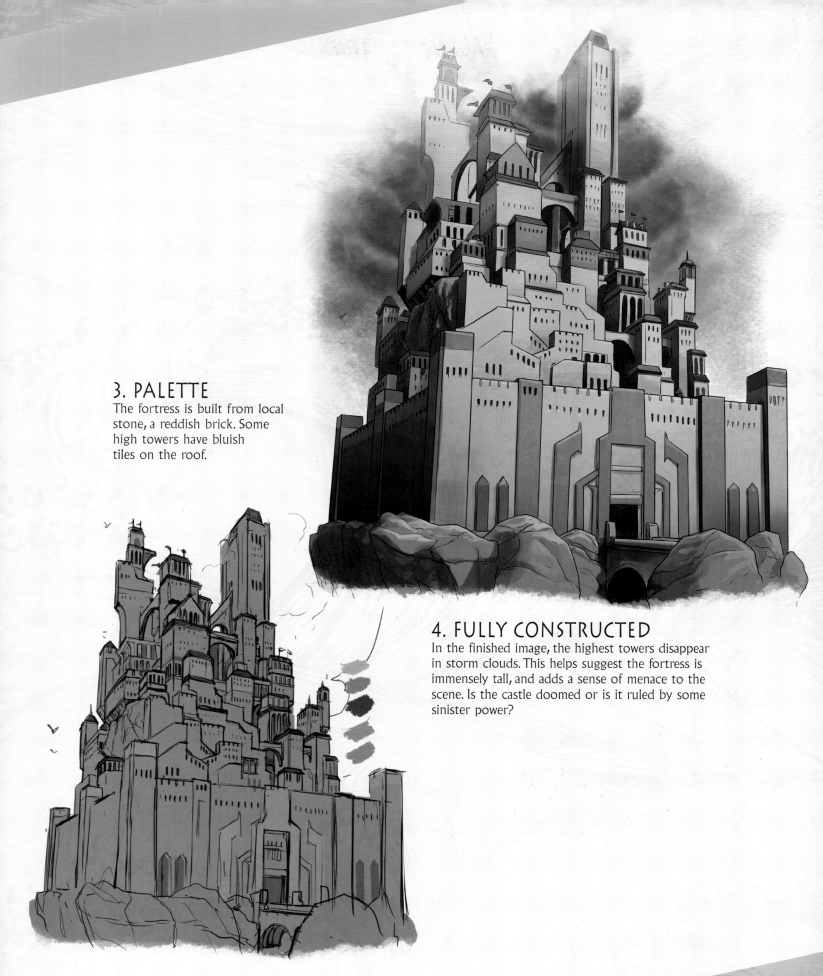

3. PALETTE

The fortress is built from local stone, a reddish brick. Some high towers have bluish tiles on the roof.

4. FULLY CONSTRUCTED

In the finished image, the highest towers disappear in storm clouds. This helps suggest the fortress is immensely tall, and adds a sense of menace to the scene. Is the castle doomed or is it ruled by some sinister power?

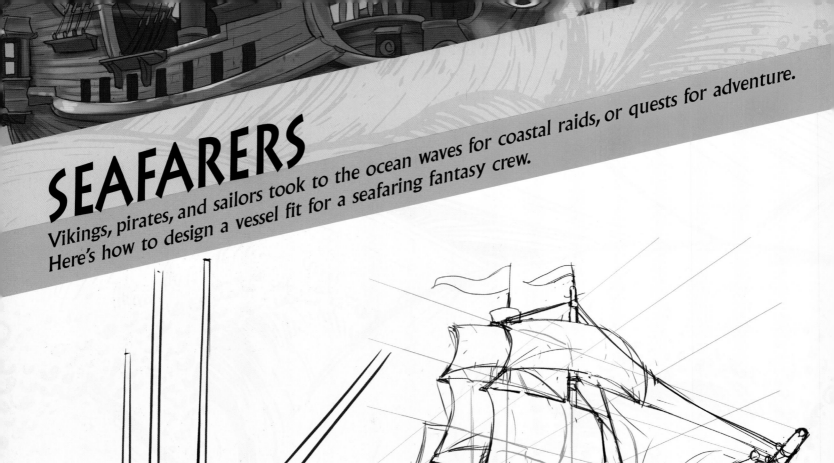

SEAFARERS

Vikings, pirates, and sailors took to the ocean waves for coastal raids, or quests for adventure. Here's how to design a vessel fit for a seafaring fantasy crew.

1. HULL

Sketch the hull of the ship as it sails toward you. Add three vertical masts, with the tallest in the middle, plus the bowsprit at an angle from the front of the ship.

2. SAILS

Now draw the sails hanging from the wooden yardarms on each vertical mast. Use perspective lines to help with the correct angles. This pirate ship has a menacing, skull-like figurehead on the bow.

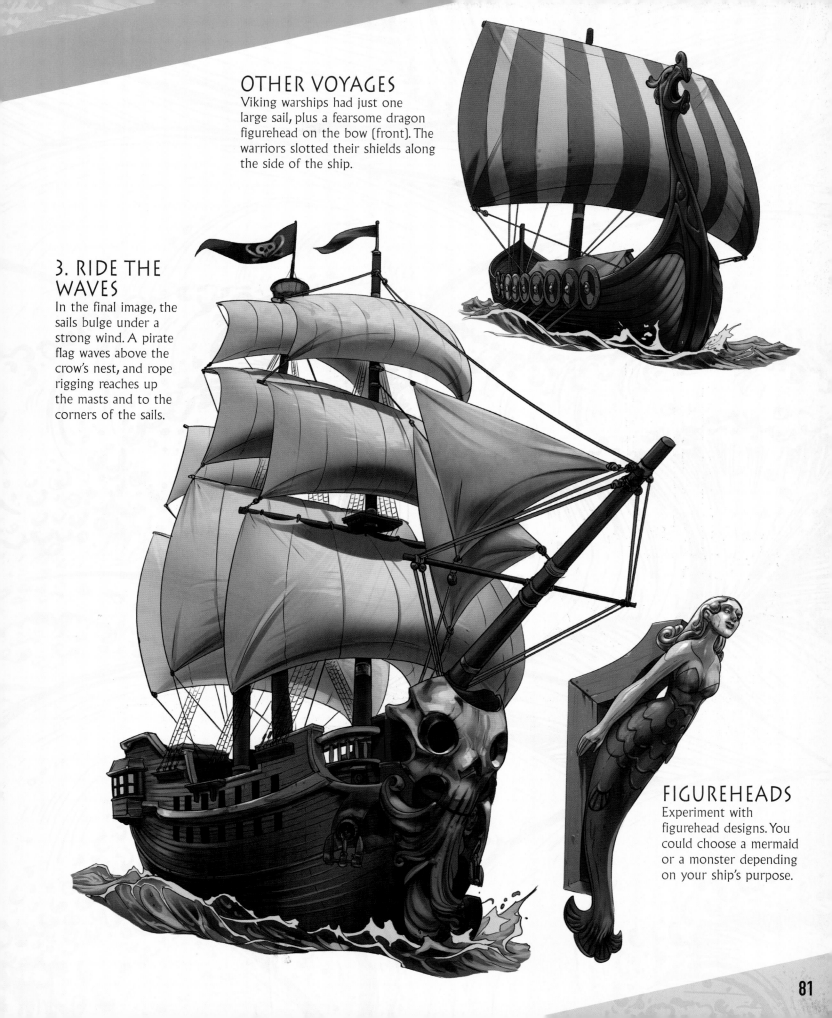

OTHER VOYAGES

Viking warships had just one large sail, plus a fearsome dragon figurehead on the bow (front). The warriors slotted their shields along the side of the ship.

3. RIDE THE WAVES

In the final image, the sails bulge under a strong wind. A pirate flag waves above the crow's nest, and rope rigging reaches up the masts and to the corners of the sails.

FIGUREHEADS

Experiment with figurehead designs. You could choose a mermaid or a monster depending on your ship's purpose.

UNDER SIEGE

A coastal town is under attack by a creature from the deep. A pirate crew has been caught in the conflict. Follow the steps to create a dramatic scene of monsters and mariners.

1. This rough plan of the scene has pirates aboard ship in the foreground, right, directing their harpoons toward a massive squid monster that is tearing down the town.

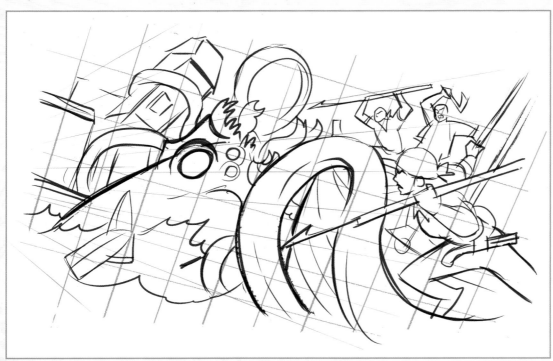

2. Perpective lines show how the scene is viewed from a dramatic angle. All the action is directed toward the monster.

3. In these tighter pencils, shading has been added. This helps bring order to the frenzied fight. Crashing waves toss smaller boats into the air. One large tentacle in the foreground threatens to squeeze the ship and crew.

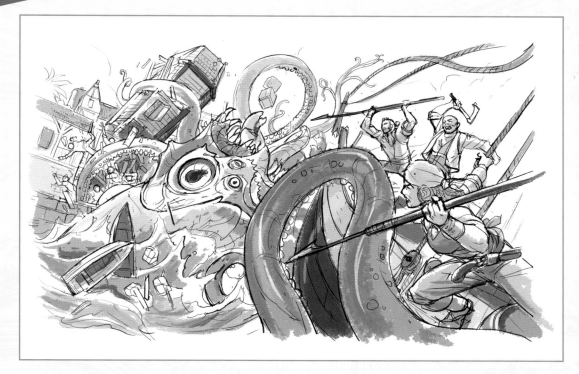

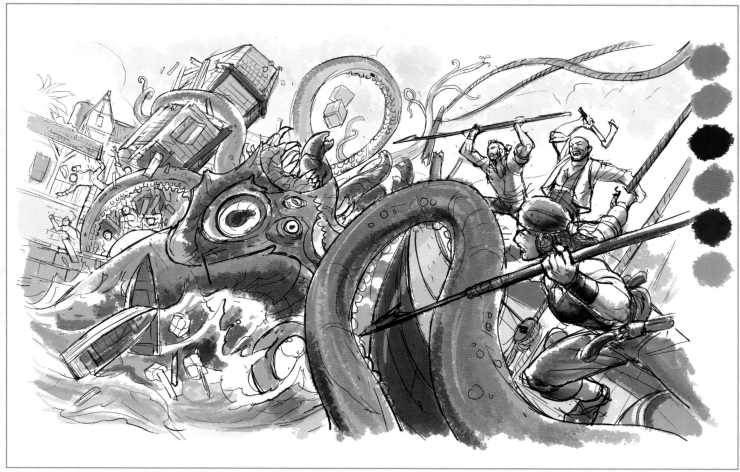

4. The monster is painted in blood red, contrasting with the turquoise of the sea water and sky. The frothing foam on the waves is streaked and splashed with white.

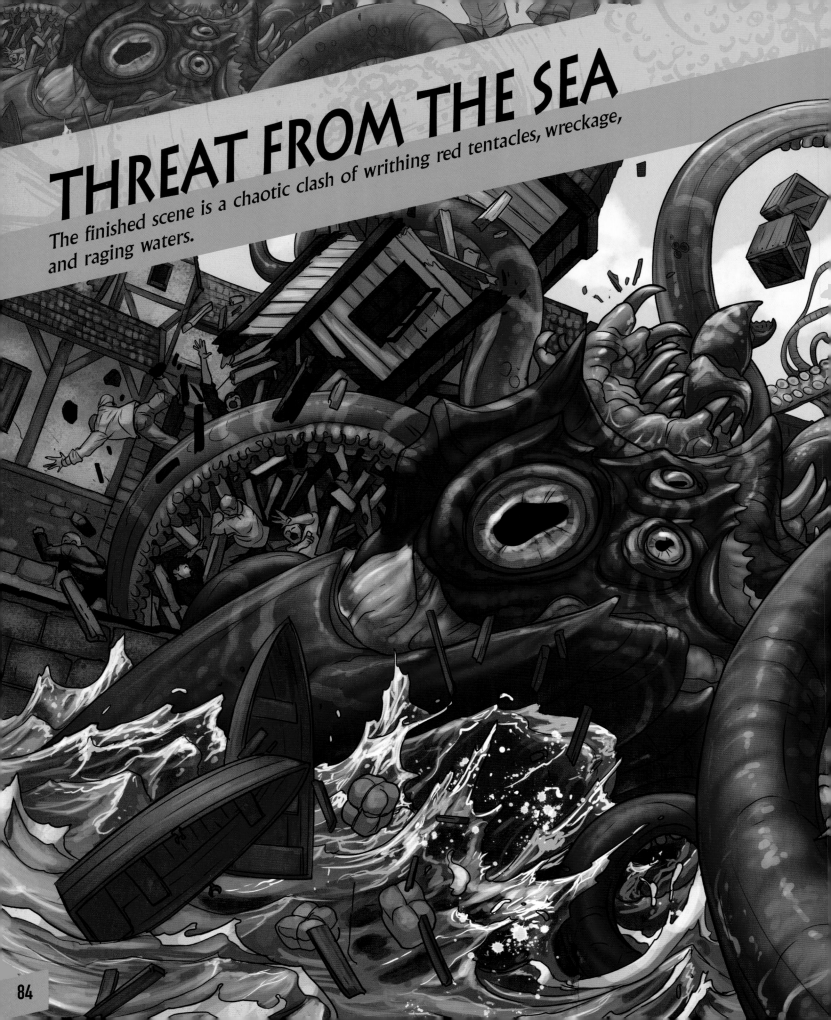

THREAT FROM THE SEA

The finished scene is a chaotic clash of writhing red tentacles, wreckage, and raging waters.

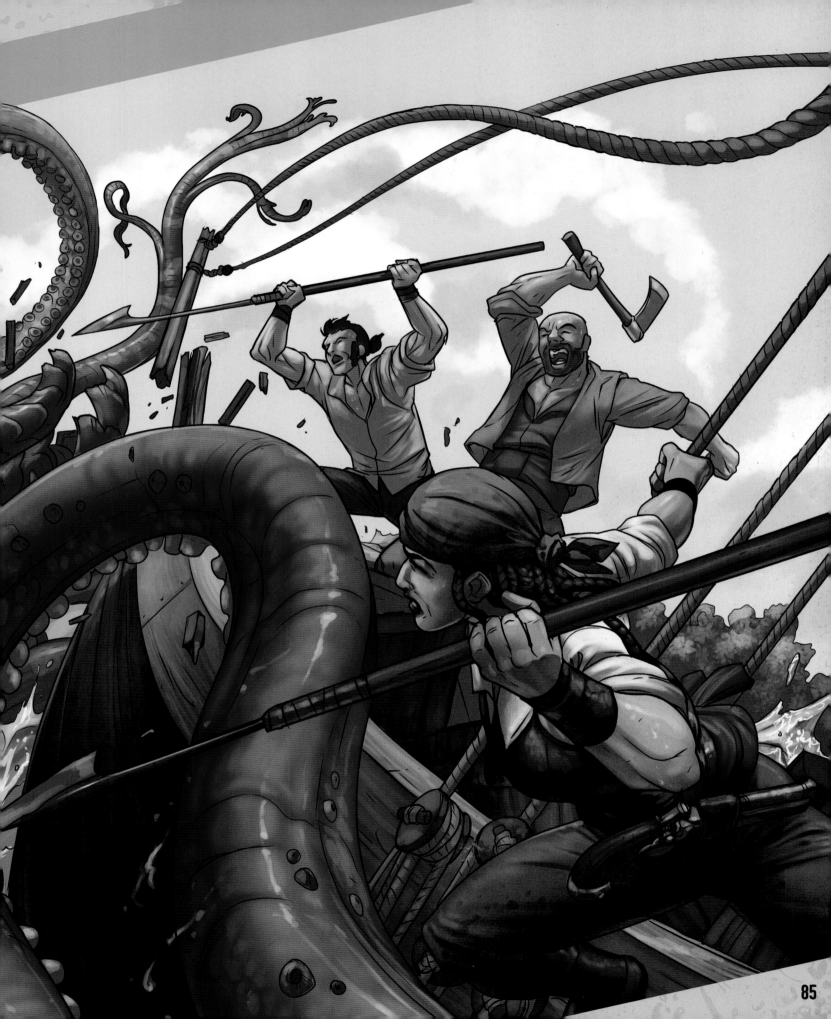

DESIGNS FROM THE PAST

Take inspiration from ancient designs to decorate your historical fantasies.

Books and museum exhibitions are great places to look for ancient designs you can use to give depth to your historic and legendary tales. Give your characters authentic brooches, belts, and buckles from their time. Copy carvings from stone and wood and turn them into warrior tattoos, helmet designs, flags, or shield patterns.

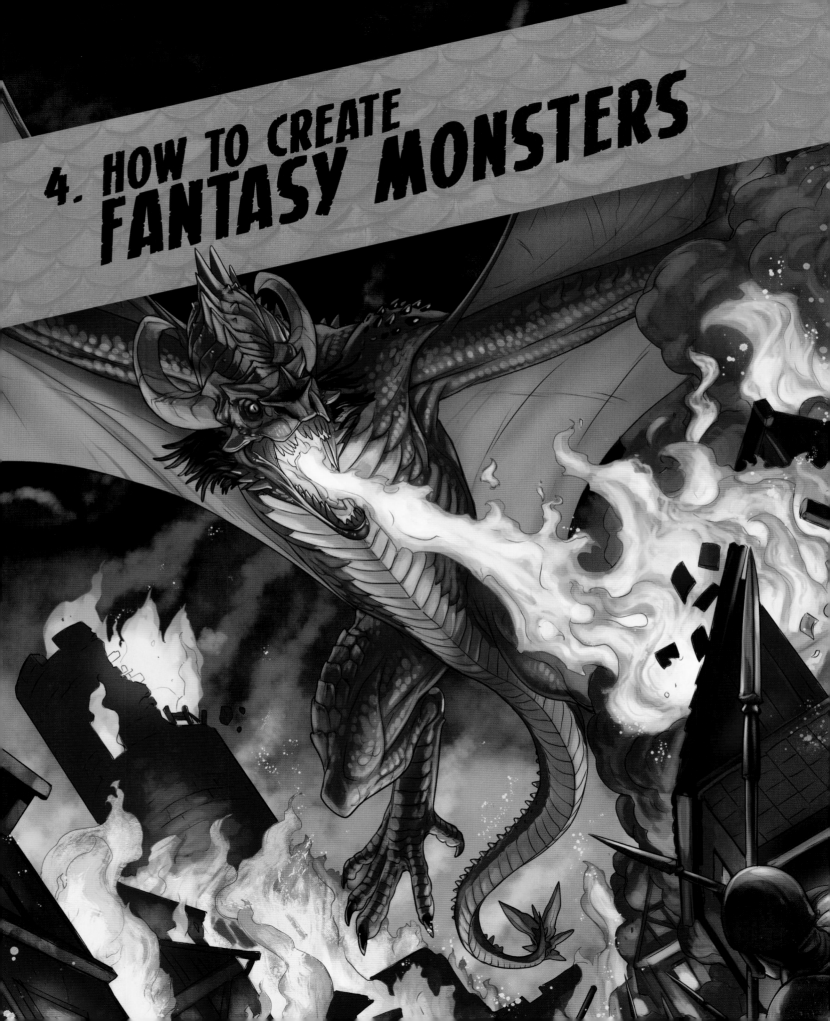

4. HOW TO CREATE FANTASY MONSTERS

LEGENDARY MONSTERS

Meet the monsters: terrifying fabled creatures, giants, or fusions of human and wild animal. Let these nightmarish creatures inspire your own frightful fantasies.

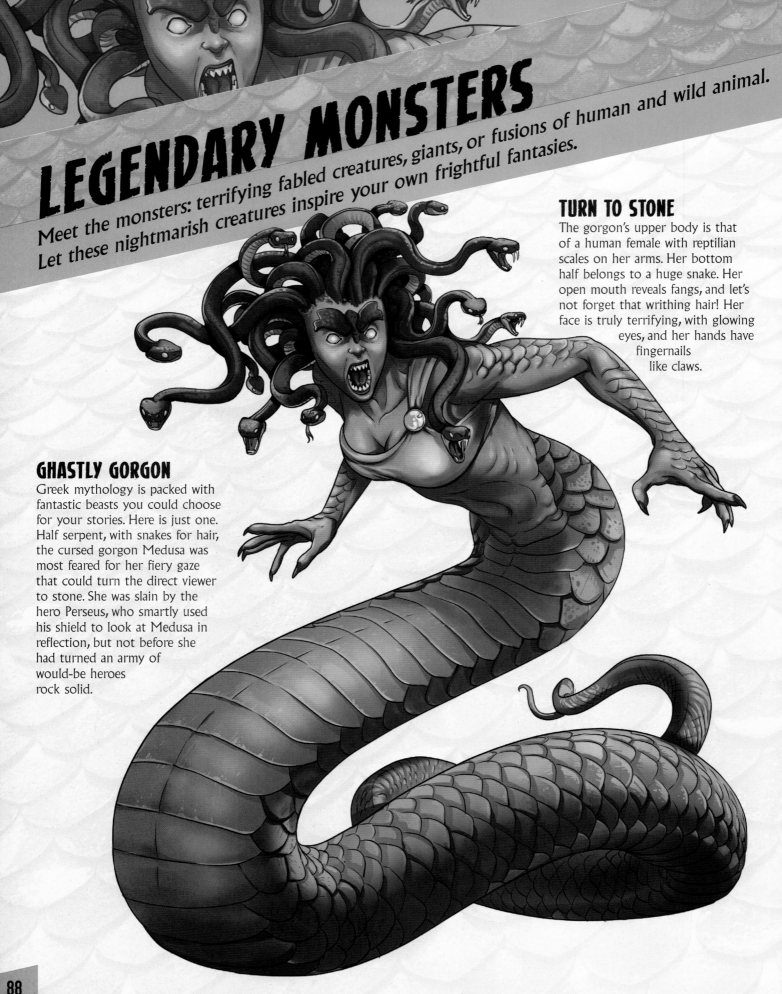

TURN TO STONE

The gorgon's upper body is that of a human female with reptilian scales on her arms. Her bottom half belongs to a huge snake. Her open mouth reveals fangs, and let's not forget that writhing hair! Her face is truly terrifying, with glowing eyes, and her hands have fingernails like claws.

GHASTLY GORGON

Greek mythology is packed with fantastic beasts you could choose for your stories. Here is just one. Half serpent, with snakes for hair, the cursed gorgon Medusa was most feared for her fiery gaze that could turn the direct viewer to stone. She was slain by the hero Perseus, who smartly used his shield to look at Medusa in reflection, but not before she had turned an army of would-be heroes rock solid.

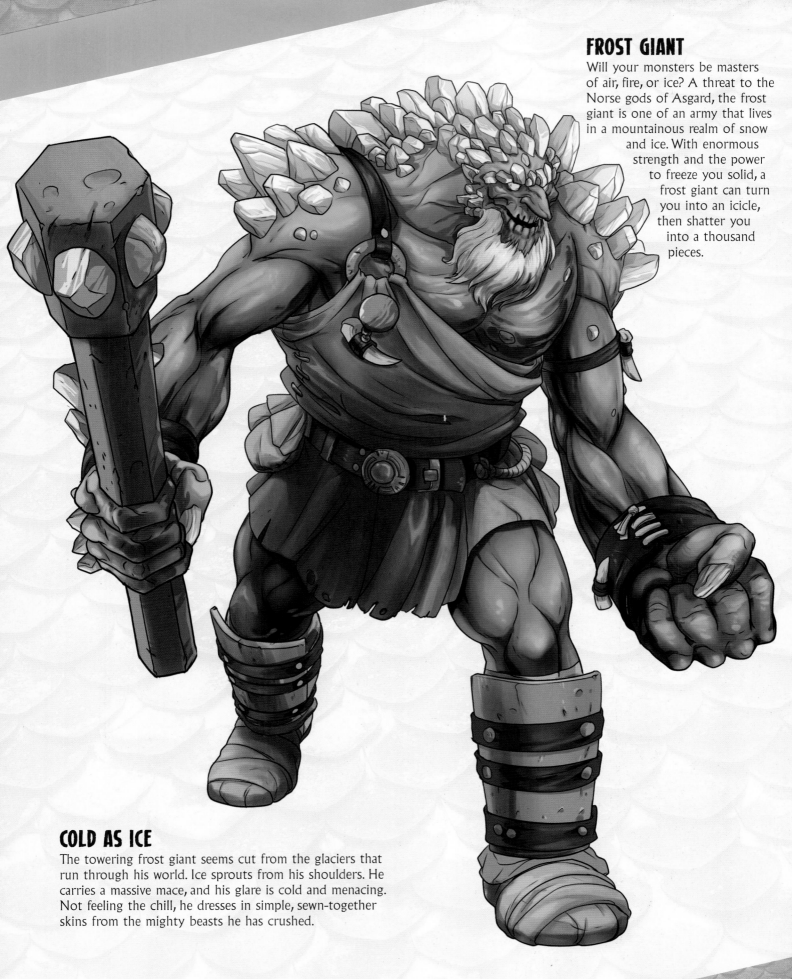

FROST GIANT

Will your monsters be masters of air, fire, or ice? A threat to the Norse gods of Asgard, the frost giant is one of an army that lives in a mountainous realm of snow and ice. With enormous strength and the power to freeze you solid, a frost giant can turn you into an icicle, then shatter you into a thousand pieces.

COLD AS ICE

The towering frost giant seems cut from the glaciers that run through his world. Ice sprouts from his shoulders. He carries a massive mace, and his glare is cold and menacing. Not feeling the chill, he dresses in simple, sewn-together skins from the mighty beasts he has crushed.

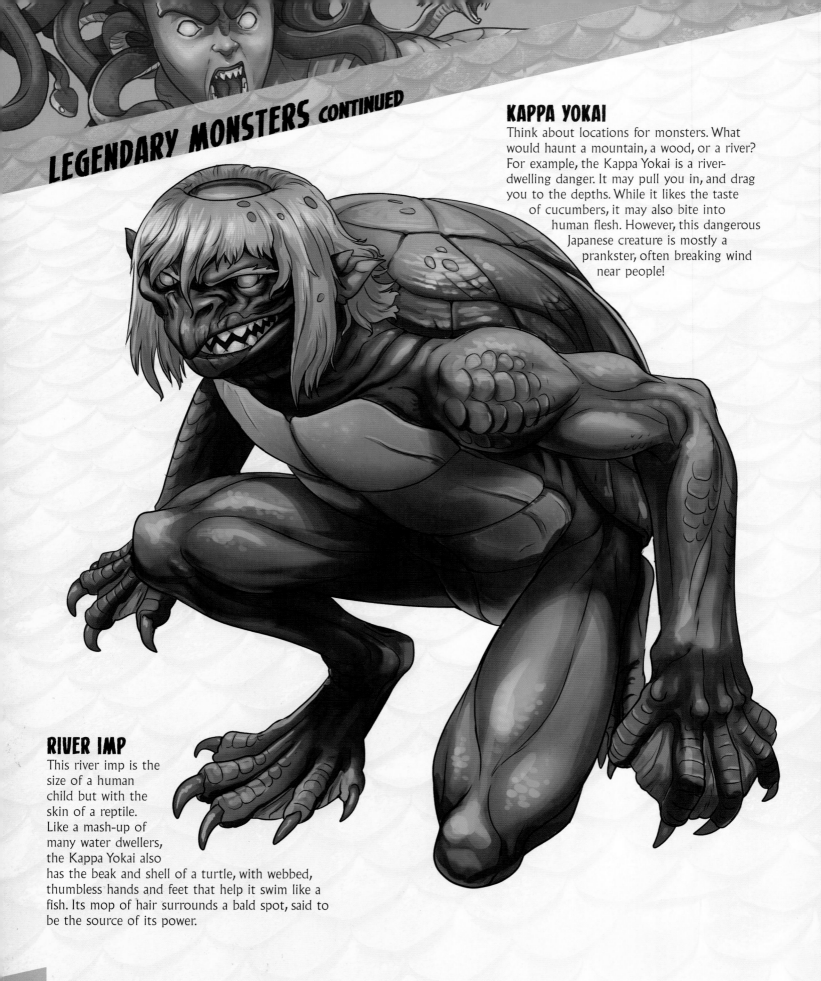

KAPPA YOKAI

Think about locations for monsters. What would haunt a mountain, a wood, or a river? For example, the Kappa Yokai is a river-dwelling danger. It may pull you in, and drag you to the depths. While it likes the taste of cucumbers, it may also bite into human flesh. However, this dangerous Japanese creature is mostly a prankster, often breaking wind near people!

RIVER IMP

This river imp is the size of a human child but with the skin of a reptile. Like a mash-up of many water dwellers, the Kappa Yokai also has the beak and shell of a turtle, with webbed, thumbless hands and feet that help it swim like a fish. Its mop of hair surrounds a bald spot, said to be the source of its power.

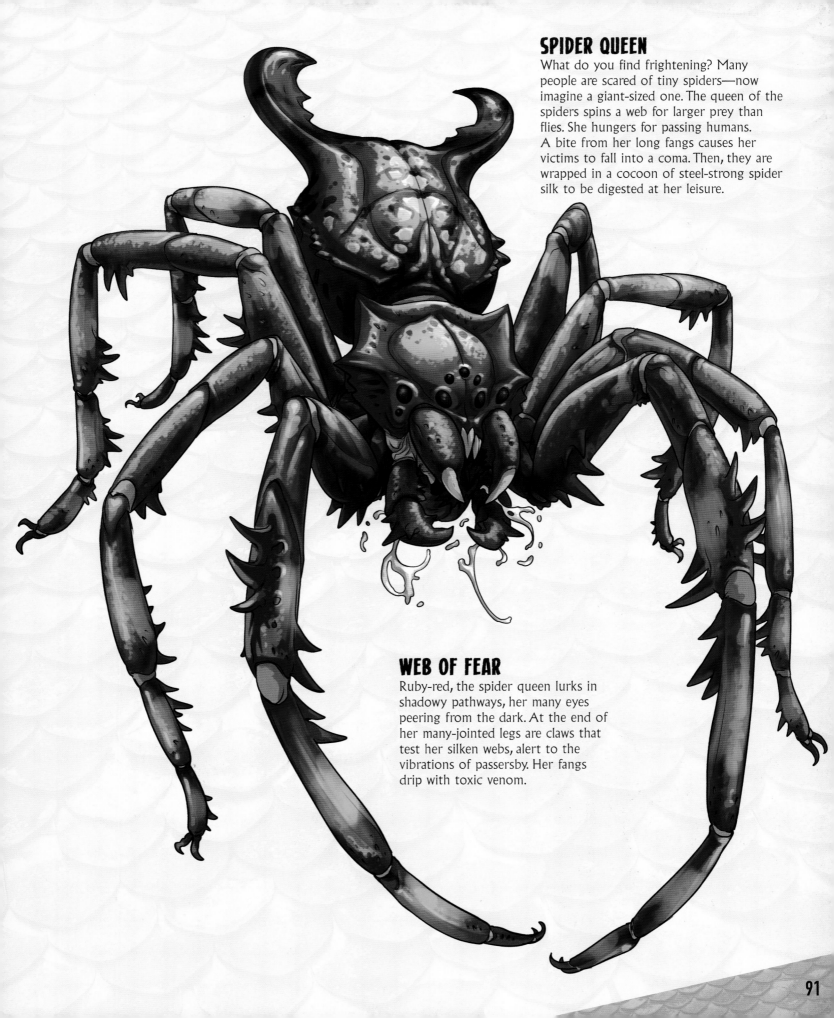

SPIDER QUEEN

What do you find frightening? Many people are scared of tiny spiders—now imagine a giant-sized one. The queen of the spiders spins a web for larger prey than flies. She hungers for passing humans. A bite from her long fangs causes her victims to fall into a coma. Then, they are wrapped in a cocoon of steel-strong spider silk to be digested at her leisure.

WEB OF FEAR

Ruby-red, the spider queen lurks in shadowy pathways, her many eyes peering from the dark. At the end of her many-jointed legs are claws that test her silken webs, alert to the vibrations of passersby. Her fangs drip with toxic venom.

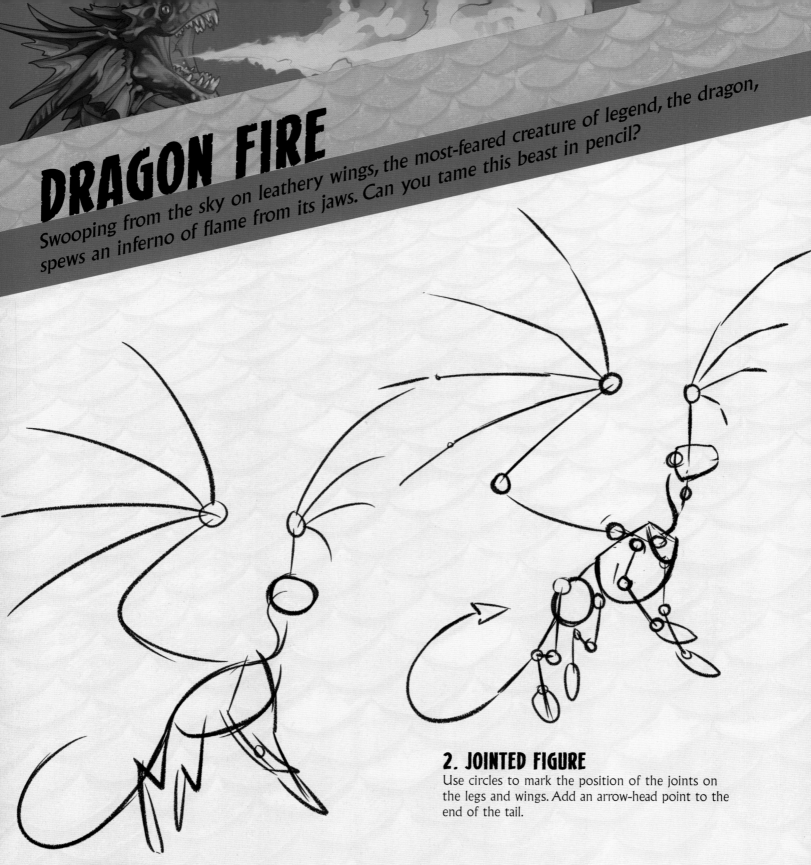

DRAGON FIRE

Swooping from the sky on leathery wings, the most-feared creature of legend, the dragon, spews an inferno of flame from its jaws. Can you tame this beast in pencil?

2. JOINTED FIGURE

Use circles to mark the position of the joints on the legs and wings. Add an arrow-head point to the end of the tail.

1. WIREFRAME

Using light pencil marks, draw a small circle for the dragon's head, leading to a long, curved line for the neck, backbone, and tail. Indicate four legs and the finger-like spread of the open wings.

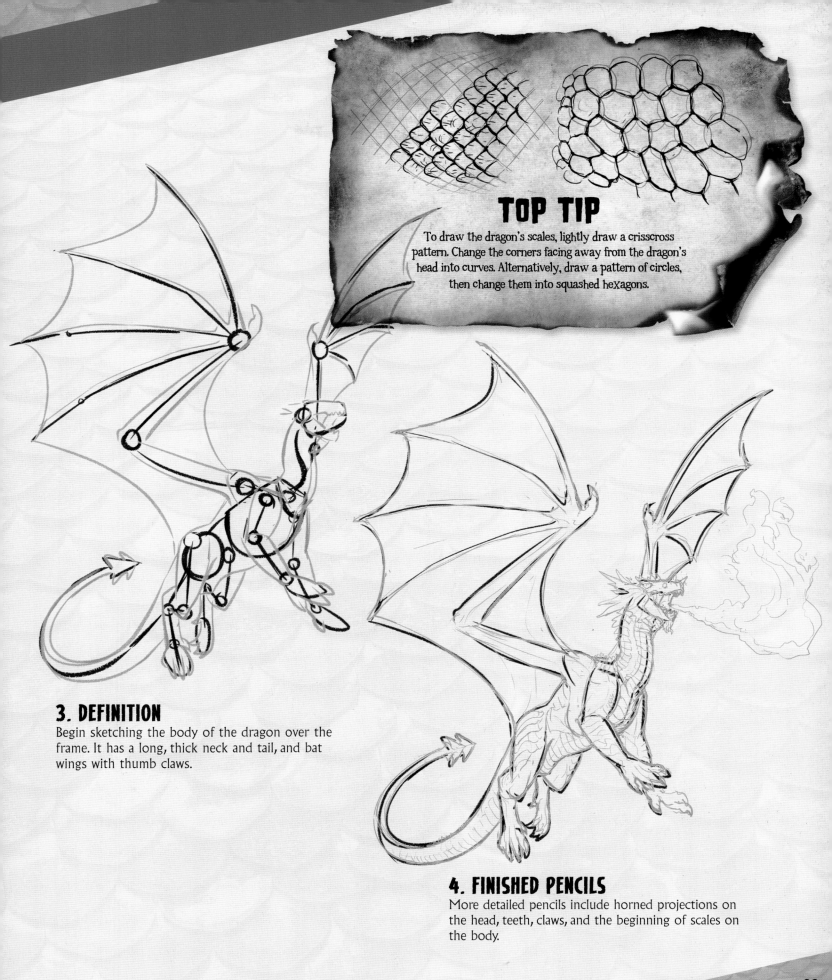

TOP TIP

To draw the dragon's scales, lightly draw a crisscross pattern. Change the corners facing away from the dragon's head into curves. Alternatively, draw a pattern of circles, then change them into squashed hexagons.

3. DEFINITION

Begin sketching the body of the dragon over the frame. It has a long, thick neck and tail, and bat wings with thumb claws.

4. FINISHED PENCILS

More detailed pencils include horned projections on the head, teeth, claws, and the beginning of scales on the body.

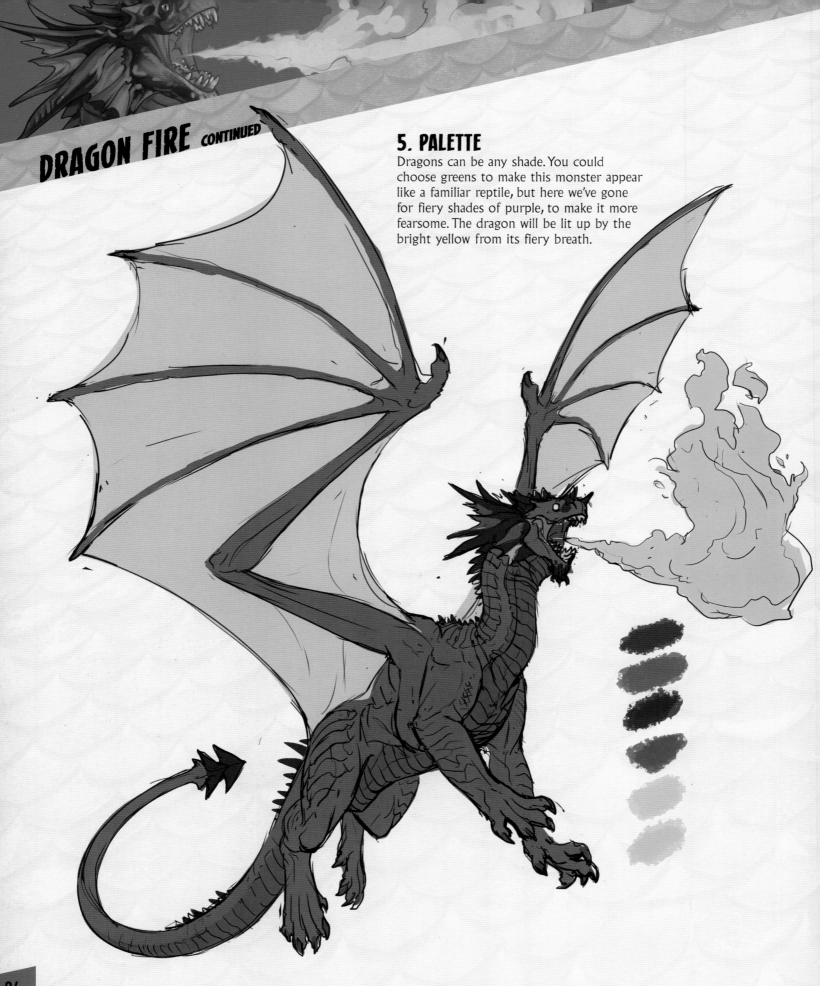

5. PALETTE

Dragons can be any shade. You could choose greens to make this monster appear like a familiar reptile, but here we've gone for fiery shades of purple, to make it more fearsome. The dragon will be lit up by the bright yellow from its fiery breath.

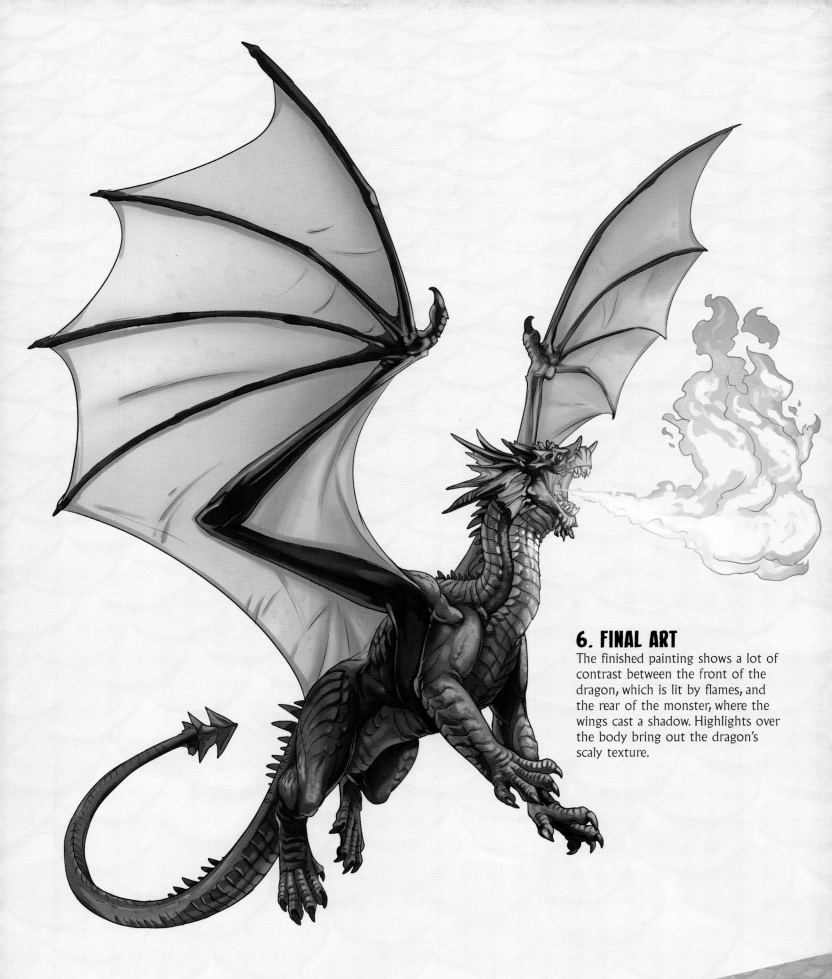

6. FINAL ART

The finished painting shows a lot of contrast between the front of the dragon, which is lit by flames, and the rear of the monster, where the wings cast a shadow. Highlights over the body bring out the dragon's scaly texture.

MINOTAUR

Half-muscleman, half-bull, this fearsome keeper of the legendary labyrinth charges forward with horns lowered and weapon at the ready.

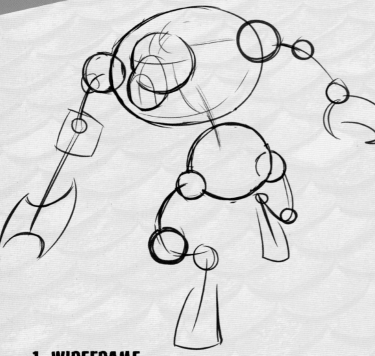

2. BODY WORK

Add muscular bulk to your Minotaur. Curved horns emerge from the sides of the head above the drooped ears. The mouth is open in a roar. The bottom of the legs extend toward the hooves.

1. WIREFRAME

The Minotaur carries most of his mass over his shoulders. Build a body around a wide oval torso with a head from its middle. One short leg strides forward, the other is set back.

3. FINE DETAIL

Now you can add definition to the muscles, fingers, and the split in the cloven hooves. Draw furry lines over the more bull-like body parts over the head, shoulders, and lower legs. Dress your Minotaur in the outfit of an ancient Greek warrior and give him a two-headed hatchet to wield.

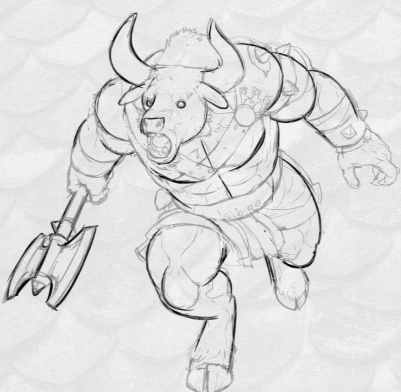

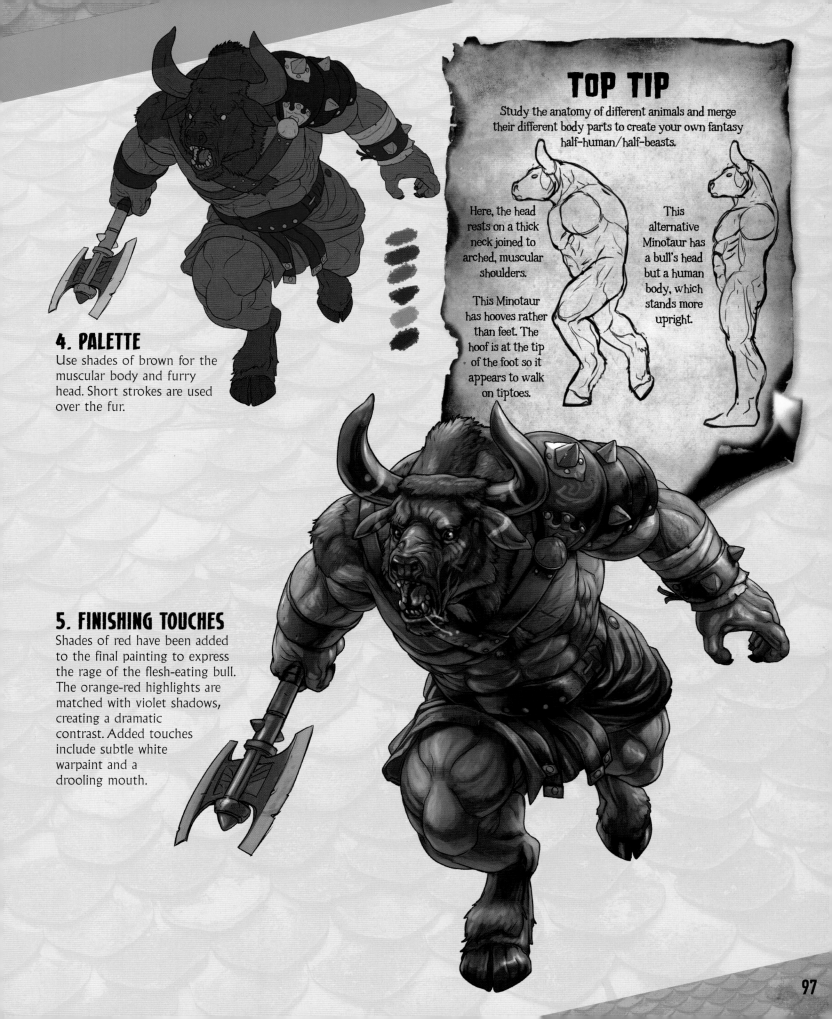

4. PALETTE

Use shades of brown for the muscular body and furry head. Short strokes are used over the fur.

TOP TIP

Study the anatomy of different animals and merge their different body parts to create your own fantasy half-human/half-beasts.

Here, the head rests on a thick neck joined to arched, muscular shoulders.

This Minotaur has hooves rather than feet. The hoof is at the tip of the foot so it appears to walk on tiptoes.

This alternative Minotaur has a bull's head but a human body, which stands more upright.

5. FINISHING TOUCHES

Shades of red have been added to the final painting to express the rage of the flesh-eating bull. The orange-red highlights are matched with violet shadows, creating a dramatic contrast. Added touches include subtle white warpaint and a drooling mouth.

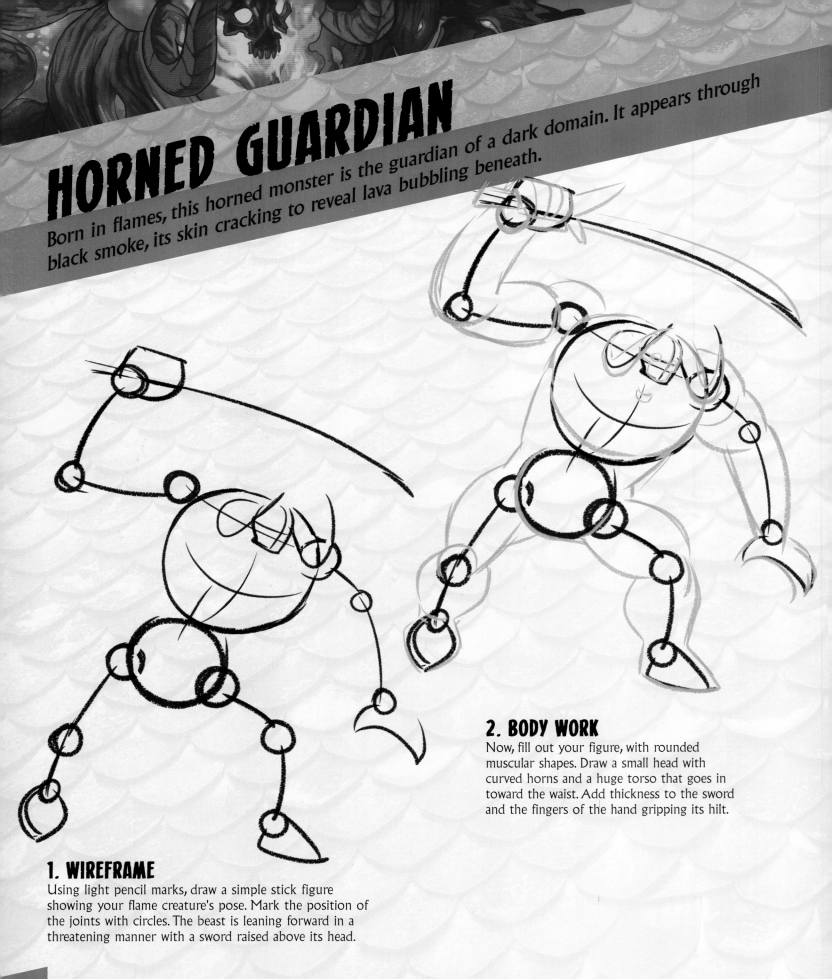

HORNED GUARDIAN

Born in flames, this horned monster is the guardian of a dark domain. It appears through black smoke, its skin cracking to reveal lava bubbling beneath.

2. BODY WORK

Now, fill out your figure, with rounded muscular shapes. Draw a small head with curved horns and a huge torso that goes in toward the waist. Add thickness to the sword and the fingers of the hand gripping its hilt.

1. WIREFRAME

Using light pencil marks, draw a simple stick figure showing your flame creature's pose. Mark the position of the joints with circles. The beast is leaning forward in a threatening manner with a sword raised above its head.

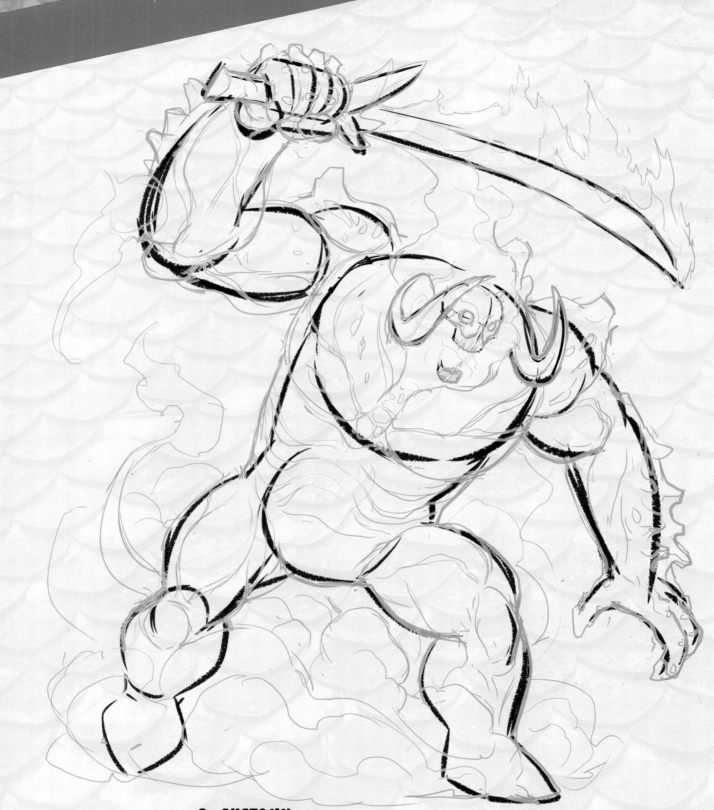

3. ANATOMY

Replace the building blocks with more detailed muscular anatomy on the chest and limbs. Add rocky shapes over the shoulders and arms, plus a curving tail. Then, draw curving flames over the head and sword, along with clouds of smoke on the ground.

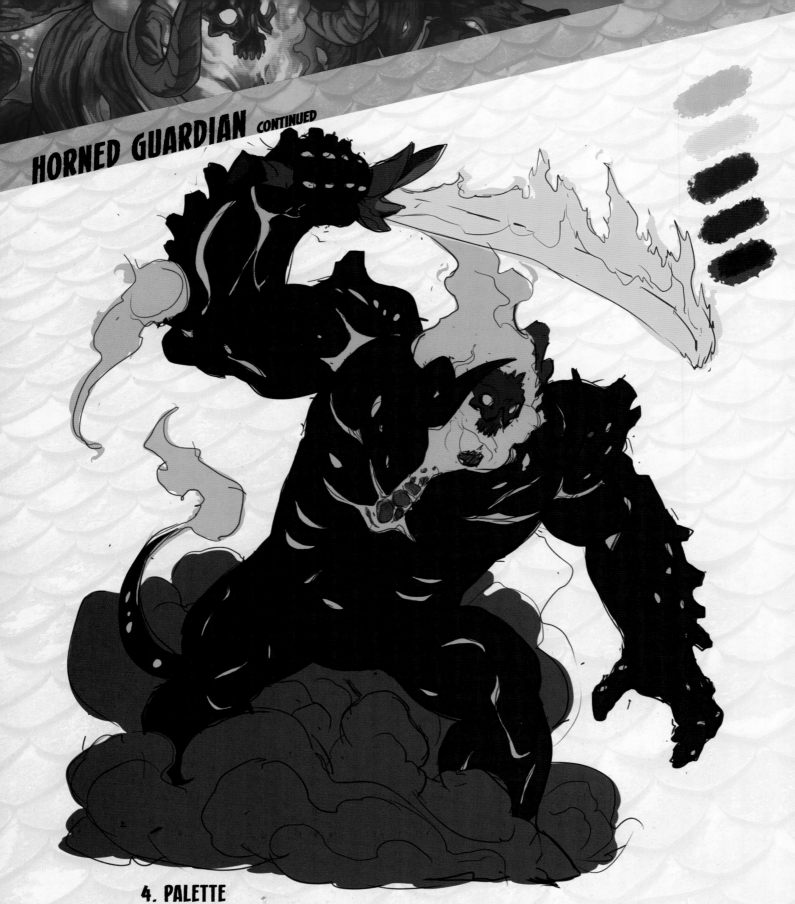

4. PALETTE

The same pose in flat hues reveals open cracks, where lava bubbles under the skin.
The sword is glowing with fire, and dark clouds of smoke surround the lower half of the
body as the monster's steps melt the ground beneath it.

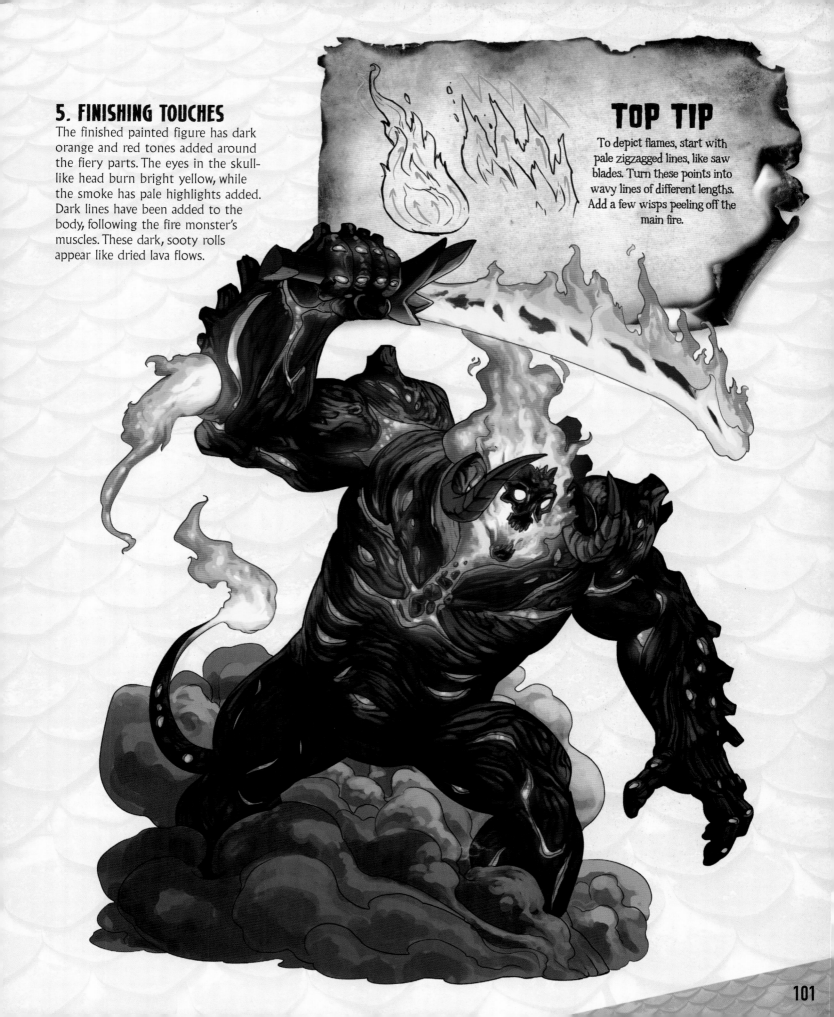

5. FINISHING TOUCHES

The finished painted figure has dark orange and red tones added around the fiery parts. The eyes in the skull-like head burn bright yellow, while the smoke has pale highlights added. Dark lines have been added to the body, following the fire monster's muscles. These dark, sooty rolls appear like dried lava flows.

TOP TIP

To depict flames, start with pale zigzagged lines, like saw blades. Turn these points into wavy lines of different lengths. Add a few wisps peeling off the main fire.

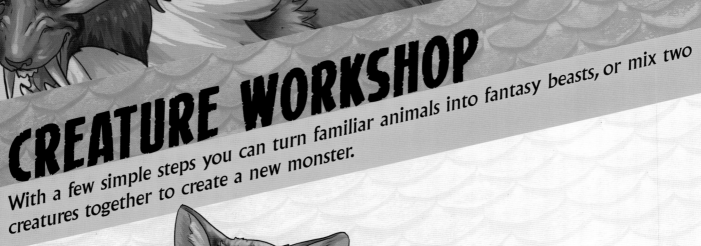

CREATURE WORKSHOP

With a few simple steps you can turn familiar animals into fantasy beasts, or mix two creatures together to create a new monster.

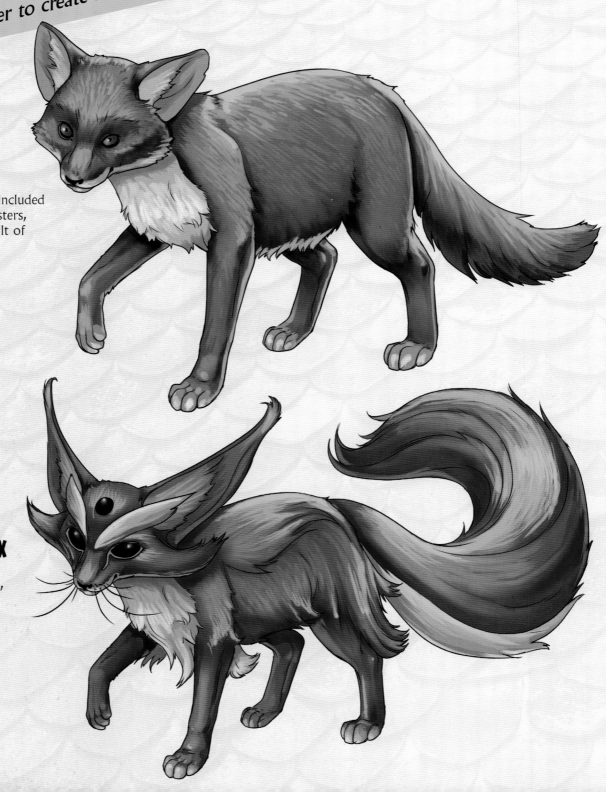

1. FAMILIAR FOX

Foxes have often been included in fantasy tales as tricksters, messengers, or the result of transformations.

2. FAIRY-TALE FOX

With long, flowing fur and three gem-like eyes, the cub is transformed into a magical beast.

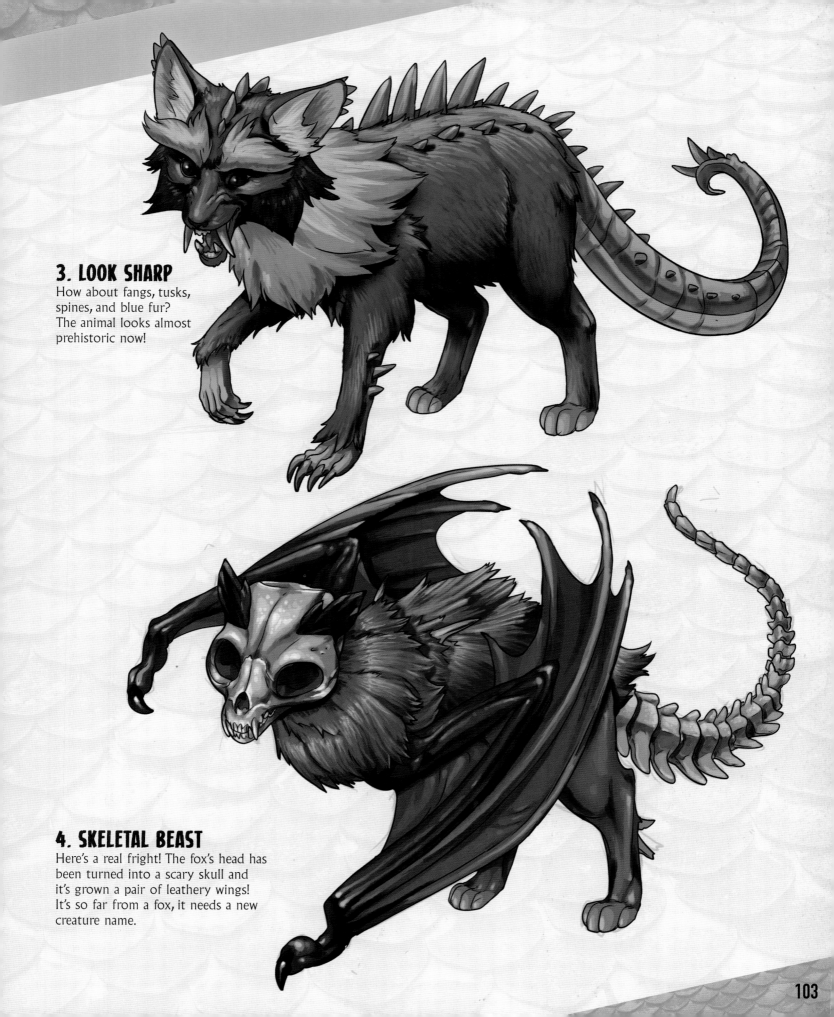

3. LOOK SHARP

How about fangs, tusks,
spines, and blue fur?
The animal looks almost
prehistoric now!

4. SKELETAL BEAST

Here's a real fright! The fox's head has
been turned into a scary skull and
it's grown a pair of leathery wings!
It's so far from a fox, it needs a new
creature name.

GRIFFIN

Another way to create a new fantasy creature is to bond one existing animal with another. The legendary griffin is half eagle, half lion. The eagle is said to be the king of birds, while the lion is the king of beasts, so the mythical griffin represents power.

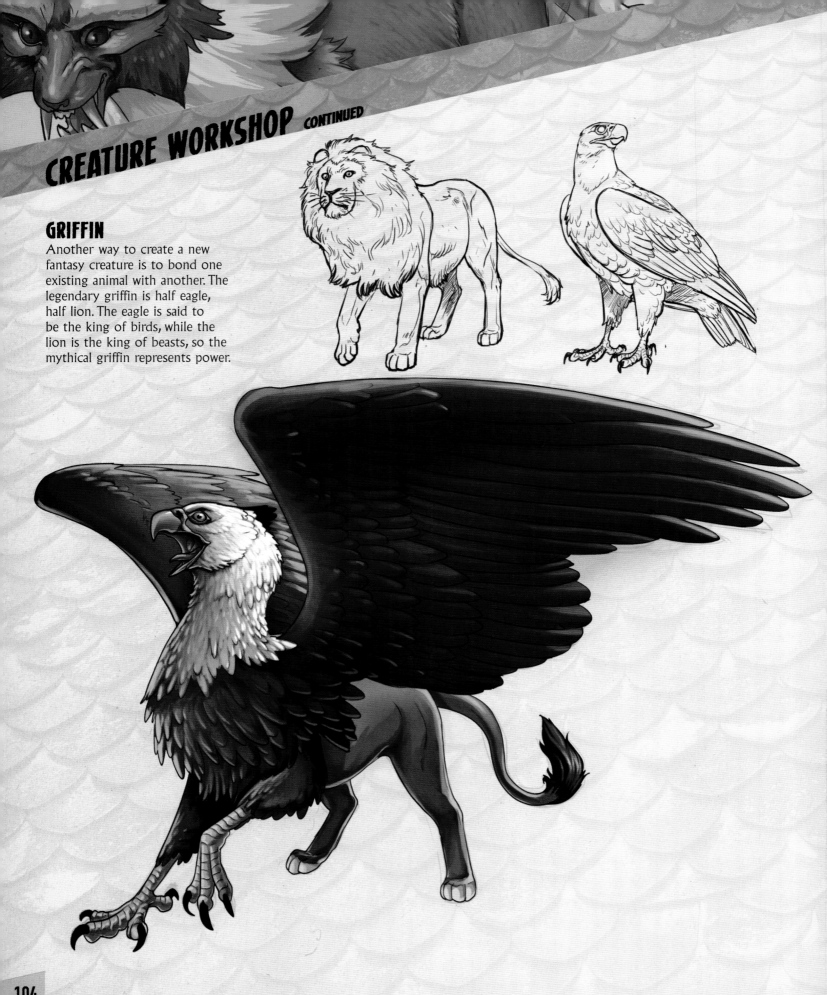

CHIMERA

You don't have to take just two animal halves to create a new beast—you can add extra parts! The mythic chimera is made of three creatures. A goat's head and neck grow from the back of a lion that also has a tail made of a snake.

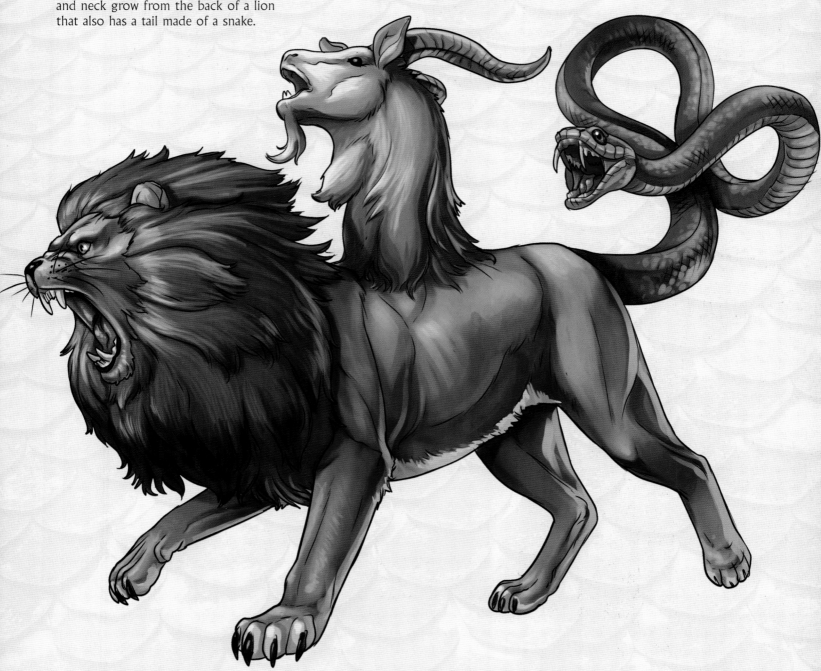

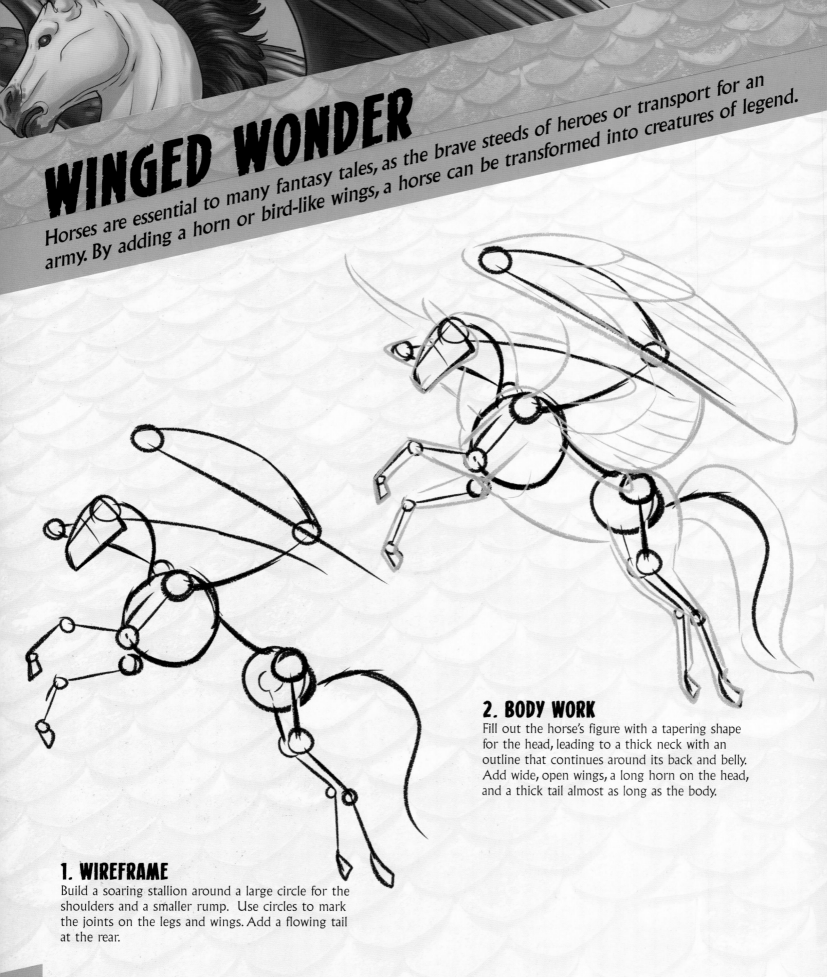

WINGED WONDER

Horses are essential to many fantasy tales, as the brave steeds of heroes or transport for an army. By adding a horn or bird-like wings, a horse can be transformed into creatures of legend.

2. BODY WORK

Fill out the horse's figure with a tapering shape for the head, leading to a thick neck with an outline that continues around its back and belly. Add wide, open wings, a long horn on the head, and a thick tail almost as long as the body.

1. WIREFRAME

Build a soaring stallion around a large circle for the shoulders and a smaller rump. Use circles to mark the joints on the legs and wings. Add a flowing tail at the rear.

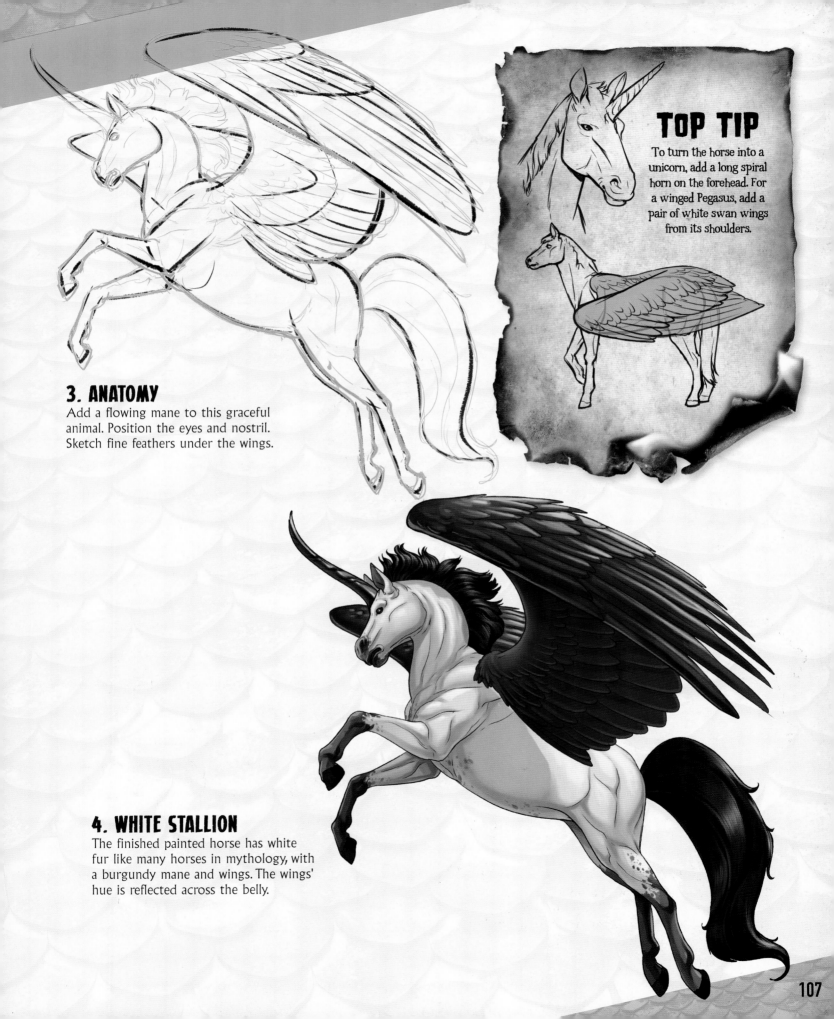

3. ANATOMY

Add a flowing mane to this graceful animal. Position the eyes and nostril. Sketch fine feathers under the wings.

TOP TIP

To turn the horse into a unicorn, add a long spiral horn on the forehead. For a winged Pegasus, add a pair of white swan wings from its shoulders.

4. WHITE STALLION

The finished painted horse has white fur like many horses in mythology, with a burgundy mane and wings. The wings' hue is reflected across the belly.

THE HYDRA RISES

Here's how to draw a mythic scene, with an ancient hero riding a flying horse into battle against the many-headed Hydra.

1. Roughly map out the scene in a small sketch. The hero on the flying horse should be close enough to the monster to reach it with his sword, but also at risk of being bitten.

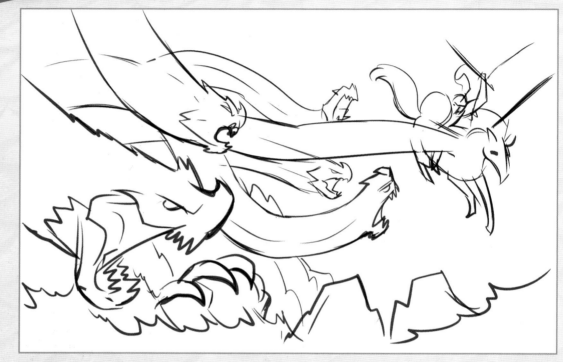

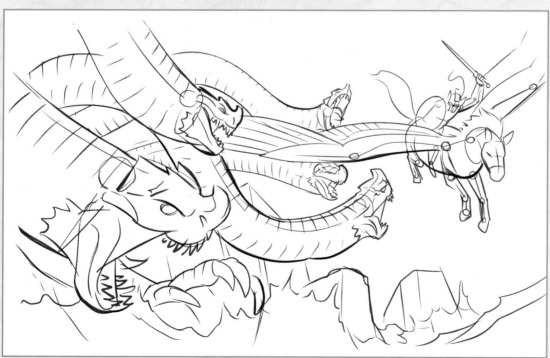

2. Carefully arrange the long necks and heads of the Hydra. The heads should reach toward the hero and horse from slightly different angles. The horse's wings are open wide, while the hero lifts his sword high.

3. The scene looks very dramatic in these more detailed pencils, with the Hydra stretching from darkness in the foreground toward the winged horse as it swoops from the clouds. Below them, waves crash against the rocks.

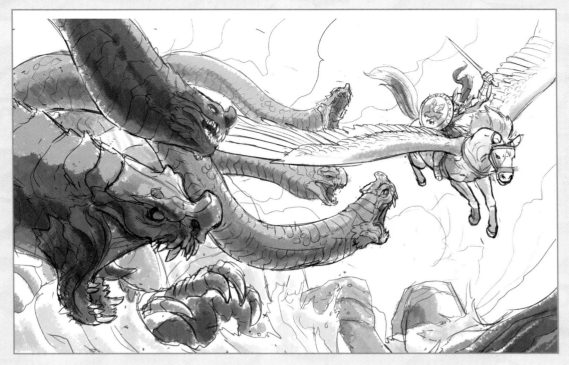

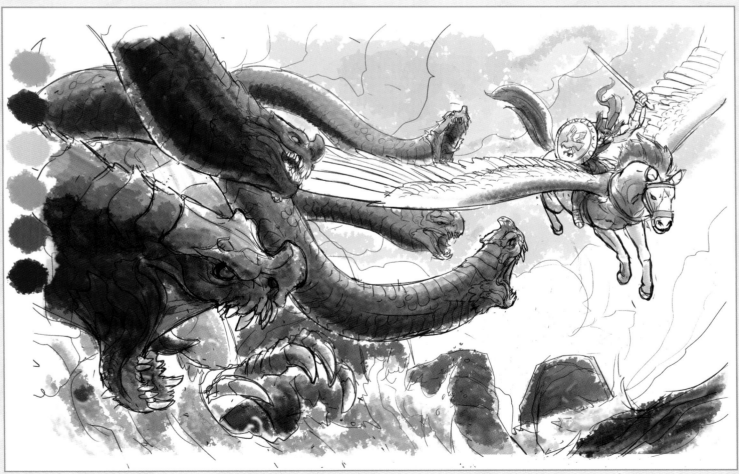

4. The chosen shades add to the menace of the Hydra with its reptilian green contrasting with a meaty red. The sky is a much paler blue than the violent sea.

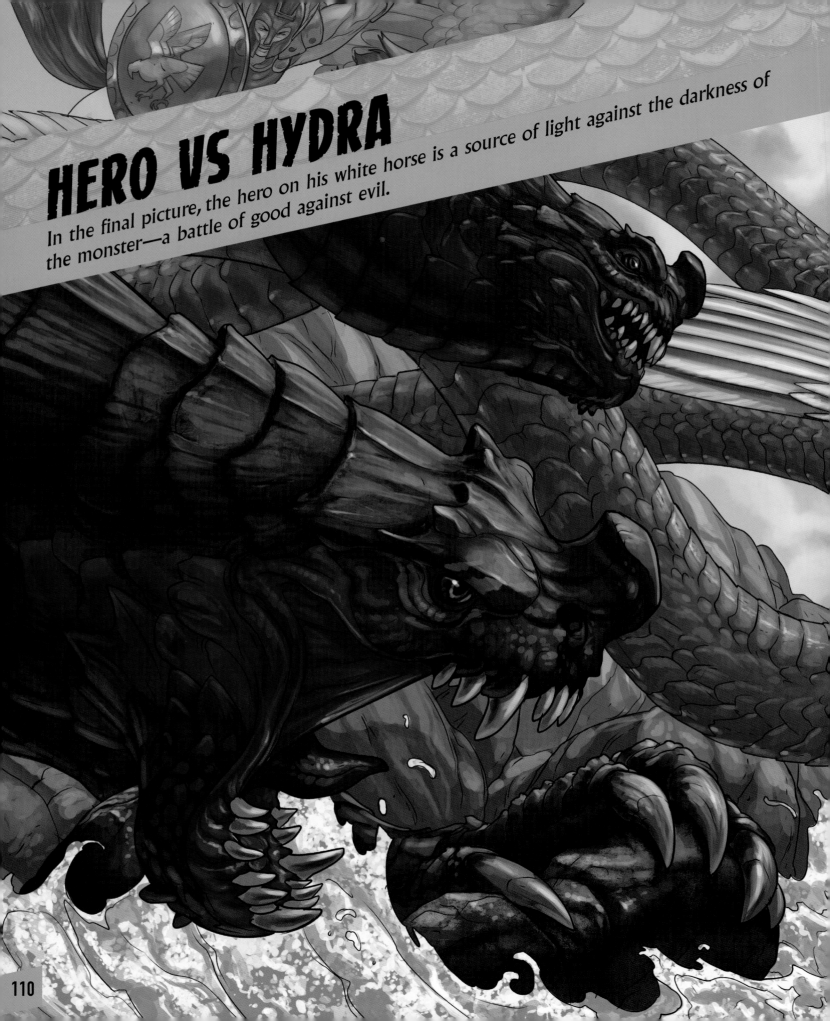

HERO VS HYDRA

In the final picture, the hero on his white horse is a source of light against the darkness of the monster—a battle of good against evil.

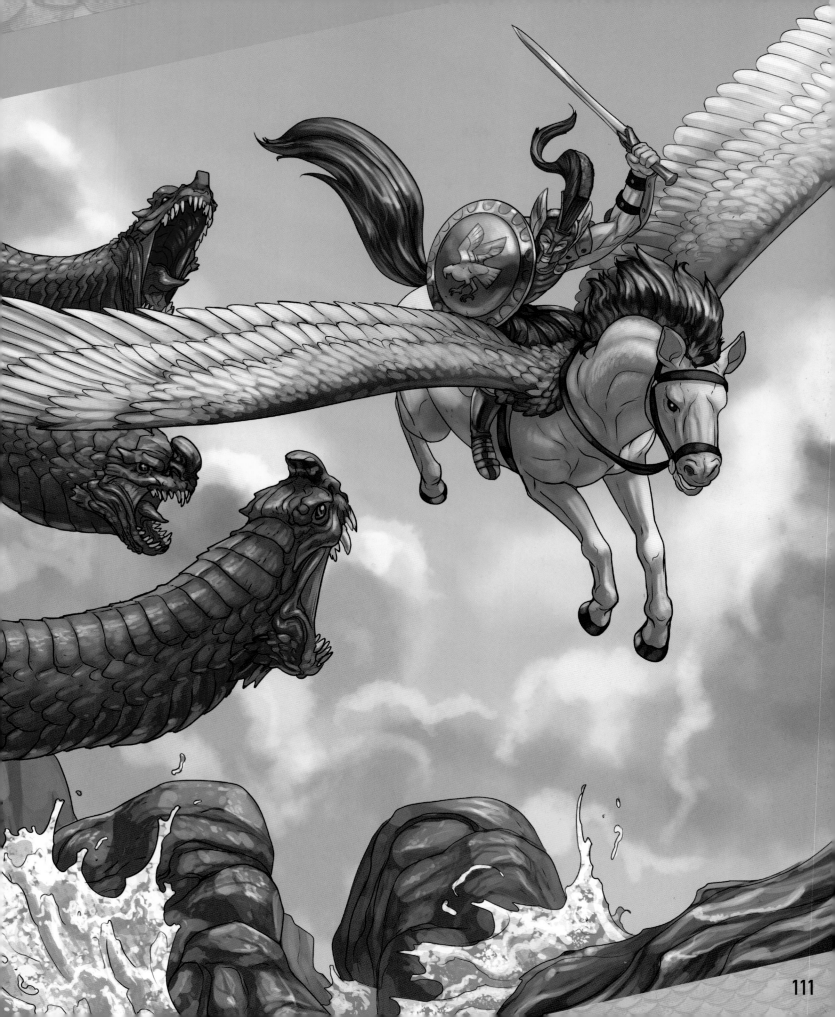

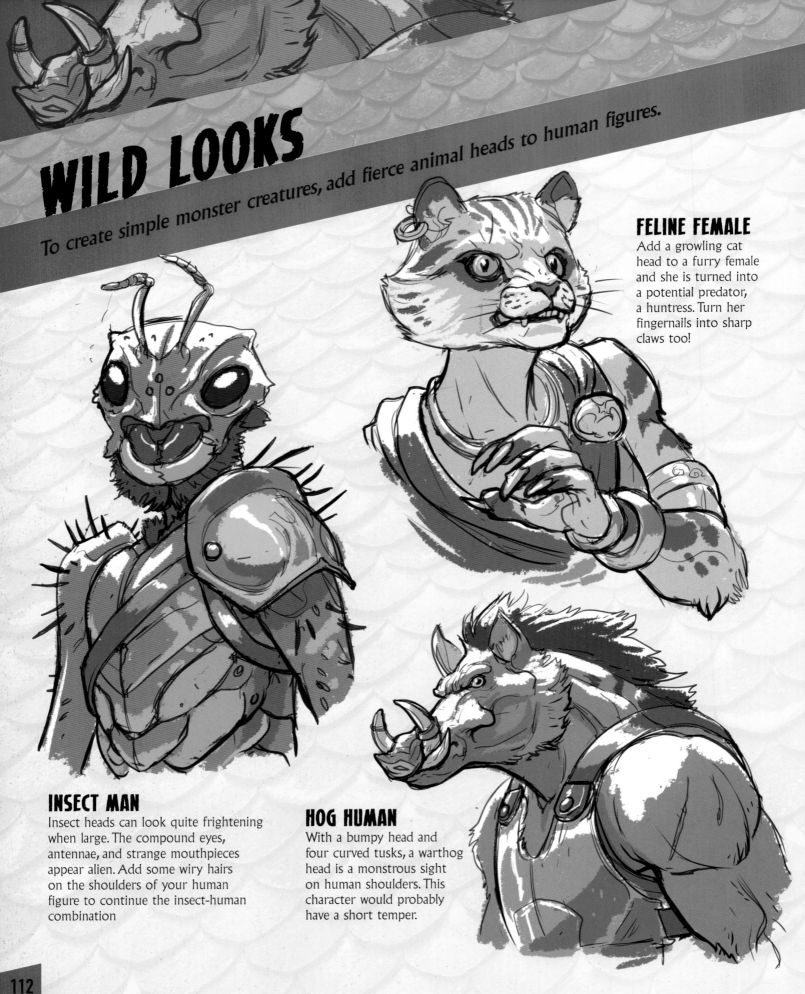

WILD LOOKS

To create simple monster creatures, add fierce animal heads to human figures.

FELINE FEMALE

Add a growling cat head to a furry female and she is turned into a potential predator, a huntress. Turn her fingernails into sharp claws too!

INSECT MAN

Insect heads can look quite frightening when large. The compound eyes, antennae, and strange mouthpieces appear alien. Add some wiry hairs on the shoulders of your human figure to continue the insect-human combination

HOG HUMAN

With a bumpy head and four curved tusks, a warthog head is a monstrous sight on human shoulders. This character would probably have a short temper.

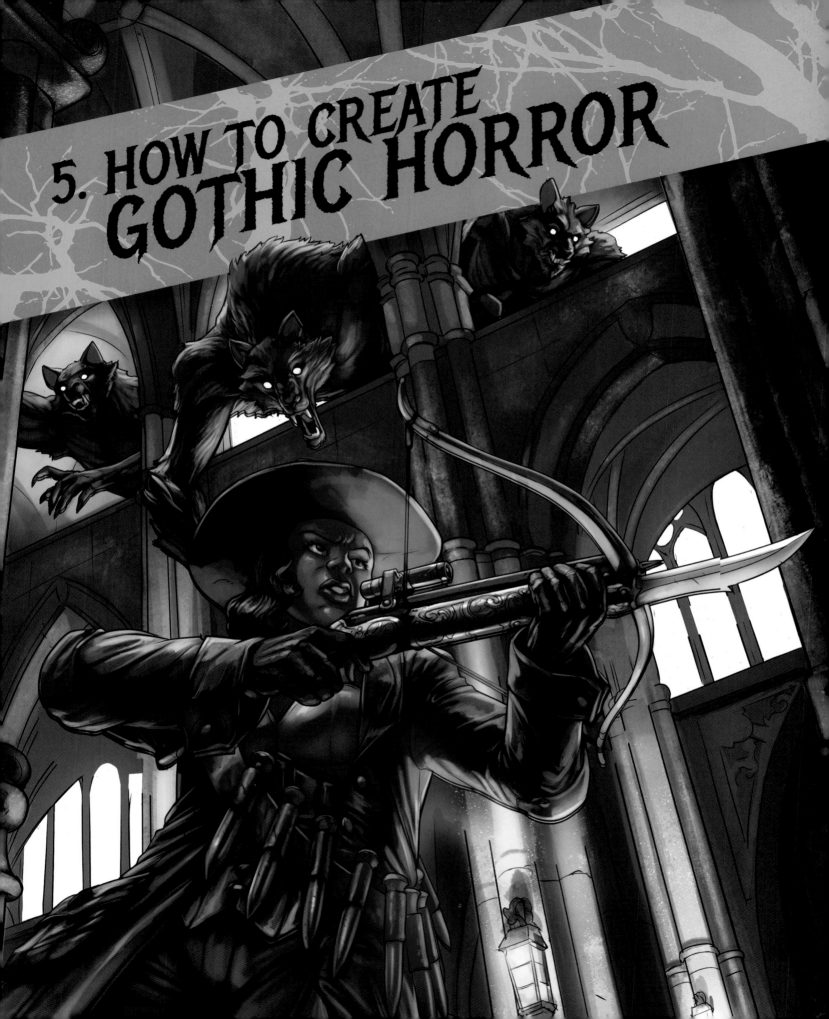

5. HOW TO CREATE GOTHIC HORROR

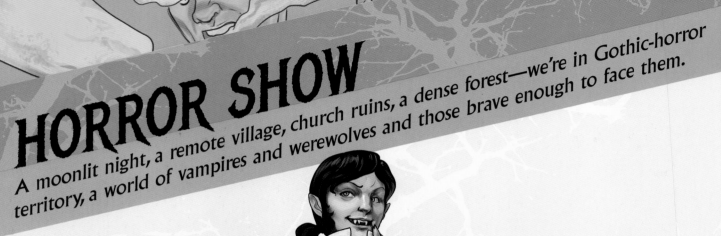

HORROR SHOW

A moonlit night, a remote village, church ruins, a dense forest—we're in Gothic-horror territory, a world of vampires and werewolves and those brave enough to face them.

HANDSOME VAMPIRE

Vampires appear in many guises. Will you design a ghoul or a charmer? This vampire may look young but he is hundreds of years old, kept youthful thanks to his vampire curse. He can only leave his secret lair after dark, search for his prey and drink their blood. His victims then share his curse, building into an army of vampires.

A SPLASH OF BLOOD

Unable to face the daylight, the vampire has pearly white skin. His hypnotic eyes are green and piercing—one look could entrap you. He carries a cane and wears clothes from another age. The vampire's smile reveals fangs, and the blood he wipes from his lips is a sign he has just feasted.

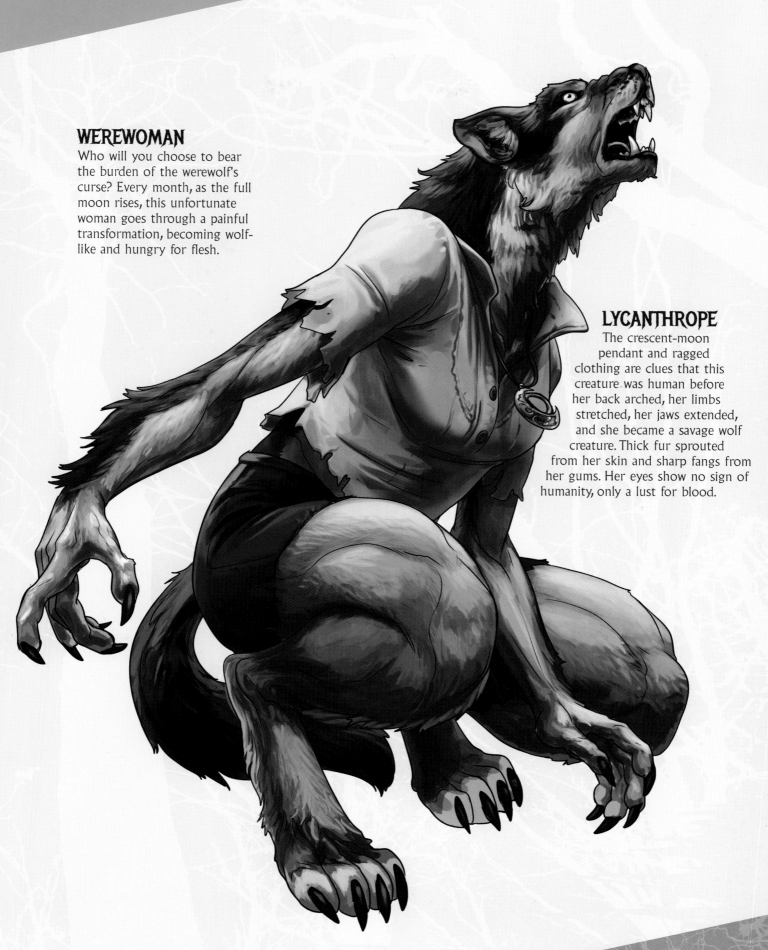

WEREWOMAN

Who will you choose to bear the burden of the werewolf's curse? Every month, as the full moon rises, this unfortunate woman goes through a painful transformation, becoming wolf-like and hungry for flesh.

LYCANTHROPE

The crescent-moon pendant and ragged clothing are clues that this creature was human before her back arched, her limbs stretched, her jaws extended, and she became a savage wolf creature. Thick fur sprouted from her skin and sharp fangs from her gums. Her eyes show no sign of humanity, only a lust for blood.

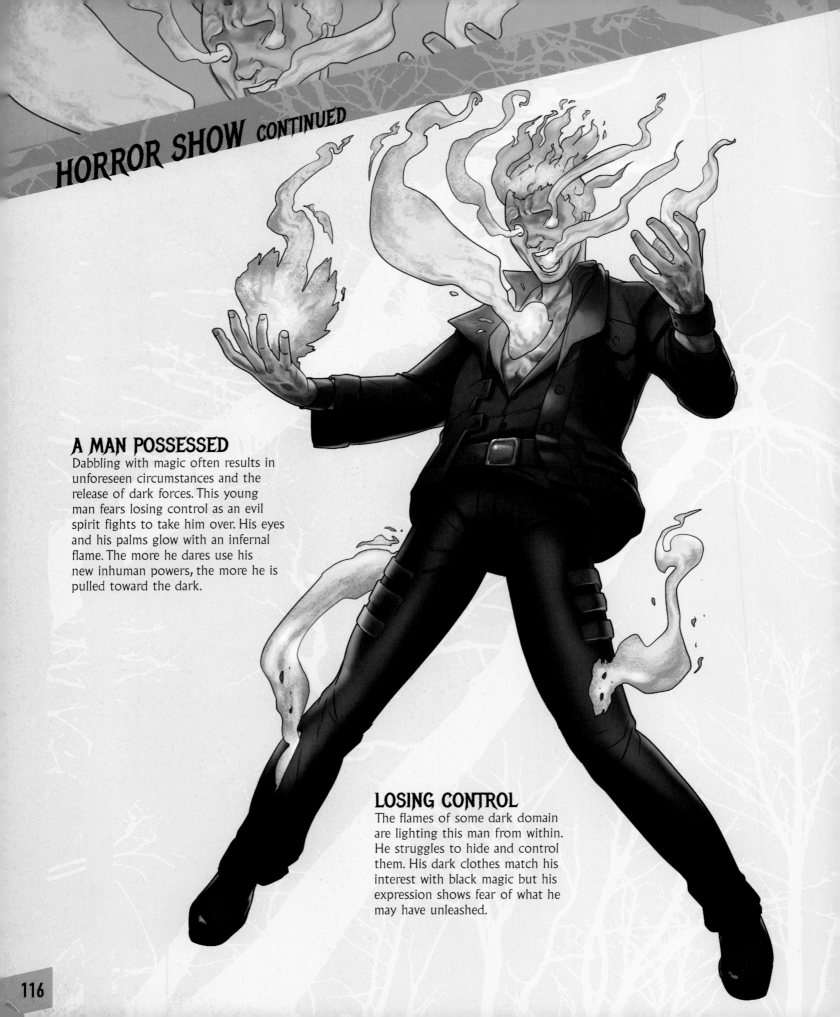

A MAN POSSESSED

Dabbling with magic often results in unforeseen circumstances and the release of dark forces. This young man fears losing control as an evil spirit fights to take him over. His eyes and his palms glow with an infernal flame. The more he dares use his new inhuman powers, the more he is pulled toward the dark.

LOSING CONTROL

The flames of some dark domain are lighting this man from within. He struggles to hide and control them. His dark clothes match his interest with black magic but his expression shows fear of what he may have unleashed.

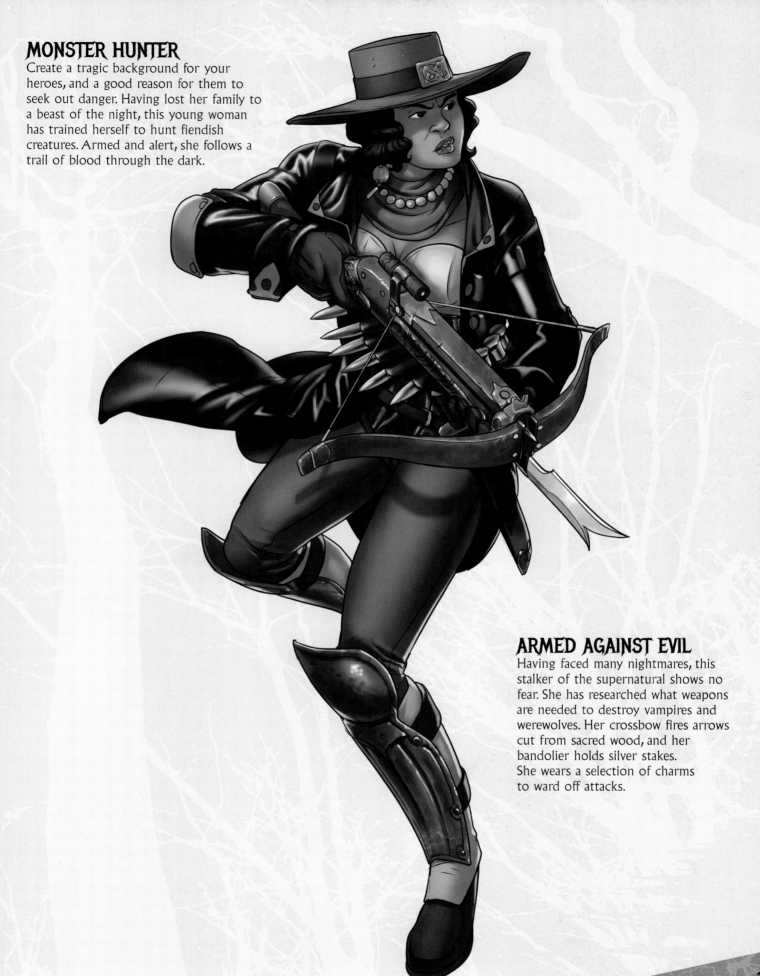

MONSTER HUNTER
Create a tragic background for your heroes, and a good reason for them to seek out danger. Having lost her family to a beast of the night, this young woman has trained herself to hunt fiendish creatures. Armed and alert, she follows a trail of blood through the dark.

ARMED AGAINST EVIL
Having faced many nightmares, this stalker of the supernatural shows no fear. She has researched what weapons are needed to destroy vampires and werewolves. Her crossbow fires arrows cut from sacred wood, and her bandolier holds silver stakes. She wears a selection of charms to ward off attacks.

ENCHANTRESS

Behold the mistress of dark magic! Dressed in raven feathers, she communicates with the undead through their bones and makes fools of the living. Here's how to bring her to life.

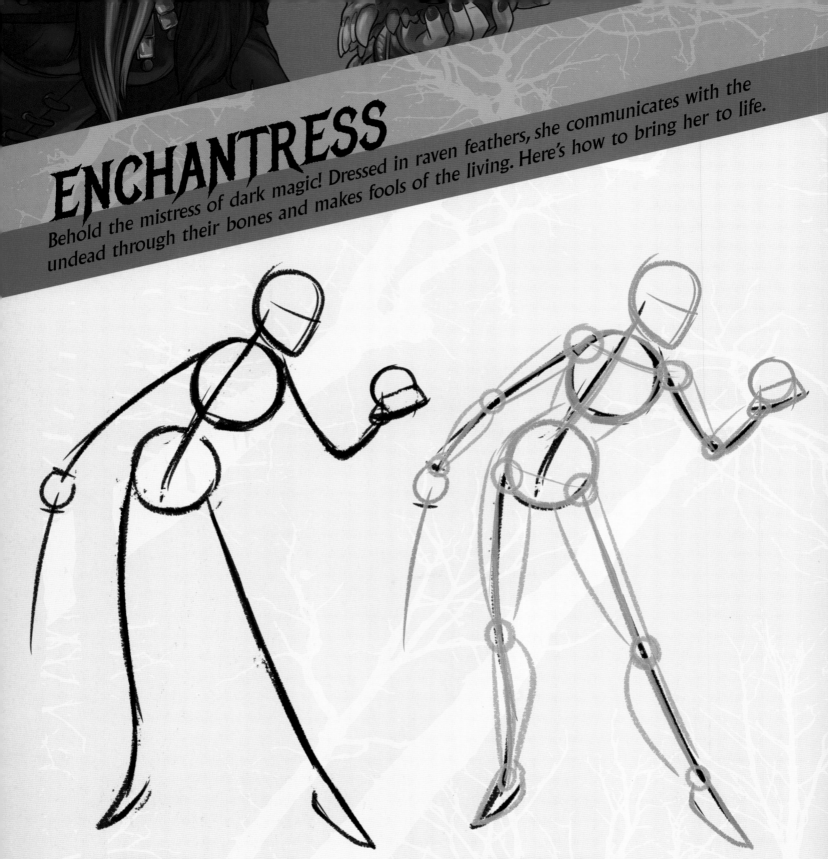

I. WIREFRAME
Using light pencil marks, draw a few simple lines to mark the position of the Gothic witch as she leans forward to talk to the skull in her left hand. A line indicates a curved blade in her right hand.

2. JOINTED FIGURE
Now, fill out her figure, with basic 3-D shapes. She has a carefully balanced, slim body. Draw circles to position her joints.

TOP TIP

Here are skulls you can add to your Gothic fantasy scenes. One is human, with a section cut away. The second belongs to a horse. The third is a mix of human and monster, with horns and tusks. These could be ornaments or vessels for communicating with the dead.

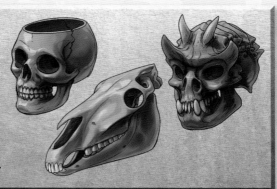

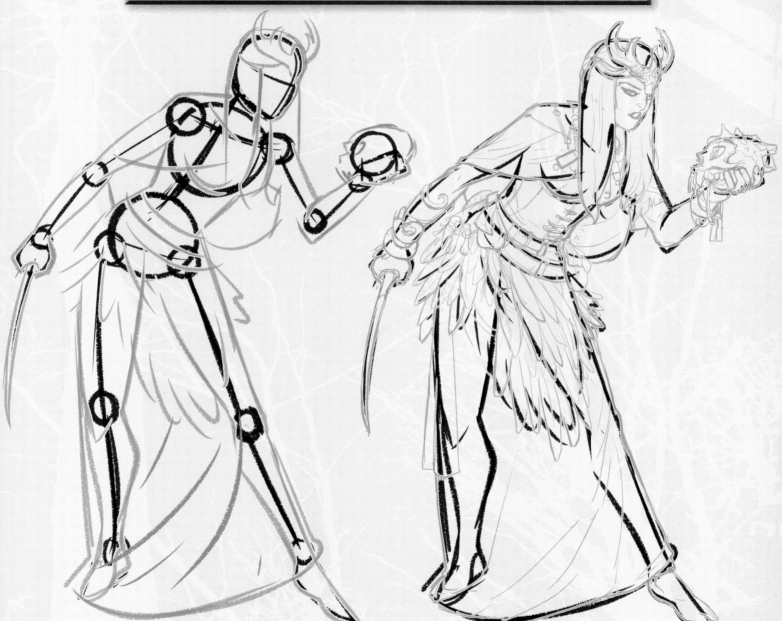

3. ANATOMY

Now sketch the witch's hair and headdress. Outline the gown over her lower body, with major folds and the beginnings of her skirt of raven feathers.

4. FINISHED PENCILS

Add her facial features, snake wristbands, and detail to her clothes and crown. The skull has a bony crest and fangs. It could not belong to a human.

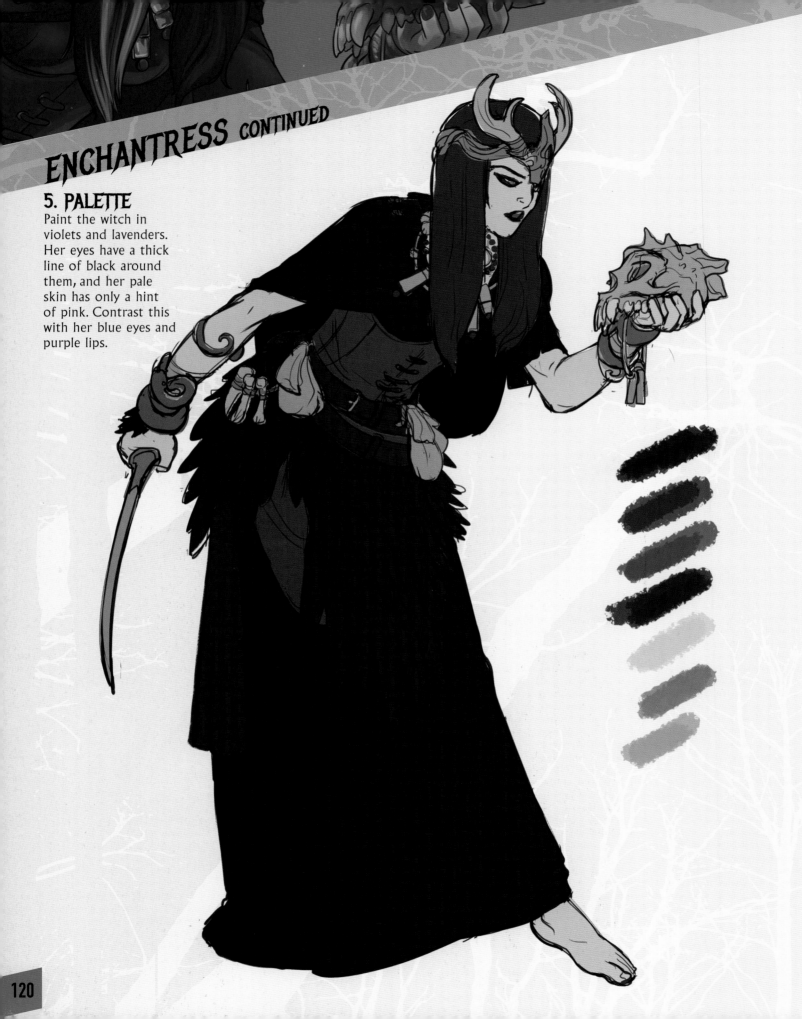

5. PALETTE

Paint the witch in violets and lavenders. Her eyes have a thick line of black around them, and her pale skin has only a hint of pink. Contrast this with her blue eyes and purple lips.

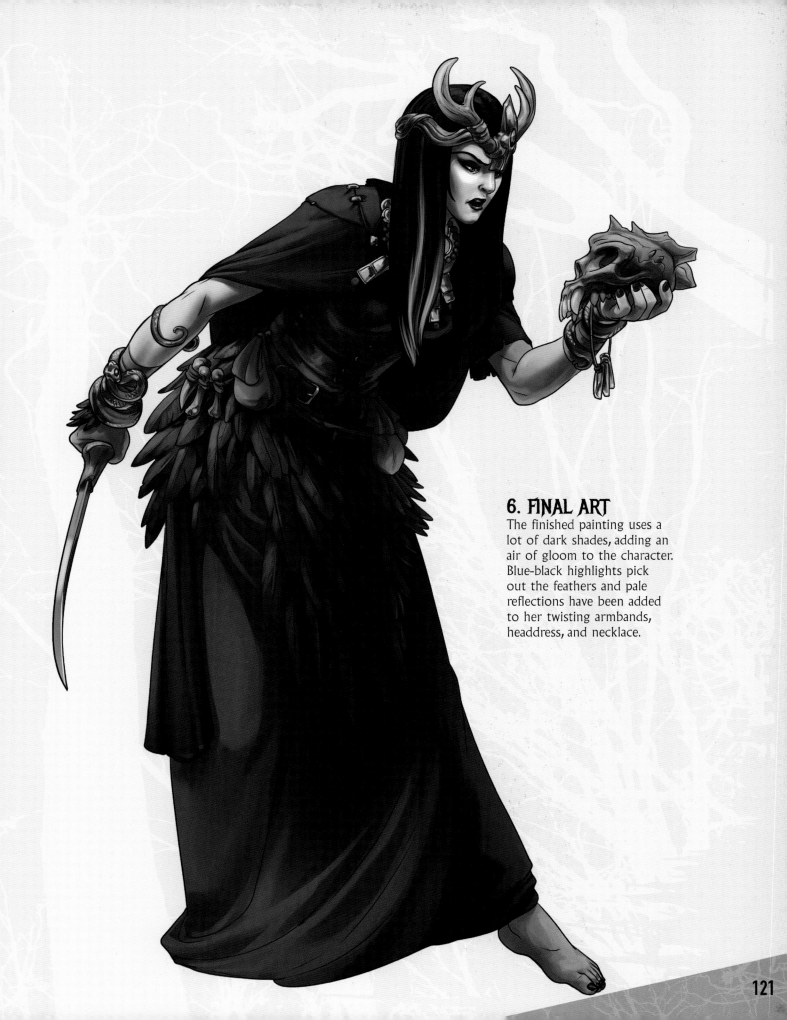

6. FINAL ART

The finished painting uses a lot of dark shades, adding an air of gloom to the character. Blue-black highlights pick out the feathers and pale reflections have been added to her twisting armbands, headdress, and necklace.

LORD OF THE VAMPIRES

Ruling a nation of bloodsuckers, the lord of the vampires sits on his throne waiting to receive his generals and plan domination of the night.

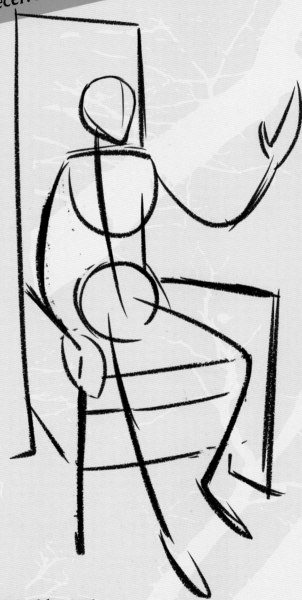

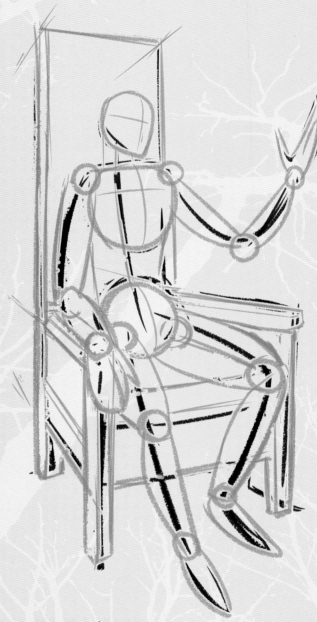

I. WIREFRAME

Using a few simple lines, mark the seated position of the vampire lord, waving his left hand to greet guests. You may need to use perspective lines to work out the angle of his great throne: the chair's arms are positioned at different angles because of perspective.

2. JOINTED FIGURE

Build up his figure and tall chair, with 3-D shapes. Use circles to mark the position of his shoulder, arm, and leg joints.

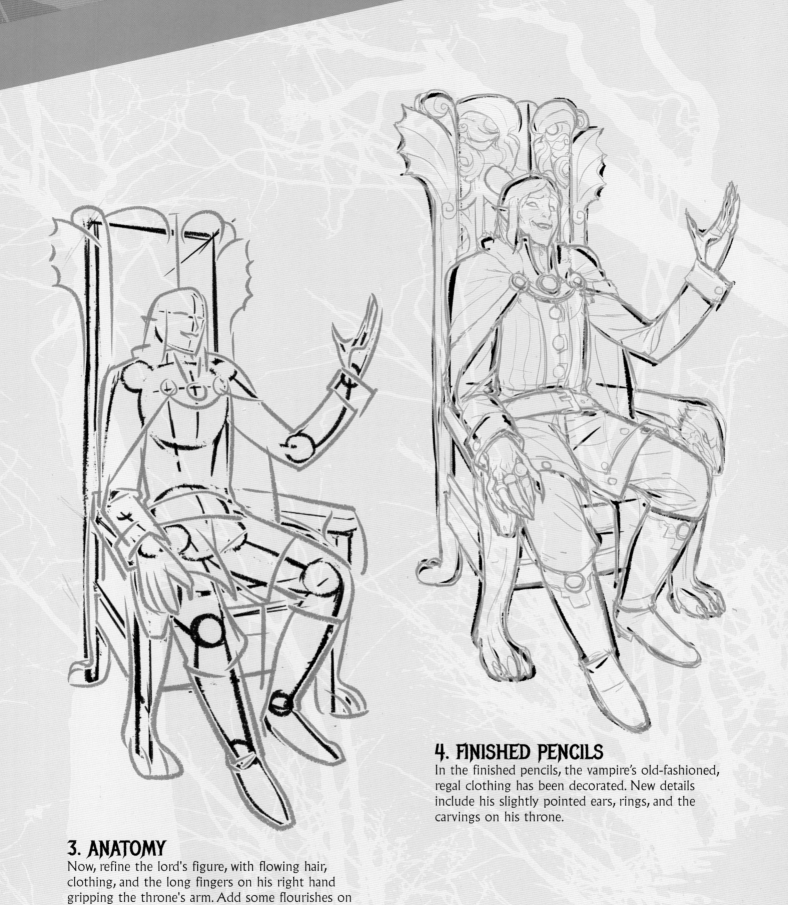

4. FINISHED PENCILS
In the finished pencils, the vampire's old-fashioned, regal clothing has been decorated. New details include his slightly pointed ears, rings, and the carvings on his throne.

3. ANATOMY
Now, refine the lord's figure, with flowing hair, clothing, and the long fingers on his right hand gripping the throne's arm. Add some flourishes on the top and the legs of the grand chair.

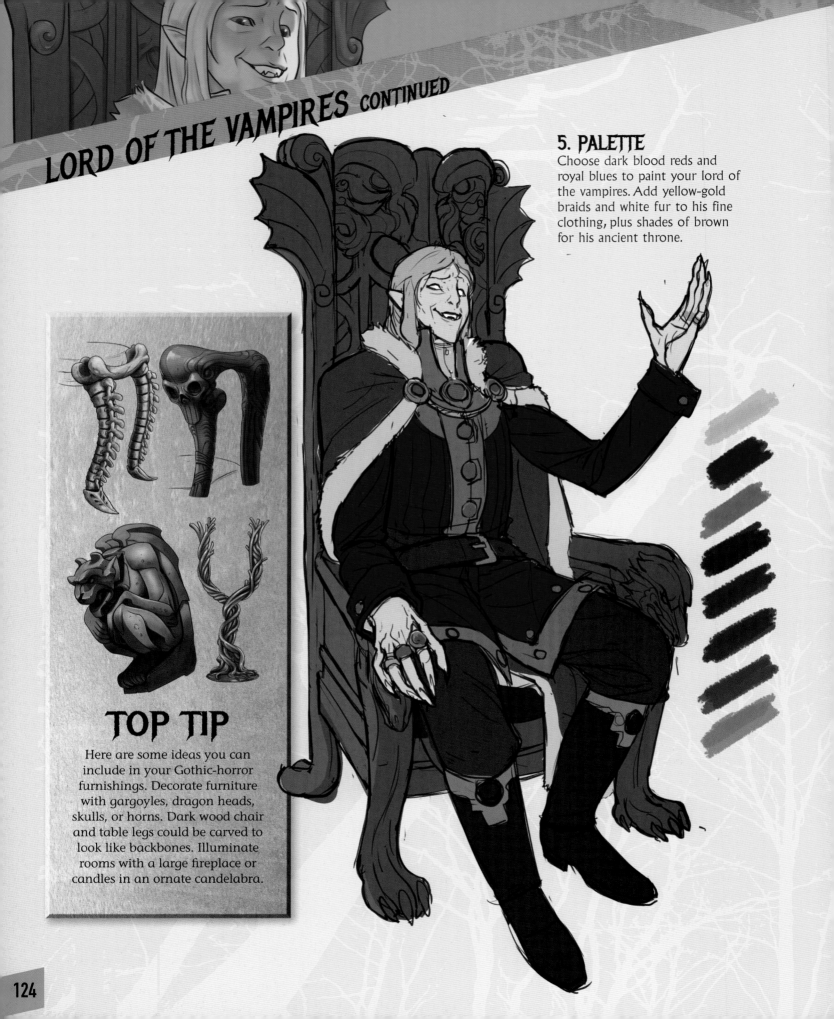

5. PALETTE

Choose dark blood reds and royal blues to paint your lord of the vampires. Add yellow-gold braids and white fur to his fine clothing, plus shades of brown for his ancient throne.

TOP TIP

Here are some ideas you can include in your Gothic-horror furnishings. Decorate furniture with gargoyles, dragon heads, skulls, or horns. Dark wood chair and table legs could be carved to look like backbones. Illuminate rooms with a large fireplace or candles in an ornate candelabra.

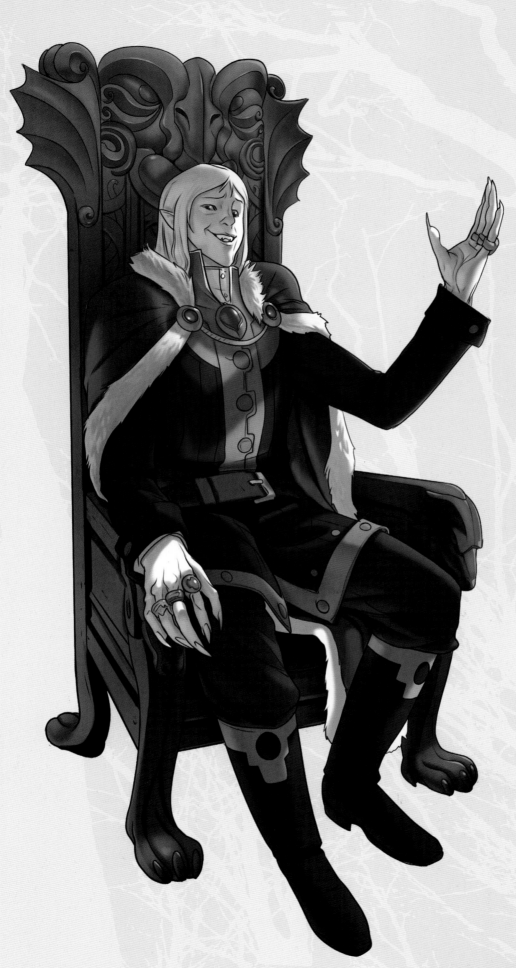

6. FINAL ART

In the finished painting, the lord looks at his finest, in rich velvets and fur trims. His skin is deathly white, lit by a cold blue and pink light. The blood red in the lord's eyes, his pointed ears, and the hint of fangs remind you he is a vampire.

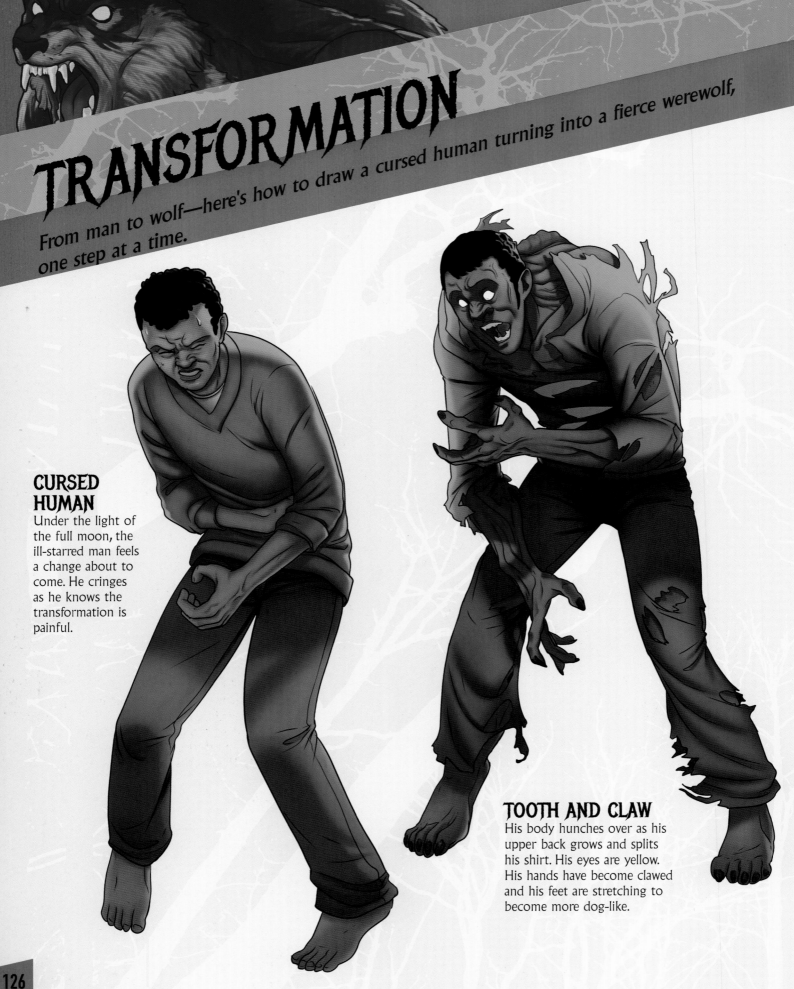

TRANSFORMATION

From man to wolf—here's how to draw a cursed human turning into a fierce werewolf, one step at a time.

CURSED HUMAN

Under the light of the full moon, the ill-starred man feels a change about to come. He cringes as he knows the transformation is painful.

TOOTH AND CLAW

His body hunches over as his upper back grows and splits his shirt. His eyes are yellow. His hands have become clawed and his feet are stretching to become more dog-like.

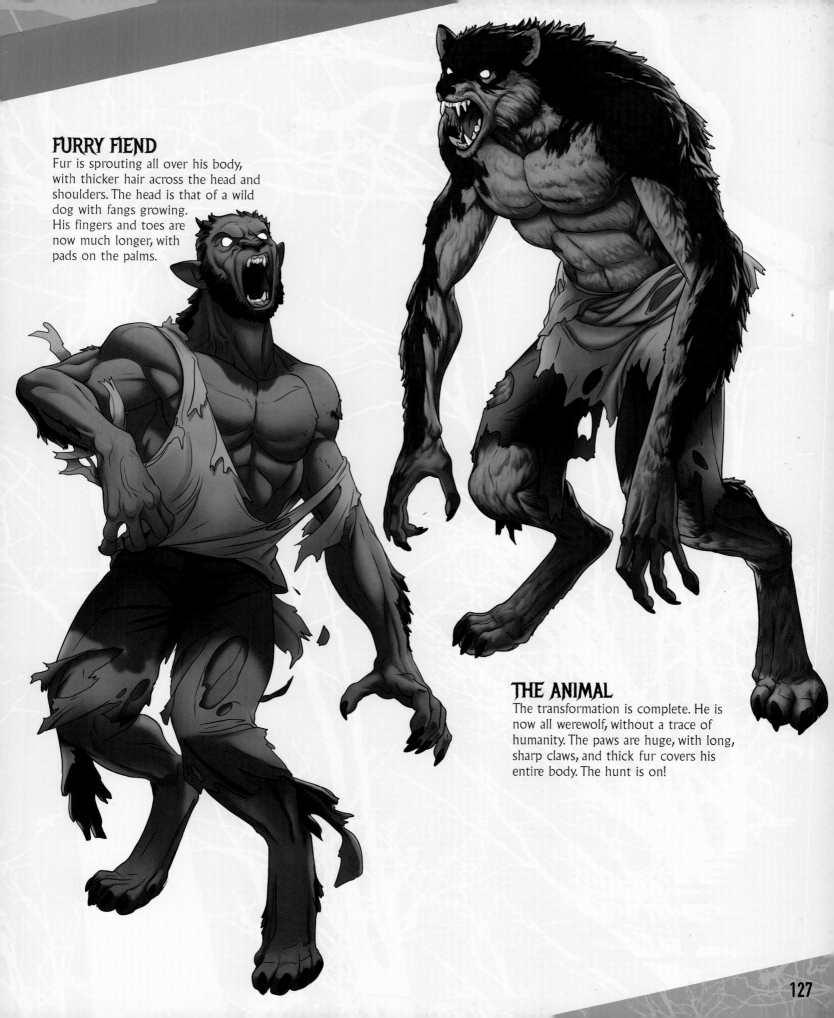

FURRY FIEND

Fur is sprouting all over his body, with thicker hair across the head and shoulders. The head is that of a wild dog with fangs growing. His fingers and toes are now much longer, with pads on the palms.

THE ANIMAL

The transformation is complete. He is now all werewolf, without a trace of humanity. The paws are huge, with long, sharp claws, and thick fur covers his entire body. The hunt is on!

ANIMAL FAMILIARS

Many horror characters are part animal or communicate with wild creatures. Here are some familiars you could use to mingle with your fantasy folk.

RAVEN

The Norse god Odin had a pair of ravens act as his eyes on the world, so you could use this bird as a messenger or a spy. But this clever bird is also said to bring ill fortune or even death. Its dark feathers are glossy, its eyes bright and inquisitive.

TOAD

The toad has been included as an ingredient in witch's brews more than a companion, and many cruel spells have transformed heroes into this warty creature. The toad has a wide mouth, raised eyes, a rounded body and hind legs with two joints.

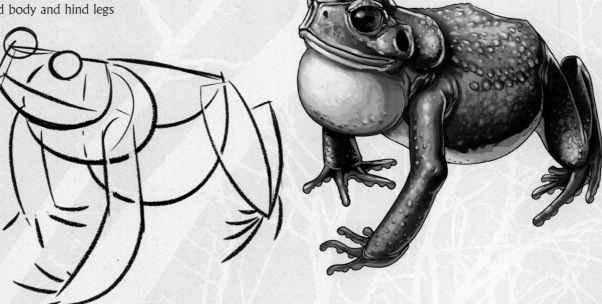

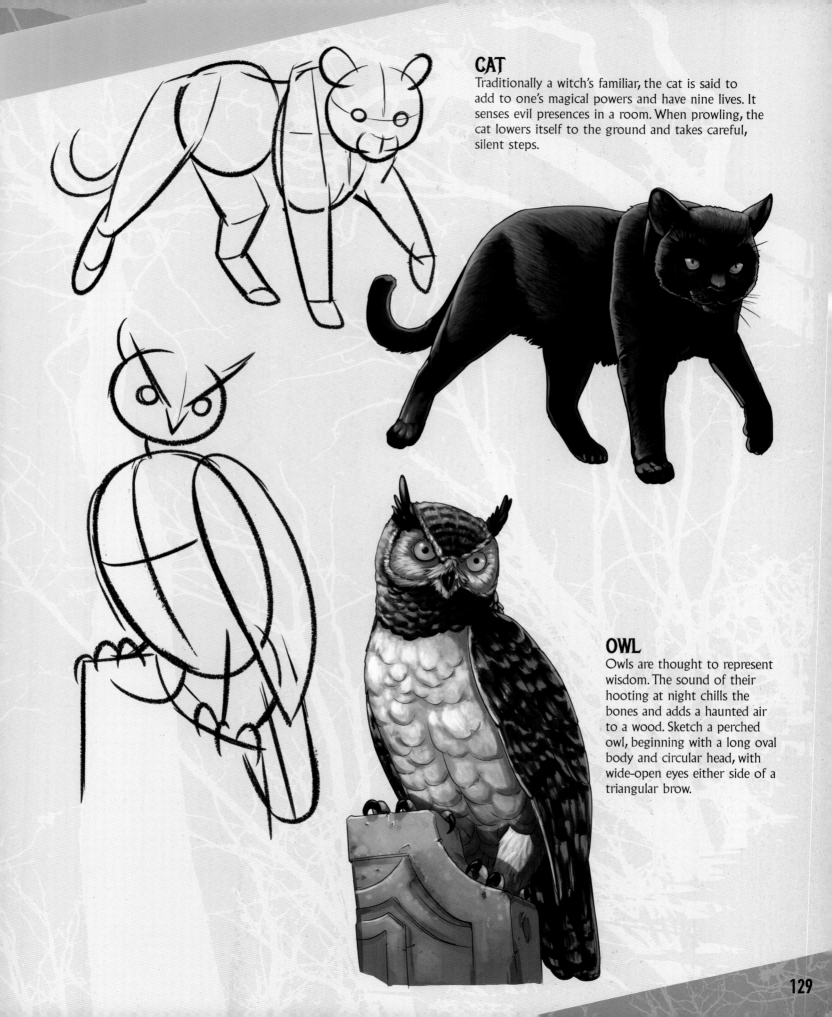

CAT

Traditionally a witch's familiar, the cat is said to add to one's magical powers and have nine lives. It senses evil presences in a room. When prowling, the cat lowers itself to the ground and takes careful, silent steps.

OWL

Owls are thought to represent wisdom. The sound of their hooting at night chills the bones and adds a haunted air to a wood. Sketch a perched owl, beginning with a long oval body and circular head, with wide-open eyes either side of a triangular brow.

THE UNDEAD RISE

The cemetery is haunted! Our protagonists—a vampire and an enchantress—are being surrounded by the spirits of the dead. Follow the steps to draw the spine-chilling scene.

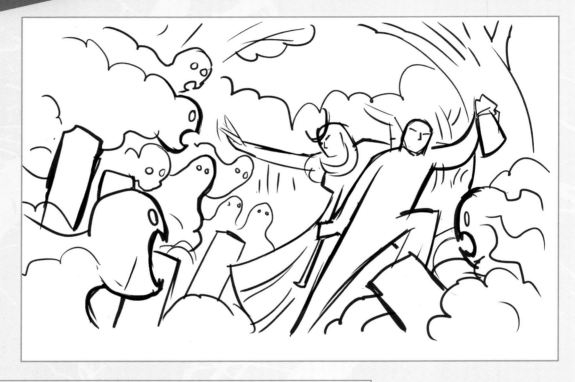

1. Roughly sketch the scene in miniature, with the two figures encircled by spirits rising from the gravestones, and the arch of an ancient tree above.

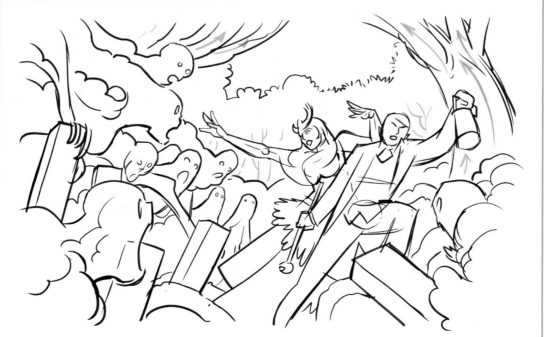

2. Now, start on the full-size drawing, building the two main figures reaching to the left and right. The cloudy spirits only have their upper halves. The gravestones are at different angles, as they have toppled over with age.

3. In these finished pencils, areas of different shading are indicated. The vampire and enchantress stand at dramatic angles in front of a dark background, trying to hold back the rising spirits with spells and lantern light. The spirits have their own unearthly light.

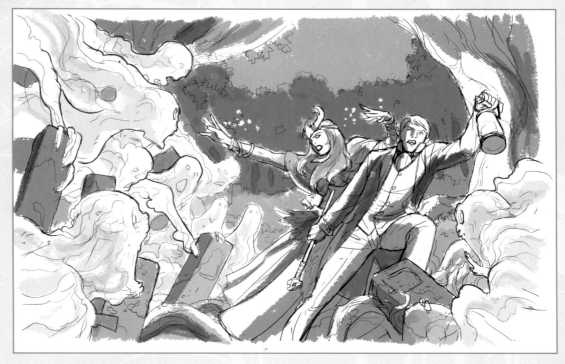

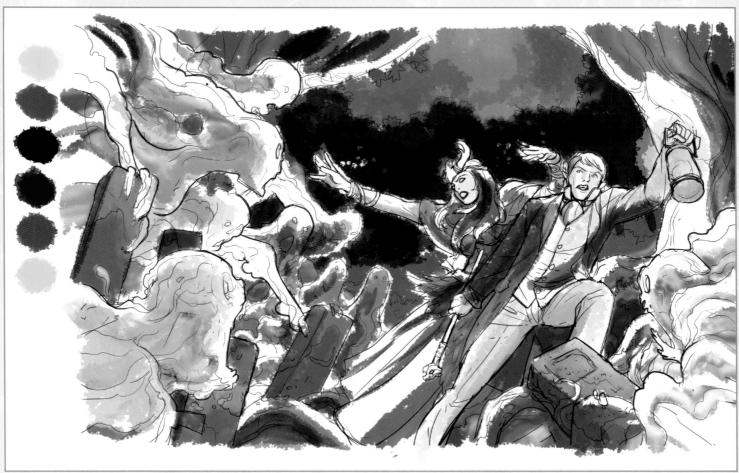

4. The scene is lit by moonlight, so most of the scene is painted with cool, bluish hues. The lantern light is yellow and illuminates the young vampire, bringing out the red of his waistcoat.

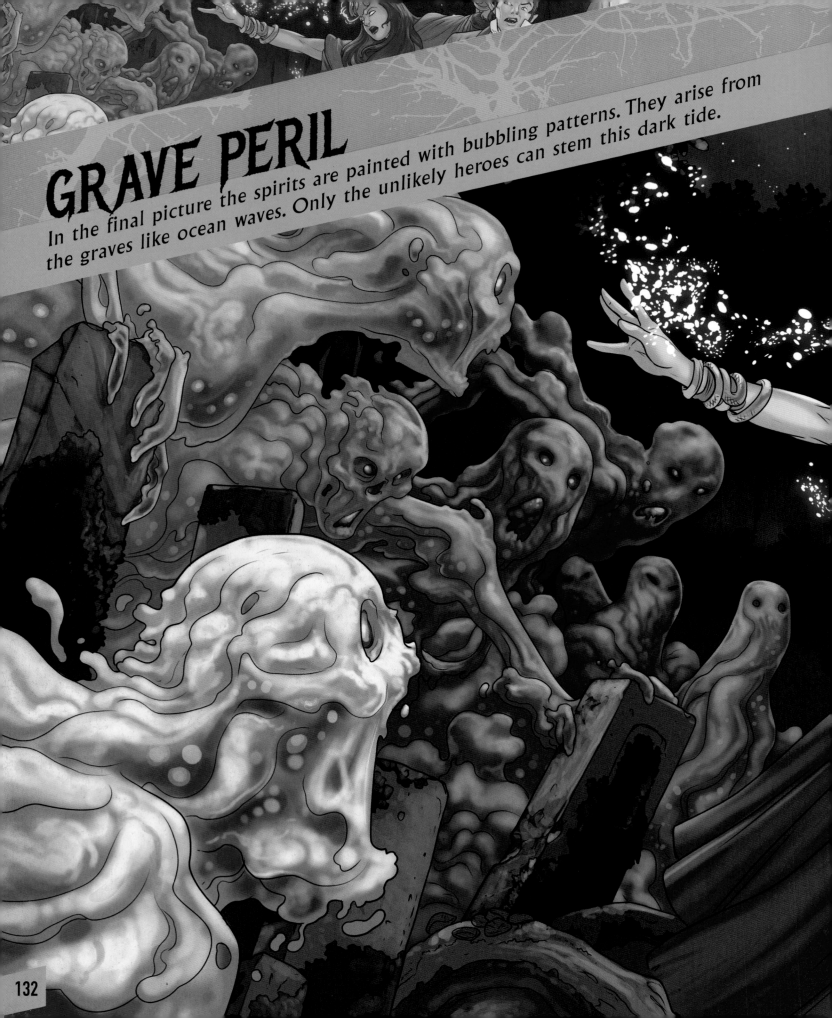

GRAVE PERIL

In the final picture the spirits are painted with bubbling patterns. They arise from the graves like ocean waves. Only the unlikely heroes can stem this dark tide.

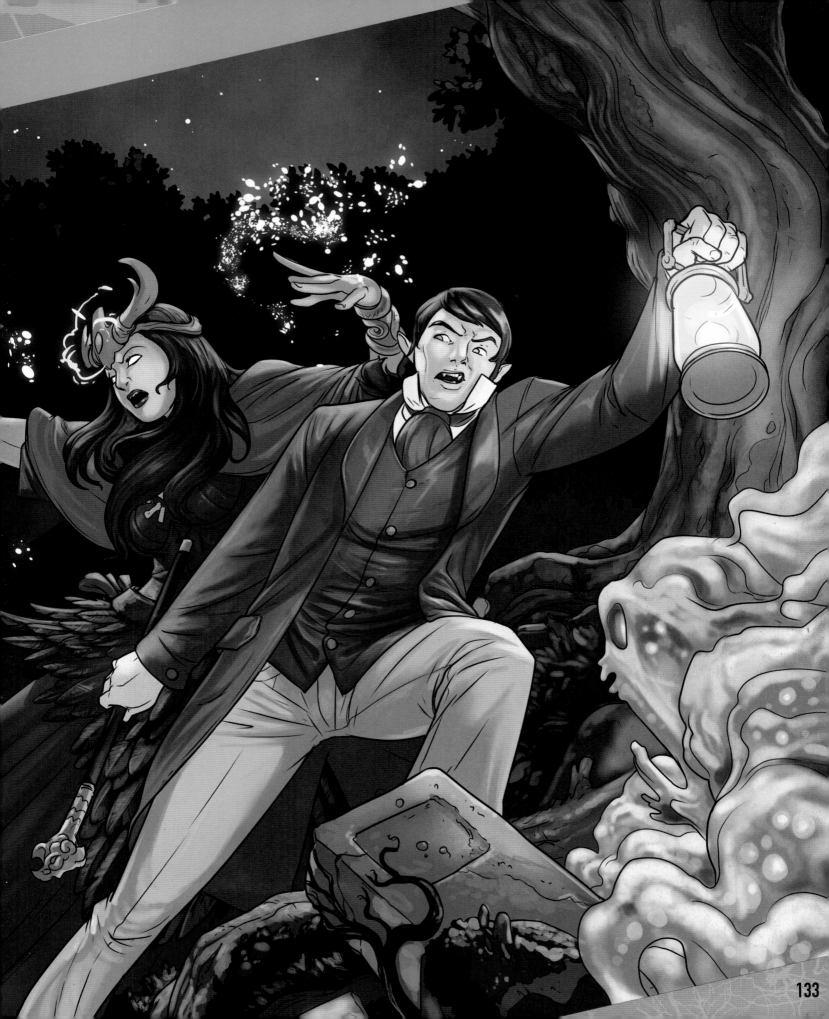

UNDER THE MOONLIGHT

Make your horror scenes appear extra chilling by giving them dramatic lighting.

With a full moon lighting the gravestone from above, and to the side, the figure of the angel is mostly in shadow, with bright highlights where the moonlight hits its form. The slow-moving shadows almost bring the mourning angel to life.

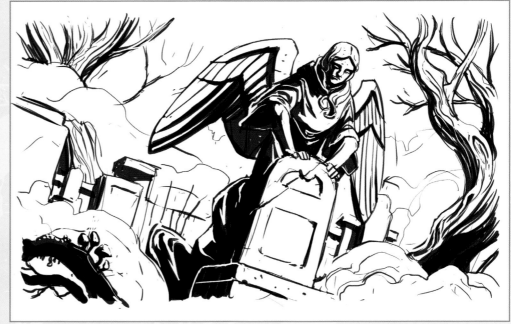

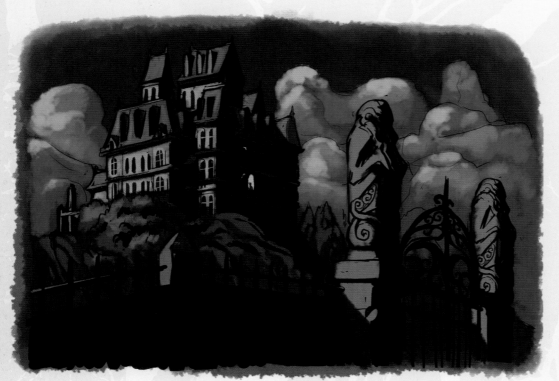

The reflected light from the moon casts a silvery blue shade over the ancient mansion. Reds turn to purple shades and greens turn turquoise. One orange light in the building suggests a room is occupied. But, by whom?!

6. HOW TO CREATE URBAN FANTASY

UNDERGROUND MAGIC

Mystics and magical beings exist in our midst. They hide their presence with cunning spells, while waging a war between light and dark. Who might you conjure up?

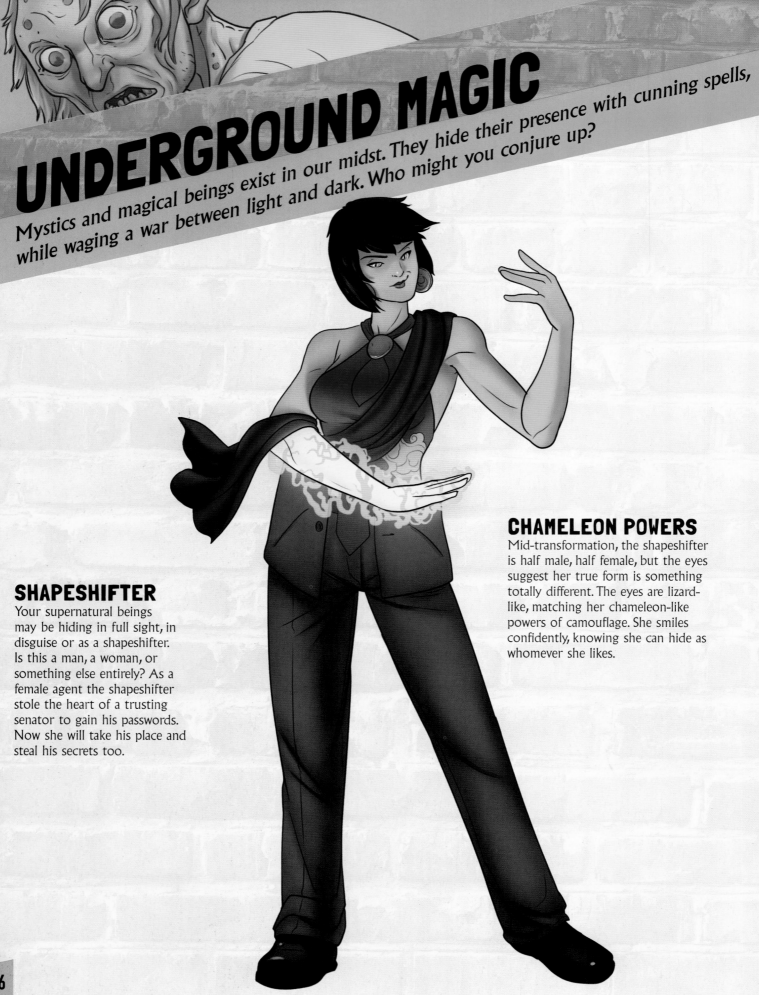

SHAPESHIFTER

Your supernatural beings may be hiding in full sight, in disguise or as a shapeshifter. Is this a man, a woman, or something else entirely? As a female agent the shapeshifter stole the heart of a trusting senator to gain his passwords. Now she will take his place and steal his secrets too.

CHAMELEON POWERS

Mid-transformation, the shapeshifter is half male, half female, but the eyes suggest her true form is something totally different. The eyes are lizard-like, matching her chameleon-like powers of camouflage. She smiles confidently, knowing she can hide as whomever she likes.

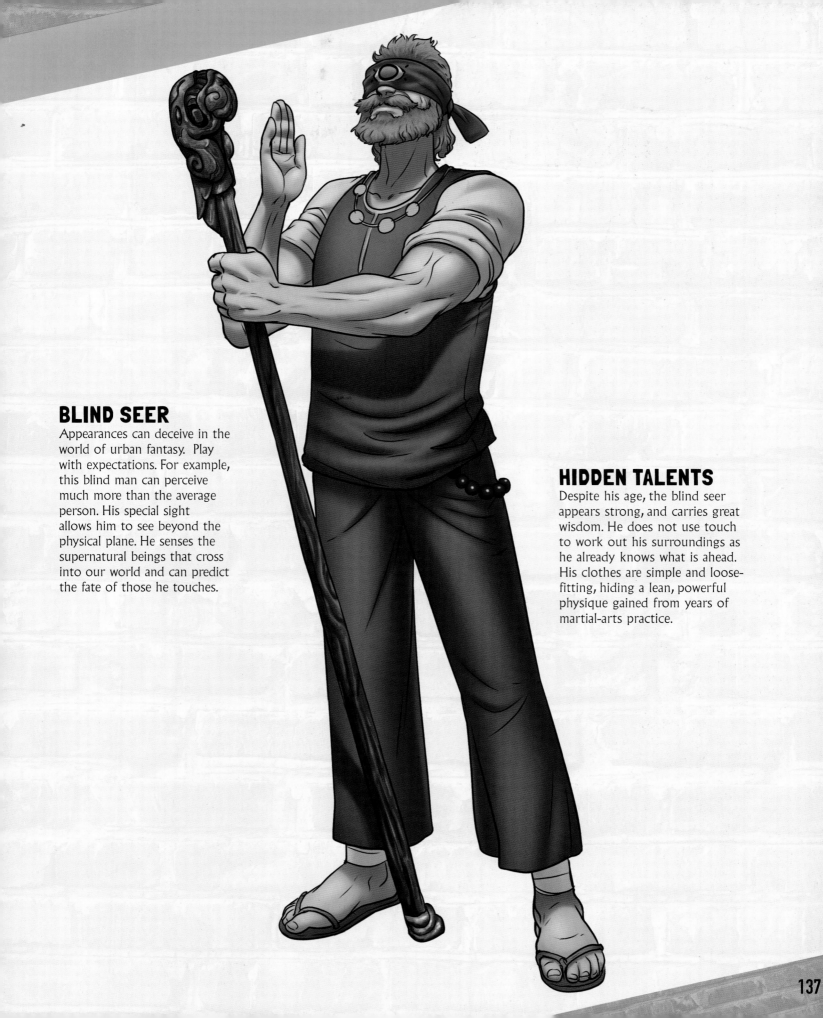

BLIND SEER

Appearances can deceive in the world of urban fantasy. Play with expectations. For example, this blind man can perceive much more than the average person. His special sight allows him to see beyond the physical plane. He senses the supernatural beings that cross into our world and can predict the fate of those he touches.

HIDDEN TALENTS

Despite his age, the blind seer appears strong, and carries great wisdom. He does not use touch to work out his surroundings as he already knows what is ahead. His clothes are simple and loose-fitting, hiding a lean, powerful physique gained from years of martial-arts practice.

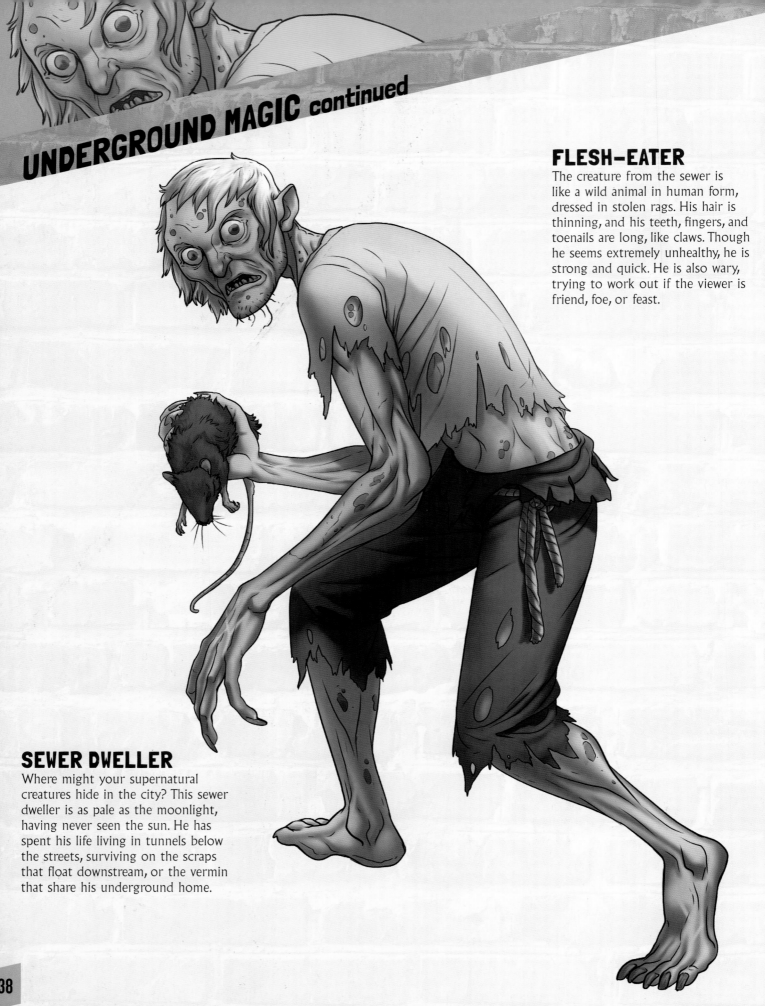

FLESH-EATER

The creature from the sewer is like a wild animal in human form, dressed in stolen rags. His hair is thinning, and his teeth, fingers, and toenails are long, like claws. Though he seems extremely unhealthy, he is strong and quick. He is also wary, trying to work out if the viewer is friend, foe, or feast.

SEWER DWELLER

Where might your supernatural creatures hide in the city? This sewer dweller is as pale as the moonlight, having never seen the sun. He has spent his life living in tunnels below the streets, surviving on the scraps that float downstream, or the vermin that share his underground home.

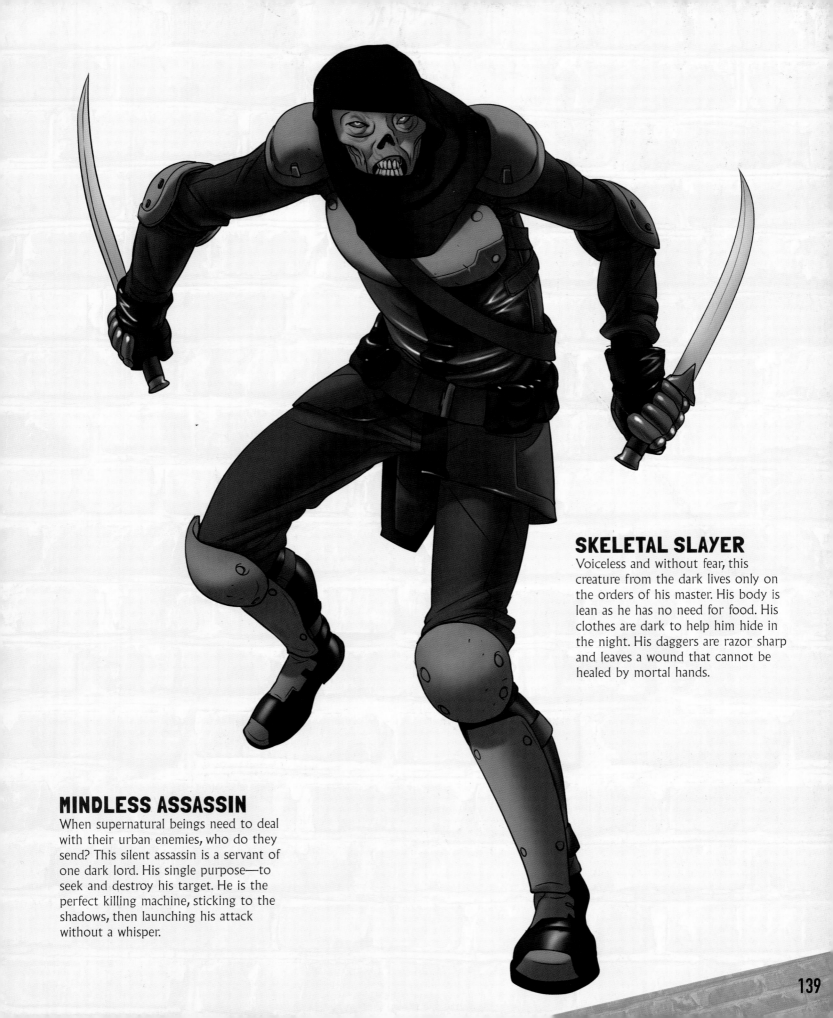

SKELETAL SLAYER

Voiceless and without fear, this creature from the dark lives only on the orders of his master. His body is lean as he has no need for food. His clothes are dark to help him hide in the night. His daggers are razor sharp and leaves a wound that cannot be healed by mortal hands.

MINDLESS ASSASSIN

When supernatural beings need to deal with their urban enemies, who do they send? This silent assassin is a servant of one dark lord. His single purpose—to seek and destroy his target. He is the perfect killing machine, sticking to the shadows, then launching his attack without a whisper.

DEMON DETECTIVE

With expert knowledge of the world's many dark arts, the paranormal detective is available for hire, to solve magical mysteries and free those in need from hauntings and curses.

1. WIREFRAME

Using light pencil marks, draw a few simple lines to sketch the pose of the detective with one hand a fist, the other shaping a mystic shield.

2. JOINTED FIGURE

Now, fill out his figure, with 3-D shapes. Draw a cross on the face to indicate the line of the eyes and nose. Use circles to mark the position of joints.

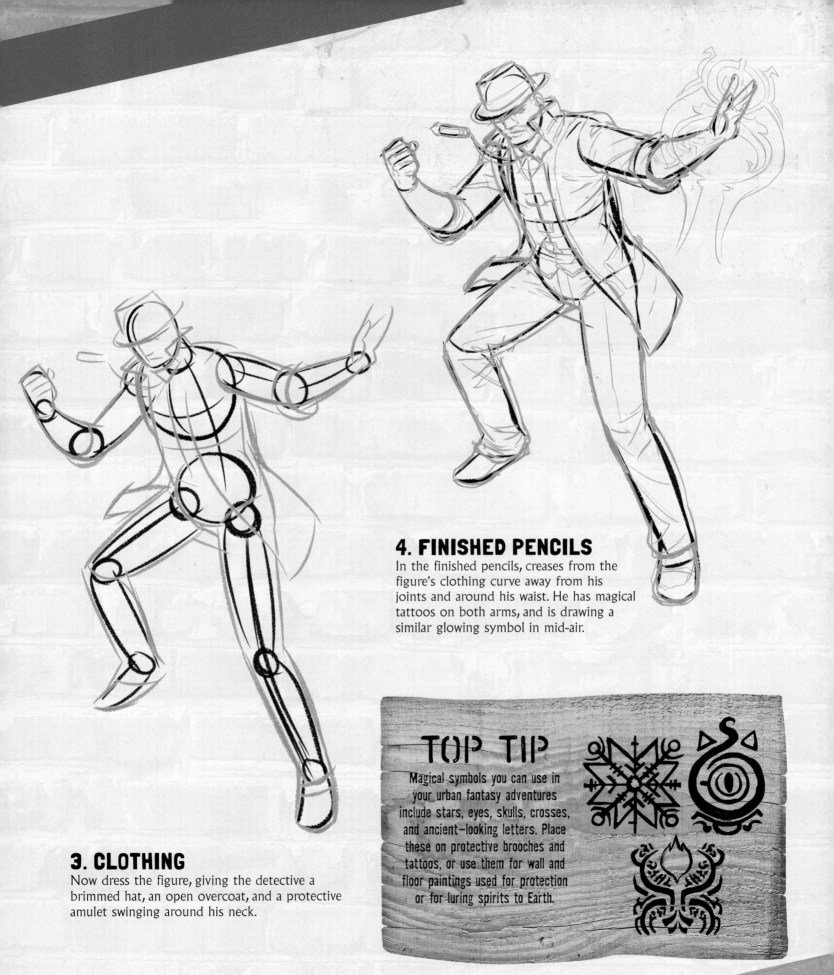

4. FINISHED PENCILS
In the finished pencils, creases from the figure's clothing curve away from his joints and around his waist. He has magical tattoos on both arms, and is drawing a similar glowing symbol in mid-air.

3. CLOTHING
Now dress the figure, giving the detective a brimmed hat, an open overcoat, and a protective amulet swinging around his neck.

TOP TIP
Magical symbols you can use in your urban fantasy adventures include stars, eyes, skulls, crosses, and ancient-looking letters. Place these on protective brooches and tattoos, or use them for wall and floor paintings used for protection or for luring spirits to Earth.

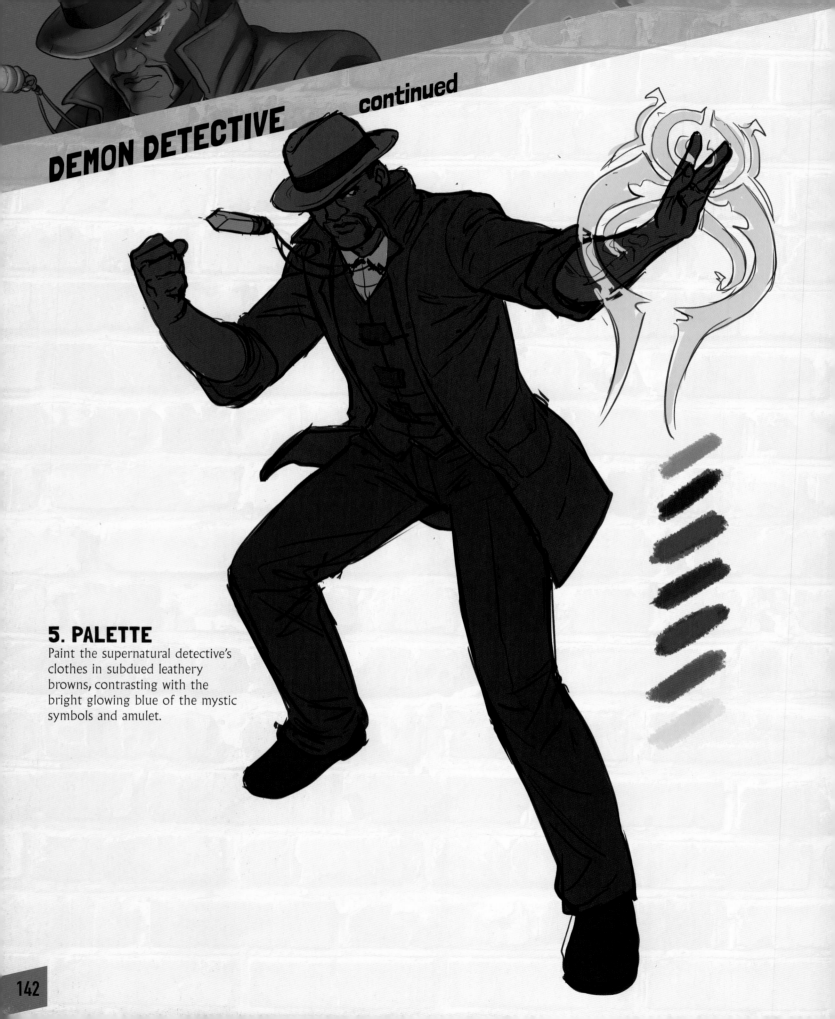

5. PALETTE

Paint the supernatural detective's clothes in subdued leathery browns, contrasting with the bright glowing blue of the mystic symbols and amulet.

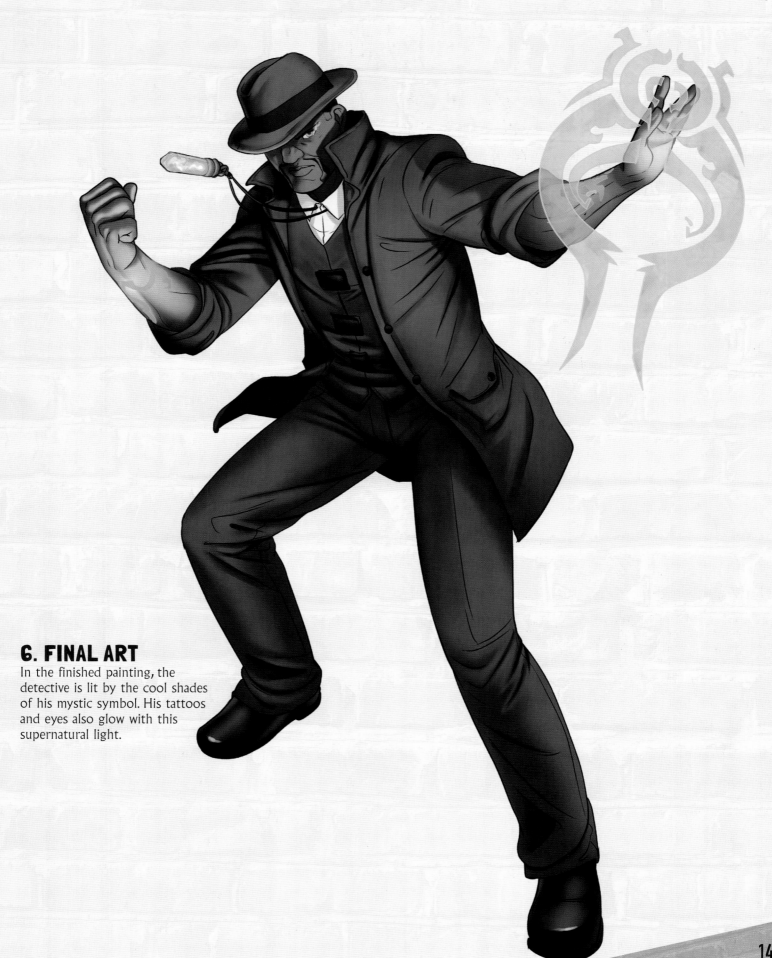

6. FINAL ART

In the finished painting, the detective is lit by the cool shades of his mystic symbol. His tattoos and eyes also glow with this supernatural light.

SECRET SABOTEUR

With her face hidden by a mask, the saboteur strikes against the enemies of freedom. Her identity is hidden to protect her family, or to hide a face scarred through tragedy.

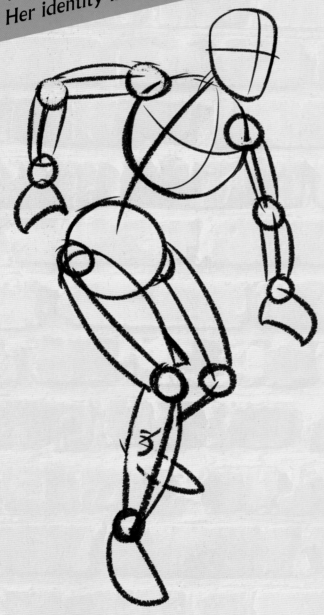

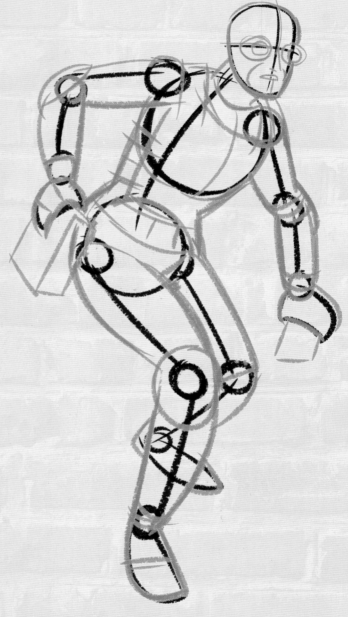

1. POSE

Using light pencil marks, draw a few lines for the pose of the saboteur, with a twist in the upper body. She crouches slightly, and holds her equipment bag with her right hand.

2. FIGURE WORK

Now, fill out her figure. She is light and slim—ideal for sneaking into buildings, but her protective clothes and tools add bulk.

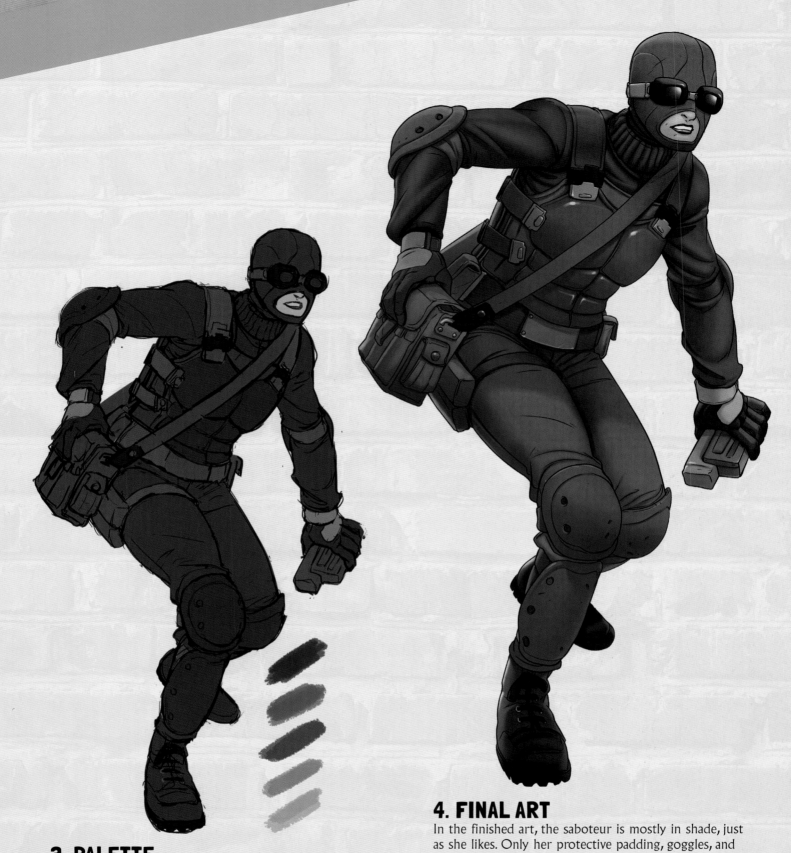

3. PALETTE
Choose stealthy dark blues and greens for the saboteur's outfit. Her clothes are military issue with straps and Kevlar protection. The mask and goggles conceal most of her face.

4. FINAL ART
In the finished art, the saboteur is mostly in shade, just as she likes. Only her protective padding, goggles, and clips reflect the little light there is.

CREATURE SUMMONED

The monster has been summoned from the dark side by unholy rituals, but will it obey the demands of those that called it, or devour them?

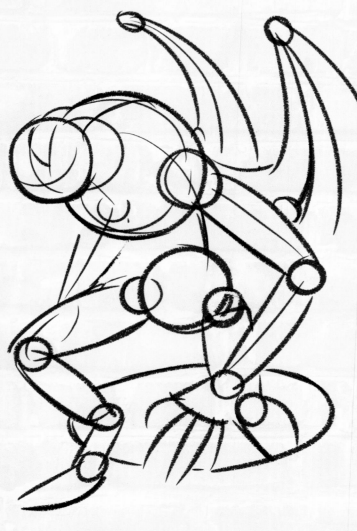

2. JOINTED BODY

Now, fill out the figure with 3-D shapes. The creature is in a crouched position. The wings curve up above the head. Use circles to mark the position of joints, including an extra one in the long foot.

1. ROUGH FIGURE

Using light pencil marks, draw a few simple lines to outline the monster. The creature is stepping through a portal from a dark world. Use circles for the head, chest, and pelvis. Add tentacles from its head, and bat-like wings from its shoulders.

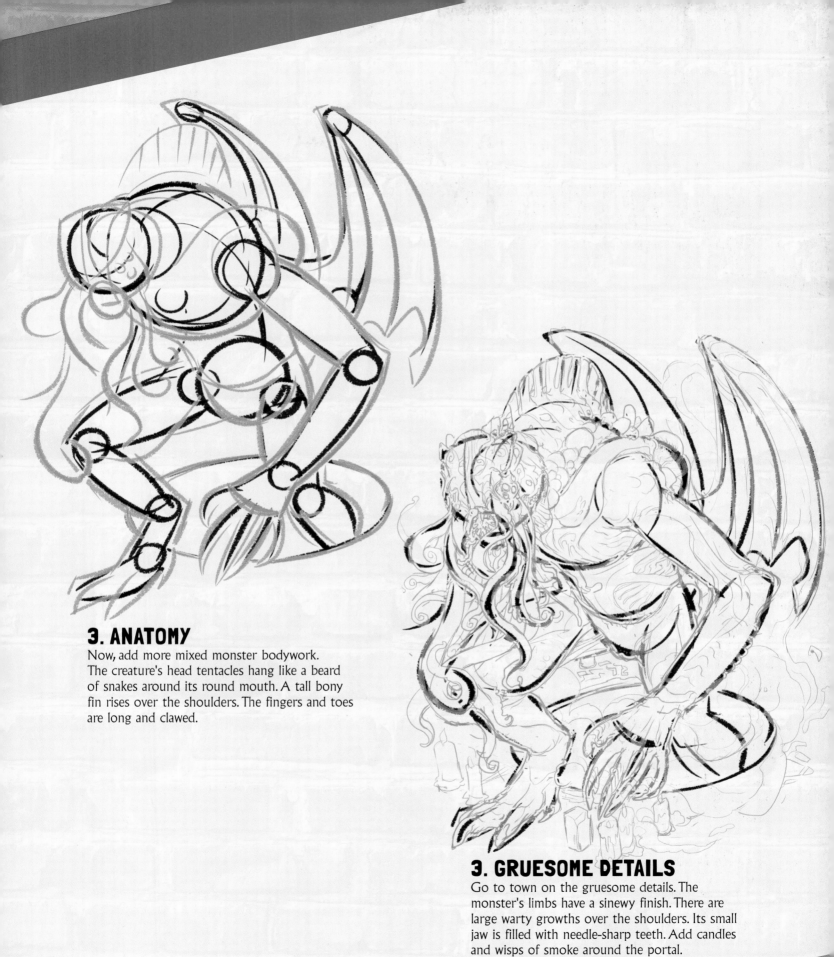

3. ANATOMY

Now, add more mixed monster bodywork. The creature's head tentacles hang like a beard of snakes around its round mouth. A tall bony fin rises over the shoulders. The fingers and toes are long and clawed.

3. GRUESOME DETAILS

Go to town on the gruesome details. The monster's limbs have a sinewy finish. There are large warty growths over the shoulders. Its small jaw is filled with needle-sharp teeth. Add candles and wisps of smoke around the portal.

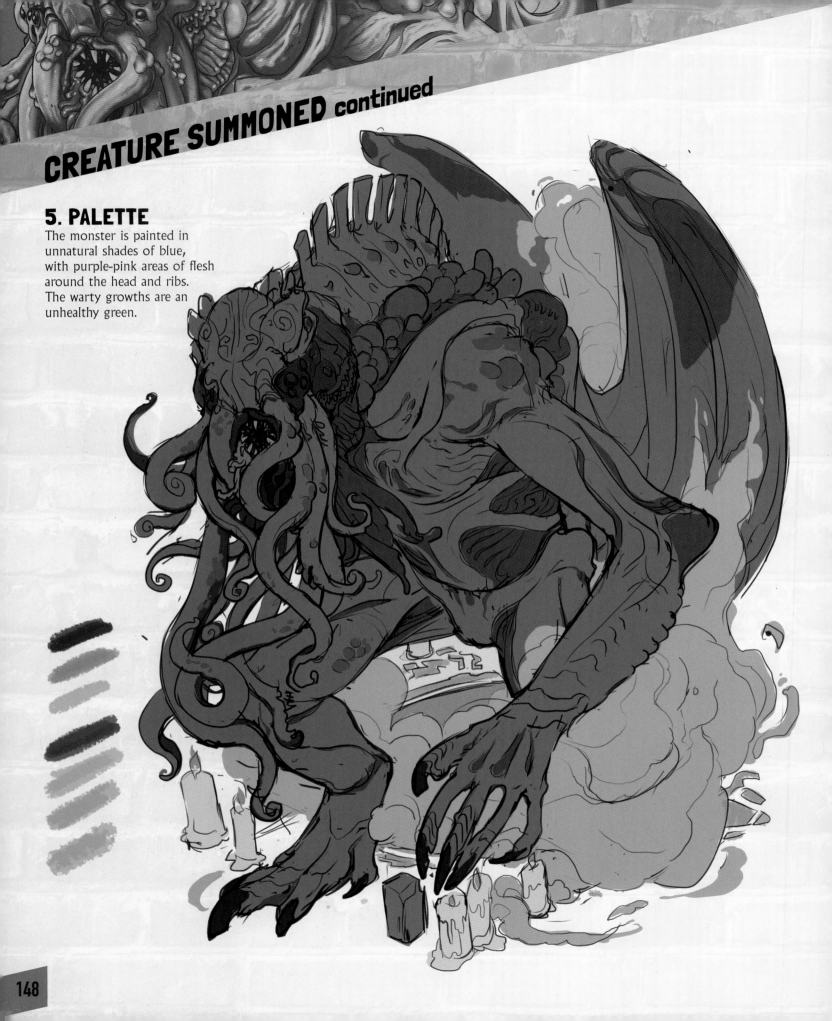

5. PALETTE

The monster is painted in unnatural shades of blue, with purple-pink areas of flesh around the head and ribs. The warty growths are an unhealthy green.

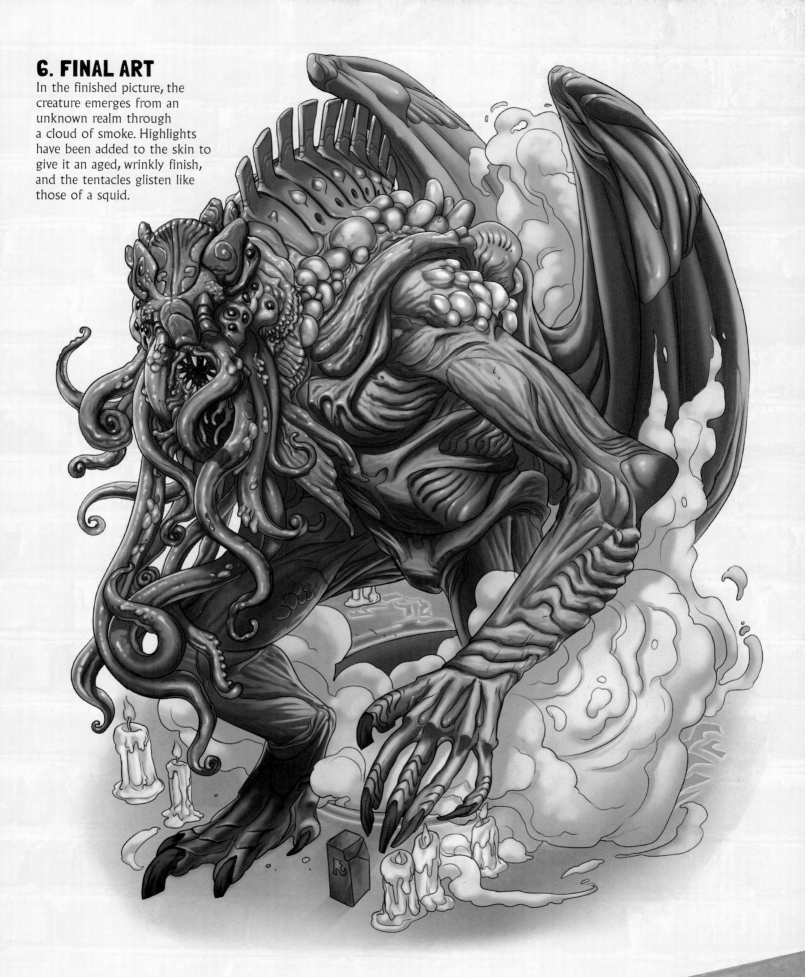

6. FINAL ART

In the finished picture, the creature emerges from an unknown realm through a cloud of smoke. Highlights have been added to the skin to give it an aged, wrinkly finish, and the tentacles glisten like those of a squid.

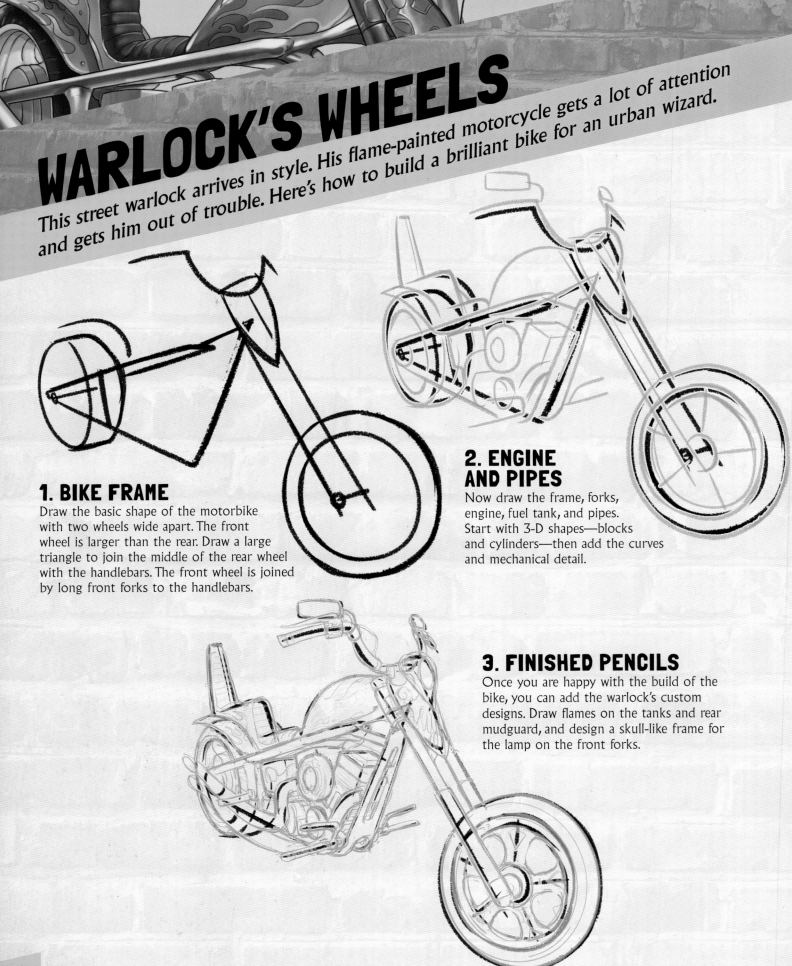

WARLOCK'S WHEELS

This street warlock arrives in style. His flame-painted motorcycle gets a lot of attention and gets him out of trouble. Here's how to build a brilliant bike for an urban wizard.

1. BIKE FRAME
Draw the basic shape of the motorbike with two wheels wide apart. The front wheel is larger than the rear. Draw a large triangle to join the middle of the rear wheel with the handlebars. The front wheel is joined by long front forks to the handlebars.

2. ENGINE AND PIPES
Now draw the frame, forks, engine, fuel tank, and pipes. Start with 3-D shapes—blocks and cylinders—then add the curves and mechanical detail.

3. FINISHED PENCILS
Once you are happy with the build of the bike, you can add the warlock's custom designs. Draw flames on the tanks and rear mudguard, and design a skull-like frame for the lamp on the front forks.

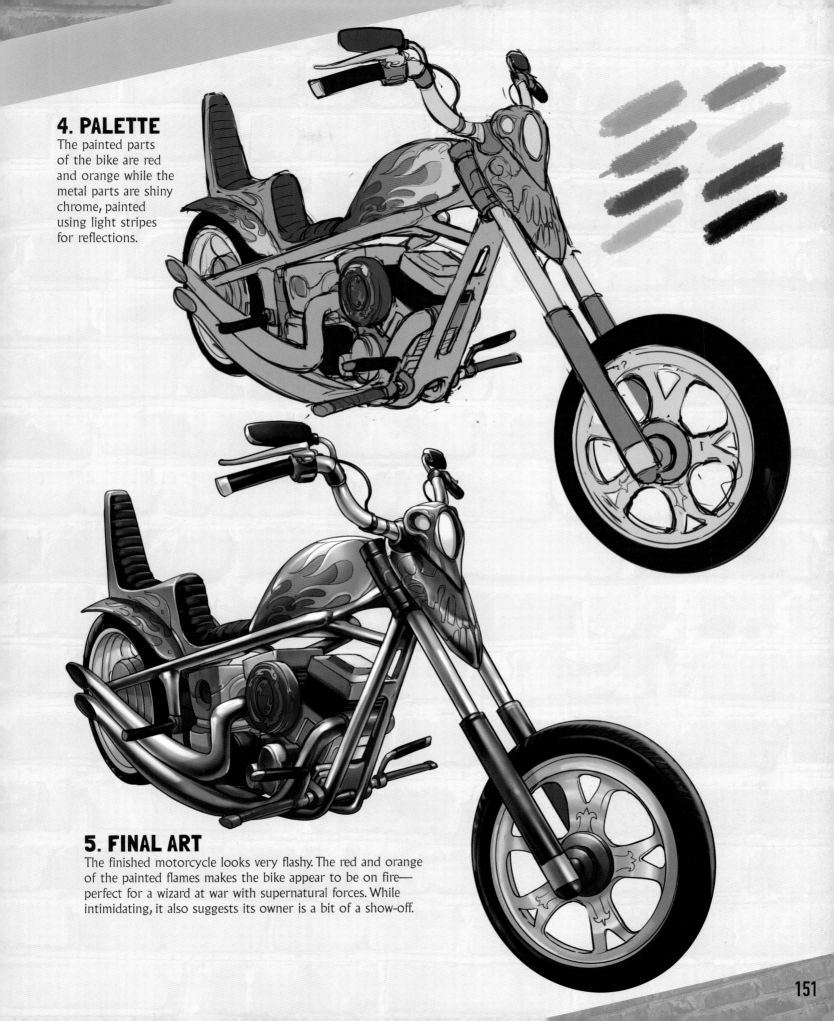

4. PALETTE

The painted parts of the bike are red and orange while the metal parts are shiny chrome, painted using light stripes for reflections.

5. FINAL ART

The finished motorcycle looks very flashy. The red and orange of the painted flames makes the bike appear to be on fire—perfect for a wizard at war with supernatural forces. While intimidating, it also suggests its owner is a bit of a show-off.

SUPERNATURAL STRIKE

In an abandoned subway station, spectral forces have found a route into our world. The occult detective and saboteur need all their knowledge of the dark arts and tech to force them back.

1. Plan the scene in a rough sketch. The occult heroes are racing forward alongside the subway train track while fighting off the winged attackers.

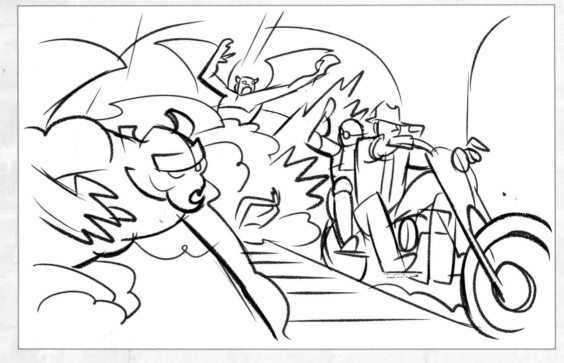

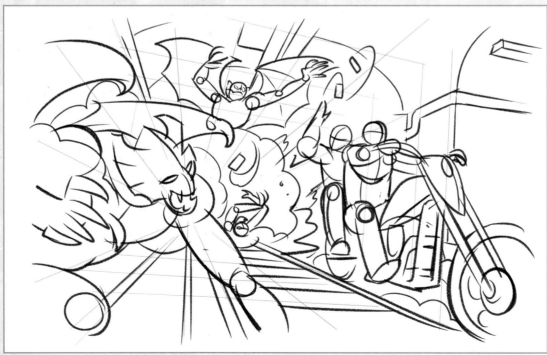

2. Use perspective lines to build up the scene, with the tunnel and track stretching from a point in the middle of the page. The whole image is tilted at a dramatic angle.

3. In the finished pencils, the winged demons are dark in tone. The scene is lit from the right by the motorcycle's headlight. Eerie graffiti has been added to the tunnel walls. Is it meant as a warning?

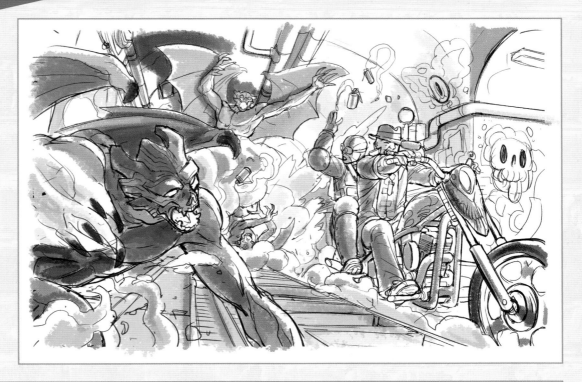

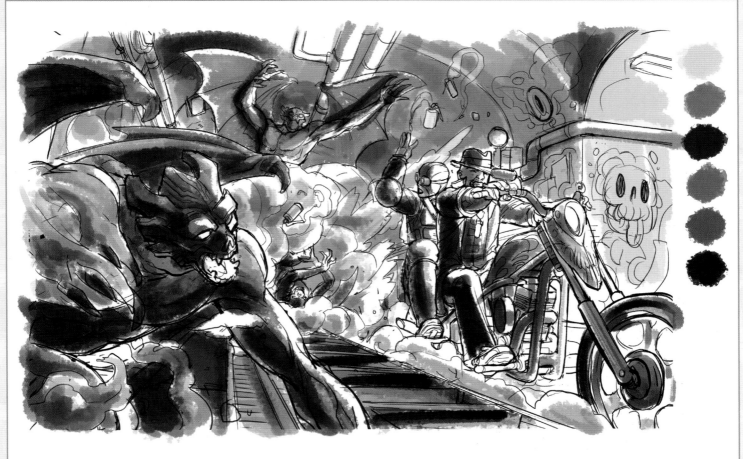

4. The subway is gloomy and forboding, painted with brown shades, the monsters in darker tones. The only bright shades are those on the detective's flashy motorcycle, a mystic shield, and the wall paintings.

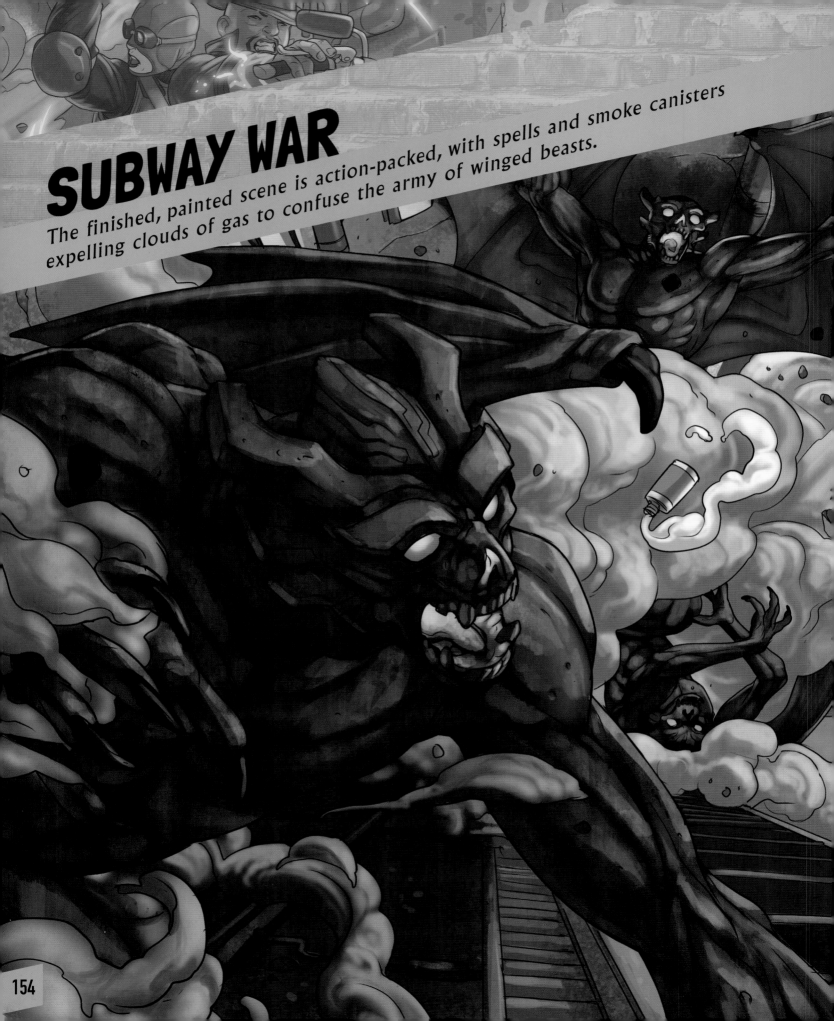

SUBWAY WAR

The finished, painted scene is action-packed, with spells and smoke canisters expelling clouds of gas to confuse the army of winged beasts.

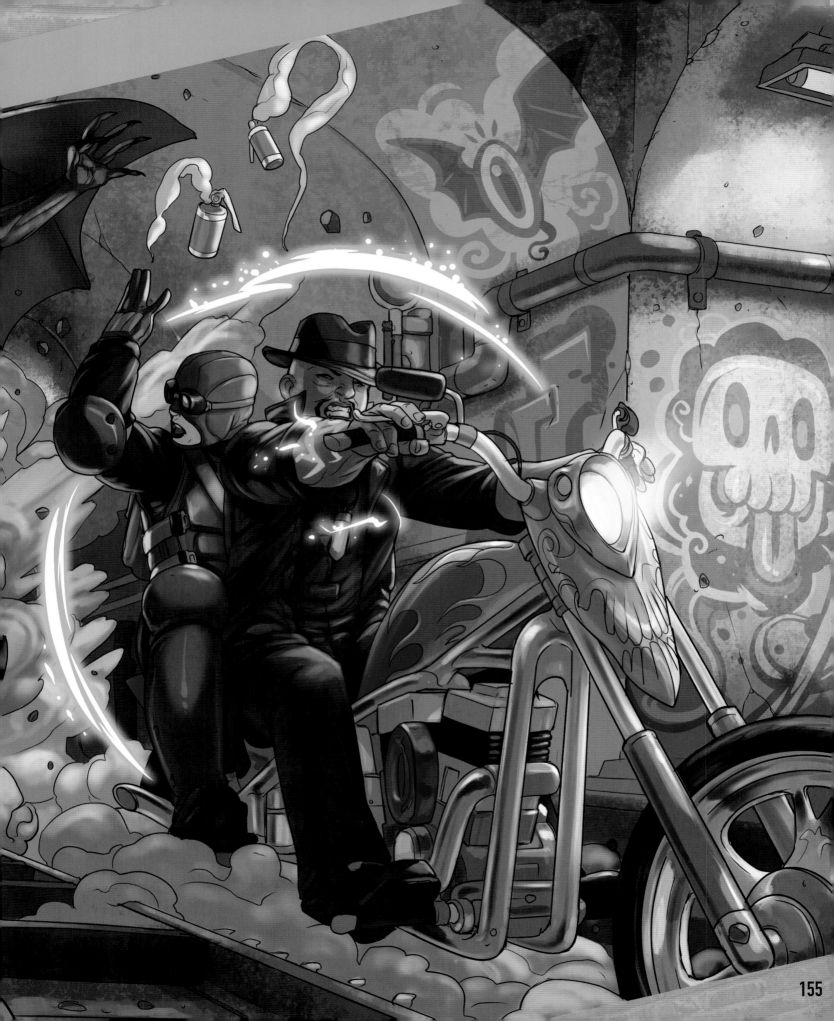

NOT WHAT IT SEEMS

Look carefully for clues that magic is afoot. Here are some details you can add to a scene to suggest that supernatural forces are close by.

Animals may be spirit creatures, or acting as the eyes of supernatural beings. This cat's red eyes are a giveaway, and look extra scary when they peer out from the darkness.

Though disguised, this paranormal being cannot fully hide his snake-like forked tongue and pointed ears. Could he also be hiding horns beneath his top hat?

Strange symbols painted on a wall may not mean anything to you, but they could be a message for unearthly eyes.

A bizarre shadow is cast but there is no visible figure causing it. Its shape is clearly not human.

CAPTURING NATURE

Knowing how to draw natural features will be useful, whether your story takes place in a real or imaginary world. Here are some tips on drawing natural features.

RUNNING WATER

For a stream of running water, use a soft pencil to indicate the direction of the water flow around obstacles. Draw dark patches following the flow, where a person, tree, or building is reflected in the water.

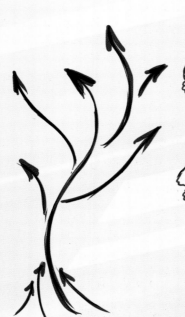

TREES

Draw a curving trunk with branches spreading from about head height. You can leave the branches bare if it's a winter scene, or add cloud-shapes for leafy bushes covering the ends of the branches in summer.

ROCKS

Pile up several 3-D shapes to build a rocky formation. Round off the shapes, then add dots and cracks over the surface for texture.

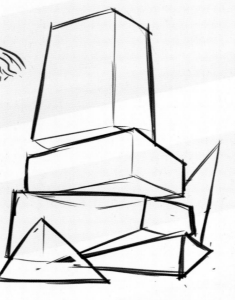
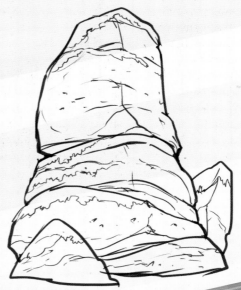

FREE YOUR IMAGINATION

Ideas for fantasy figures and stories can come at any time. Carry a sketchbook with you to doodle ideas and make notes.

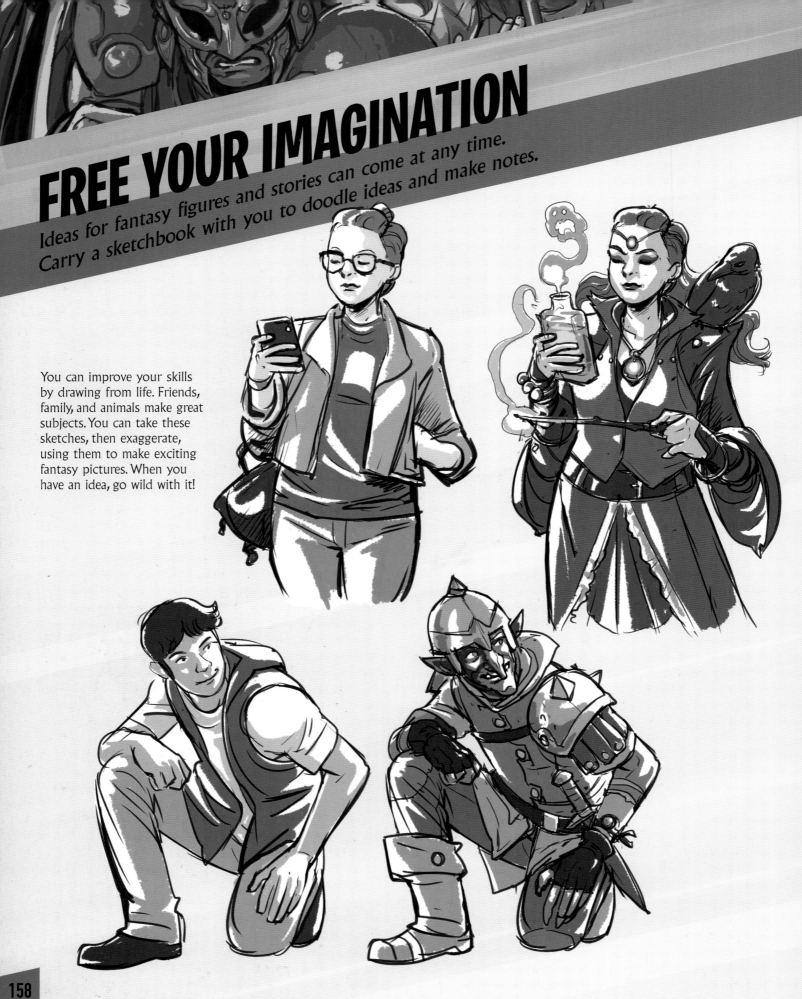

You can improve your skills by drawing from life. Friends, family, and animals make great subjects. You can take these sketches, then exaggerate, using them to make exciting fantasy pictures. When you have an idea, go wild with it!

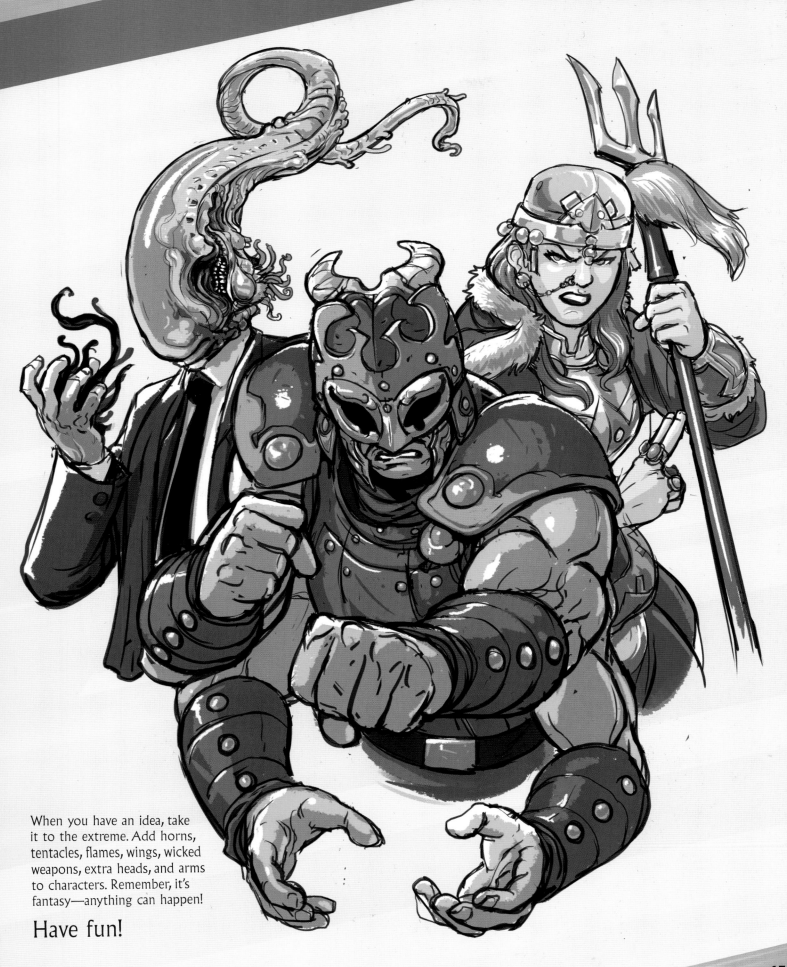

When you have an idea, take it to the extreme. Add horns, tentacles, flames, wings, wicked weapons, extra heads, and arms to characters. Remember, it's fantasy—anything can happen!

Have fun!

GLOSSARY

Here are a few of the trickier words you may encounter in this book.

AUTOMATON A moving machine designed to resemble a human.

AXE A weapon with a steel edge and wooden handle.

BANDOLIER A shoulder-belt with pockets or loops to carry cartridges.

BOWSPRIT A pole running from the front of a ship.

BROOCH An ornament fastened to clothing with a pin.

FIGUREHEAD A carved bust or full figure placed on the front of a ship.

GAUGE A measuring instrument with a display.

GAUNTLET A protective glove.

GORGON One of three monstrous, mythic sisters with snakes for hair.

HIGHLIGHT The white area that helps to make a drawing look solid and draw attention to its shape.

HORIZON The line at which the sky and ground appear to meet.

HYDRA A legendary, many-headed, snake-like monster.

LABYRINTH A maze.

LYCANTHROPE A werewolf.

MERCENARY A soldier for hire.

MONOCLE A single eyeglass.

PARANORMAL Something beyond scientific understanding.

PERSPECTIVE The representation on a flat surface of a three-dimensional image as seen by the eye, to give the illusion of distance and depth.

PALETTE The range of shades chosen by an artist.

QUIVER An archer's case for holding arrows.

SABOTEUR Someone who deliberately damages or destroys something for a political advantage.

SCABBARD A sheath for a sword's blade.

TORSO The chest, belly, and back of a body.

WARLOCK A male sorcerer.